LANDSCAPES FROM A HIGH LATITUDE
ICELANDIC ART 1909-1989

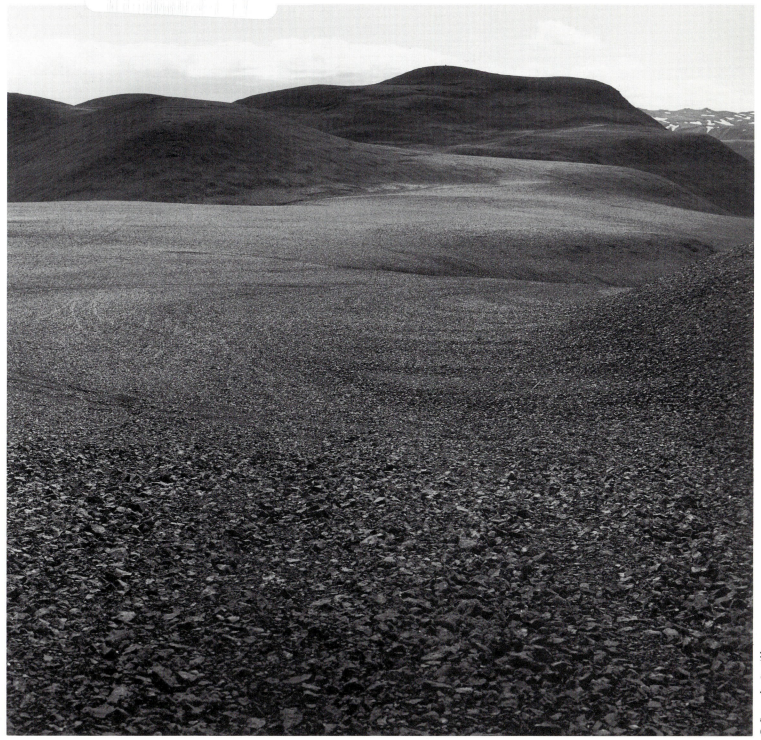

Guðmundur Ingólfsson

Patrons

The Rt Hon. Richard Luce
Minister for the Arts

Mr Svavar Gestsson
Icelandic Minister of Culture and Education

To me Iceland is sacred soil. Its memory is a constant background to what I am doing. No matter that I don't make frequent references to the country; it is an equally important part of my life for all that. I may be writing about something totally unrelated, but it is still somewhere close by. It is different from anything else. It is a permanent part of my existence, even though I am not continually harping on it. I said it was a kind of background, that's right. I could also say that Iceland is the sun colouring the mountains without being anywhere in sight, even sunk beyond the horizon.

W H AUDEN
in a newspaper interview, Reykjavík, April 1964

Landscapes from a High Latitude
Icelandic Art 1909-1989

Edited by Julian Freeman

in a collaboration between Listasafn Íslands (The National Gallery of Iceland)
and Brighton Polytechnic Gallery

Foreword by Magnus Magnusson

Published for The Government of Iceland and the City of Reykjavík

by Lund Humphries · London

FRONT COVER
Ásgrímur Jónsson *Winter Sun in Hafnarfjörður, 1929-30*
Listasafn Íslands (cat.6)

Copyright © 1989 The Government of Iceland and the City of Reykjavík
Texts Copyright © 1989 the authors
Illustrations Copyright © 1989 as per photographic acknowledgements

First edition 1989

Published by Lund Humphries Publishers Limited
16 Pembridge Road London W11 3HL
for the Government of Iceland and the City of Reykjavík

British Library Cataloguing in Publication Data
Landscapes from a high latitude: Icelandic art, 1909-1989
1. Icelandic paintings, history
I. Freeman, Julian
759.9491′2

ISBN 0 85331 573 6

Designed by Alan Bartram
Printed in Great Britain by BAS Printers Limited
Over Wallop, Stockbridge, Hampshire

Photo Credits

All photographs in this book have been supplied by Listasafn Íslands and taken
by Kristján Pétur Guðnason
except for the following:

Mike Fearey: Plate 41
Guðmundur Ingólfsson: Photographs on pages 1, 9, 10, 14, 17, 20
Listasafn ASÍ: Colour plate XIII
Listasafn Einars Jónssonar: Plate 10
Listasafn Reykjavíkur, Ásmundarsafn: Plates 11, 12, 40
Louisa Matthíasdóttir: Colour plate XII, Plate 24
Nasjonalgalleriet, Oslo (Jacques Lathion): Plates 43, 44
Odd Nerdrum: Plate 45
Ása Ólafsdóttir: Colour plate XIV
Leifur Thorsteinsson: Plate 15
J F Willumsen Museum, Frederikssund, Denmark: Plate 46

LANDSCAPES FROM A HIGH LATITUDE
ICELANDIC ART 1909-1989

is published to coincide with an exhibition of the same name touring Britain,
to
the Ferens Art Gallery, Hull;
Great Grimsby Town Hall;
The Barbican Art Centre, London;
Brighton Polytechnic Gallery and the Burstow Gallery, Brighton College, for the
1990 Brighton Festival;
The Talbot Rice Art Centre, University of Edinburgh

Contents

List of Illustrations

Magnus Magnusson

Foreword

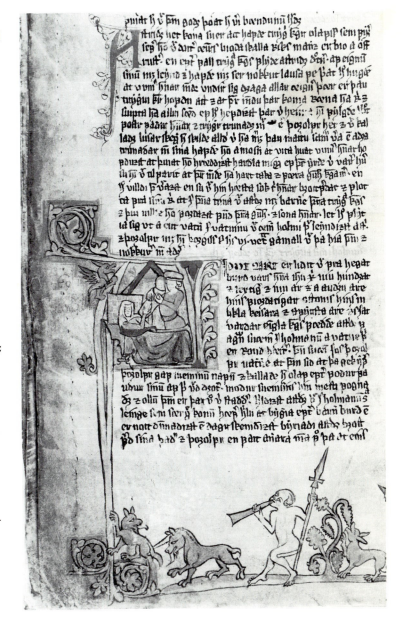

Illumination from an Icelandic manuscript, *The Book of Flatey*, written in the late 14th century, the largest of all Icelandic vellum manuscripts. It contains Sagas of Norwegian kings and many other narratives. The detail shows the birth of Ólaf Tryggvason, King of Norway (995 - 1000).
Stofnun Árna Magnússonar, Reykjavik

More than a century ago, in 1856, the noted diplomat, the Marquis of Dufferin and Alva, visited Iceland for the first time and published a book called *Letters from High Latitudes*, which opened the eyes of the English-speaking world to the strange and still little-known country that lay far to the north of their ken, the 'Ultima Thule' of legend and tradition and imagination.

As an Icelander long resident in Britain, it is my hope that this magnificent and comprehensive exhibition of Icelandic art, so appropriately named *Landscapes from a High Latitude*, will have something of the same impact here that Lord Dufferin had, all those years ago.

Iceland's heritage has traditionally been expressed through its literature. It was the Word itself which uttered the uniqueness of the Iceland experience. Yet Iceland might well have been created with artists in mind – an endless vista of magnificent locations, each more urgently breath-taking than the last ; a landscape that inspired the great Icelandic Sagas, that inspired its people to survive every hardship, and has always inspired its artists to celebrate its beauty and its brightness.

In Iceland the challenge of existence is still the very stuff of life ; it is a challenge to achievement that is finding a new and expressive voice in the subtle idioms of art. The language is cosmopolitan – but the accent is distinctively and creatively Icelandic.

Iceland today is a veritable crucible of artistic activity, where the arts in public and in private flourish as they have seldom done before. It is the arts that are our common language ; it is through the arts that we speak most intimately to one another.

In my own fields of occupation and preoccupation I have always been entranced by legend and folk-tale. Folklore is the ultimate art of the common people. In the wild and rugged hinterland of Iceland there are strange and mystic places, weird shapes and curious rock formations. There are winter storms that used to snuff out lives like candles in a breeze. No wonder, then, that folklore flourished, to help give meaning and proportion to the vast and the inexplicable.

The lava rocks became the homes of elves and trolls whose land it really was, and at whose sufferance alone the people lived. The elements were real, and they were harsh, and it behoved all men to know them and if possible befriend them. The mountains were the homes of trolls who could destroy the land and all who lived in it. But the mountain lakes were also home to wishing-stones, magic stones that floated to the water's edge on hallowed nights, on Midsummer's Eve, perhaps; and those who found one would be granted everything their hearts had ever longed for.

It was the folk-art of these stories, of fearful things that might befall, and wishes that might all come true, that expressed the way that people really are, and tells us more about them than it does about wishing-stones or trolls.

In this way art speaks intimately of ourselves and what we are. But it speaks intimately to others, too. Art is the most revealing and immediate of all men's activities. The very word 'art' suggests both substance and insubstantiality, reality and unreality, image and imagination. For art both reflects and refracts; it both mirrors and interprets the society which we inhabit, and our responses to it.

That is why, perhaps, some countries in the past have seemed to be afraid of art, afraid of what it might say to them about themselves. There have been times when we would only let artists speak when they were safely dead. In Iceland today, I am glad to say, we cannot wait to hear what they are saying to us:

Artists whose ears can hear the music of the spheres and so transform our own mundane tonalities . . .

Artists whose tongues elaborate the stories that express our lives: our past, our present, and all that is to come . . .

Artists whose eyes glimpse that which others cannot see, and mirror it for us to view . . .

Artists whose hands shape the dull clay of our everyday existence and turn it into gold . . .

Above all, artists in whose deep imaginings our dreams are dreamed, to make reality more tolerable — and more real.

For it is only with the perception of the artist that we can begin to perceive ourselves; and it is through the perception of the artist that others can perceive us, too.

Through this splendid exposition of *Landscapes from a High Latitude*, I hope that Britain will see something of the real Iceland, which no other medium could show with such variety and colour. I hope it will express something of our creativity and our inspiration — not just the way Icelanders live, but the way in which Icelanders are.

When the first Scandinavian explorers approached the virgin land of Iceland, they took care to send ambassadors ahead. They had brought with them the hallowed wooden pillars of their high-seats, symbols of everything they held dear at home. Artists had carved them with the pictures of their gods. And now when they came within sight of land, they threw these pillars overboard; and they vowed to settle where the guardian spirits of their promised country would welcome them to make land.

Let these *Landscapes from a High Latitude* be Iceland's ambassadors to you. Let them do Iceland's speaking for us Icelanders. I hope you will welcome them, and take them to your hearts. For they are sent with friendship, and respect, from across the deep Atlantic that both separates and joins us.

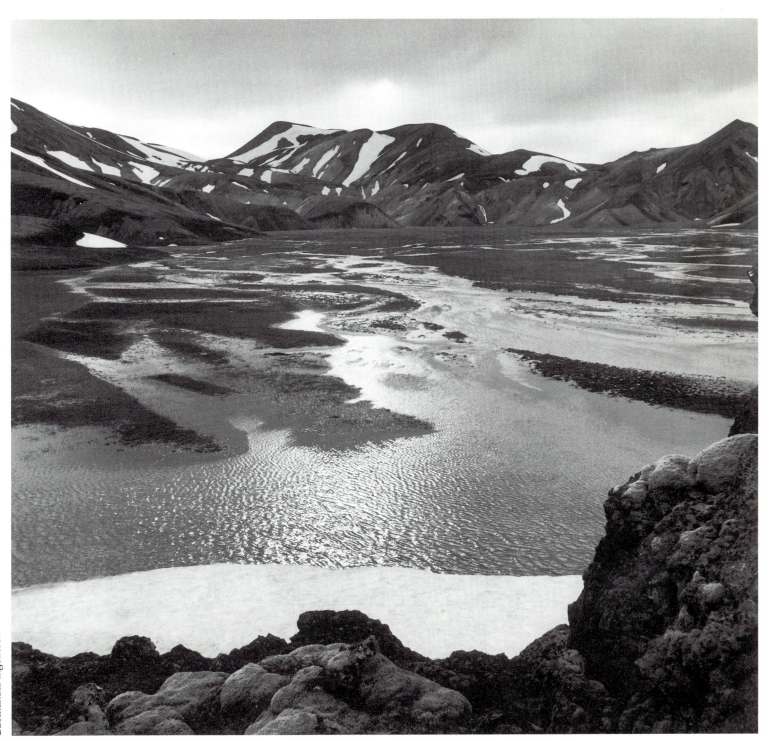

Guðmundur Ingólfsson

Guðmundur Ingólfsson

Editor's Preface

Until 1989 and the appearance of *Landscapes from a High Latitude*, no printed survey of twentieth century Icelandic art had appeared in Great Britain. Nor has any exhibition been mounted in this country which has been exclusively devoted to that subject. It is sincerely hoped that both this publication and its parallel exhibition will act as landmarks in Britain's growing appreciation of Nordic art. At one level these events provide new, vital, aesthetic stimuli and reference sources; at another, they are tangible results of an excellent collaboration which it is hoped will be of lasting value.

This project began following a visit by the Ambassador of Iceland to the 1987 Brighton Festival, on the invitation of its Artistic Director, Gavin Henderson. In two years it has evolved from an informal partnership between Brighton Polytechnic and the Government of Iceland into a fully-fledged collaboration. As a result, many people in Britain and Iceland have been involved in considerable effort. The extent of their achievement should not go unsung, and in this context I write for myself, for the Government of Iceland, and for the City of Reykjavík, in order to extend sincere thanks to all of them.

No words of appreciation are adequate to describe the very real support, commitment and guidance freely given by the Ambassador of Iceland to the Court of St James's, Ólafur Egilsson. Without him, neither this publication nor the present exhibition would have existed. Two research visits to Iceland were necessary, and were greatly aided by the Ministry of Education and Culture in Reykjavík, its Secretary-General Knútur Hallsson, and his colleague Kristinn Hallsson. In the Ministry's Legal Department, Thórunn Hafstein established the project's basis in Law. At its earliest stage, the scheme was strongly supported by Sveinn Einarsson, then working for the Ministry: his was a most important and beneficial role.

A huge debt is owed to the Administrators of the major art collections in the City of Reykjavík and its Municipality, who willingly consented whenever possible to the heavy demands made of them for picture loans and information. At Listasafn ASÍ (The Icelandic Labour Unions' Museum) its Director Sólveig Georgsdóttir was an early supporter of the scheme, and at Kjarvalsstaðir (the Reykjavík Municipal Art Museum) its new Director Gunnar B Kvaran was similarly helpful. I would particularly like to thank Einar Hákonarson, late of Kjarvalsstaðir, and his wife Sólveig, for their insights and hospitality.

However, the heaviest load in the preparation in Reykjavík of both this publication and the exhibition was borne by Listasafn Íslands (The National Gallery of Iceland) and its Director, Bera Nordal. She organised a complex exercise in information retrieval, with her colleagues, the specialist Art Historians Hrafnhildur Schram and Júlíana Gottskálksdóttir, and with the gallery staff. Much of that work has enriched this publication, but they have covered other areas also. I am also most grateful to Hrafnhildur Schram for her untiring ability in organising studio visits for me and for colleagues in Reykjavík in 1989. To the artists and lenders (listed elsewhere) who willingly participated in those meetings, often at short notice, I offer my sincere thanks.

As this project has developed, so our British collaborators have been unflagging in their support. Dr Duncan Macmillan, of the Talbot Rice Gallery, University of Edinburgh, deserves special mention. His proposal that the exhibition concentrate on landscapes did much to define its eventual form. At Hull, we received consistent encouragement from Patrick Doyle, Leader of the City Council, and from John Bradshaw, Curator of the City's Art Galleries and Museums. I am especially grateful to Ann Bukantas, Assistant Keeper at the Ferens Art Gallery, for her fresh views on the exhibition's selection, and for her willing assistance in many other matters. From the same region, our thanks also go to all concerned from Great Grimsby Borough Council, for their firm commitment to a new venture. In London, endorsement for the project came from Humphrey Burton, Artistic Director of the Barbican Arts Centre, and from Maggie Wyllie, the Centre's Visual Arts Manager, who provided most useful practical information and advice. In Brighton, thanks are due to the Headmaster of Brighton College, John Leach MA, and to his Director of Art, Nicholas

Bremer, with whom I have been able to continue a well-established process of interchange.

Brighton Polytechnic contributed substantially to the travel costs necessary to research this project, and for the many meetings it has entailed. We are particularly grateful to the Director of the Polytechnic, Professor G R Hall OBE, and to John Crook, Assistant Dean of the Faculty of Art, Design & Humanities, both of whom have been most active in assisting the exhibition's appearance in Brighton for the 1990 Festival. My thanks also to Robert Haynes, Head of the Department of Art and Design History, and to many other colleagues, for their interest.

The preparation of articles for this publication has been an exacting process, and I record here my sincere appreciation to all contributors for their excellent and varied texts. Others have provided information or photographs for specific purposes. For this I wish to thank Odd Nerdrum, Oslo; The National Gallery of Norway, Oslo; the J F Willumsen Museum, Frederikssund, Denmark; and Jón Reykdal and Guðmundur Ingólfsson, Reykjavík. At Lund Humphries, John Taylor and Lionel Leventhal deserve the deepest thanks for their patience, interest and expertise. I am especially grateful to Charlotte Burri and Alan Bartram for the sensitivity and enthusiasm they have shown in their editorial and design work. Dr Guðrún Nordal's proof-reading was also extremely valuable.

Landscapes from a High Latitude would have been impossible to produce without encouragement and financial assistance from numerous benefactors, who have helped in a variety of ways. We therefore express our warmest thanks to Richard Smith, and Manufacturers Hanover Ltd, and to Gísli Ólafsson and Tryggingamiðstöðin, Reykjavík. The willing involvement of Hörður Sigurgestsson of EIMSKIP, The Icelandic Steamship Company Ltd, has ensured that the exhibition reaches Britain. Vital practical input was also given by Steinn Lárusson, of Icelandair, whose generosity guaranteed vital research time in Reykjavík. No less intrinsic has been the support given to the project by other companies based around Humberside, and elsewhere in England. For this we thank Sigurður Sigurðsson, Iceland Seafood Ltd; Jón Olgeirsson, Fylkir Ltd; Pétur Björnsson, Ísberg Ltd; Jóhann F Sigurðsson, Anglo-Icelandic; John W Gott Ltd; Ingólfur Skúlason, Icelandic Freezing Plants Ltd; Stefán Stefánsson, MGH/EIMSKIP Ltd; and Eggert Sverrisson, Samband of Iceland. Garrett Bouton, and The Scandinavian Bank Group plc also deserve mention.

Great interest in this event has always been forthcoming from Claus Henning, Director of The Visiting Arts Unit of Great Britain, and from Frances Smith, Visual Arts Officer of South East Arts. Their organisations' assistance and their personal encouragement have been important as plans developed.

Collaborations work at many levels, and here I wish to pay unreserved tribute to the support and advice received from my colleague and co-selector, Michael Tucker, of Brighton Polytechnic. Ours has been a splendid partnership. It does not, however, quite match that offered by my wife, Estelle, whose tolerance has been both remarkable and hard-tested whilst I have been away, physically or mentally, in the High North.

JULIAN FREEMAN
Exhibition Officer, Brighton Polytechnic Gallery
August 1989

JULIAN FREEMAN (*b.*1950) has been Exhibition Officer at Brighton Polytechnic since 1978. In that time he has produced over 150 exhibitions and has enlarged an existing course on Artists and War. He has written articles for *Military Illustrated Magazine* and for *The Burlington Magazine,* for which he is an occasional reviewer.

Introduction

This publication is a major part of the first comprehensive promotion of Icelandic art ever mounted in the United Kingdom, also involving a touring exhibition. Credit for this initiative is above all due to the particular interest shown by two Britons, Julian Freeman and Michael Tucker, who selected the artists and works to be shown after visiting Iceland to study them. The idea for an exhibition of Icelandic art originated with the Icelandic Ambassador to the United Kingdom, Ólafur Egilsson, and his deep interest and encouragement have made a major contribution towards its realisation. As its title suggests the exhibition reflects the Icelandic landscape, but in a very broad sense.

Modern Icelandic pictorial art began around the turn of the century with an exhibition by Thórarinn B Thorláksson, which represented a cultural turning-point as the first public showing by an Icelandic artist in his own country. Icelandic painting developed towards the end of the nineteenth century as society began to undergo radical changes and the nation was granted greater independence by Denmark, to which it was linked until becoming a republic in 1944. In all its many and varied forms, the landscape has been one of the greatest influences upon Icelandic artists from the very beginning. Initially, Icelandic artists mainly worked under Danish academic influence in the spirit of *fin de siècle* natural realism and symbolism, but found it difficult to adapt their foreign schooling to the Icelandic landscape and reality. A national school gradually emerged with distinctively Icelandic characteristics, interpreting both the country's unique natural phenomena and the mounting tension between the old agricultural community and new urban society.

The event spans the entire history of Icelandic painting, from the pioneering attempts of Thórarinn B Thorláksson (1867-1924) and Ásgrímur Jónsson (1876-1958) around the turn of the century to express their sentiments towards their mother country, right up to the present day. Like his predecessors, the youngest artist represented here, Georg Guðni Hauksson (b.1961), seeks inspiration in the landscape, but interprets it on different premises as a vehicle for introspective and stylised works which purvey the symbol of Iceland, the mountain. Also represented in the exhibition are abstract artists, particularly from the 1940s onwards, who display a very powerful and subjective perception of nature. Works are also included in which artists use the land to interpret its delicate interplay with men and animals. But no discussion of Icelandic landscape art can omit to mention Jóhannes S Kjarval (1885-1972). His interpretation of the Icelandic landscape unfolded new horizons and, through its powerful approach to detail and the close-up, has played a large part in shaping the way the Icelanders themselves comprehend the natural world around them.

Long-standing cultural bonds link Iceland and Great Britain. Although Icelandic culture will continue to be recognised by virtue of the medieval writings which are among the treasures of world literature, there is also a remarkable tradition in the visual arts. Particularly noteworthy are the Icelandic manuscript illuminations and woodcarving, in which British influences, incidentally, can be discerned. Imports of precious church objects from Britain were also quite common. But the present exhibition focuses upon modern Icelandic culture. We are not a populous nation, but we have had, and still have today, accomplished artists who pay loving tribute to their country's landscapes in all their variety. Artists who, through their perceptions, have opened our eyes to both the beauty of the landscape and its awesome qualities.

It is the sincere hope of Listasafn Íslands (The National Gallery of Iceland) that this long-overdue exhibition will arouse interest among the British public in the culture and art of Iceland today.

BERA NORDAL
Director, National Gallery of Iceland
Reykjavík 1989

A carved pine wood church door from Valthjófsstaður (north-eastern Iceland), c.1200. Detail showing a nobleman who has saved the lion from a dragon. On the far right, the lion lies on its saviour's grave, mourning his death. It is a good illustration of the European influences on Icelandic art in the Middle Ages. Thjóðminjasafn Íslands

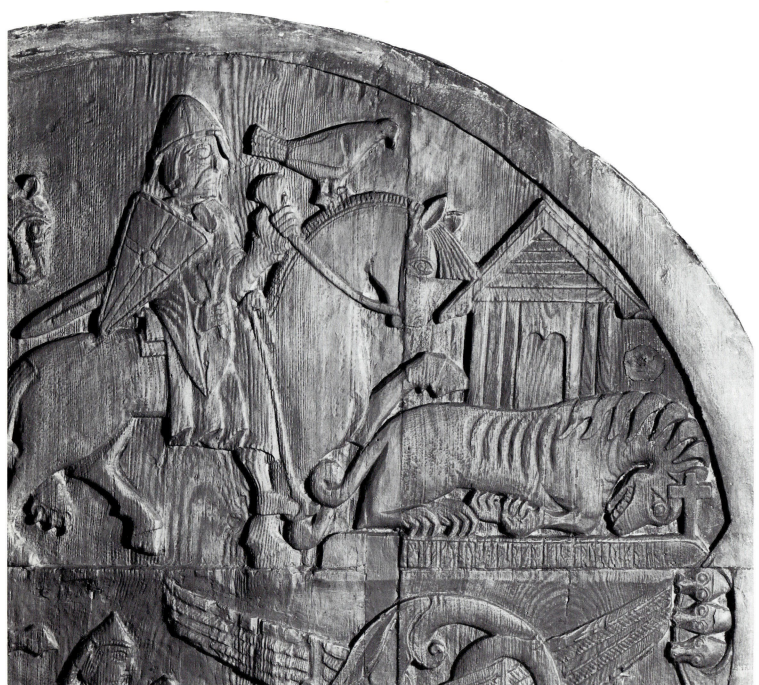

Guðmundur Ingólfsson

Sigurður A Magnússon

A Bird's-Eye View of Icelandic Culture

To the uninformed observer, it must be a bewildering enigma that a sparsely populated and remote volcanic island in the North Atlantic, on the very verge of the habitable world, should have become one of the world's most prodigious workshops and storehouses of literature in the Middle Ages.

First, let us look at the locality.

Iceland, the second-largest island in Europe, skirting the Arctic Circle, is by most standards an uncommonly rugged and barren country, a paradox of fire and ice, of molten rock and frozen water. Geologically it is a young country and the process of its formation is still going on. It is in large part a table-land broken up by tectonic forces. Its interior consists entirely of mountains and high plateaux, devoid of human habitation. Its average height is 500 metres above sea level. The salient features of the country are the glaciers covering over 11 per cent of its total area: the 200 post-glacial volcanoes, at least thirty of which have erupted since Iceland was settled (on the average there is an eruption every fifth year): the 250 low-temperature areas with some 800 hot springs: the fourteen bubbling solfatara fields (high-temperature activity): the sparseness of vegetation (only one quarter of the country has any kind of continuous plant cover); and the smallness of its fields (merely one per cent of its total area is under cultivation). When considering these facts, one realises how harsh and exacting the country must have been to its inhabitants through the ages.

Iceland was settled in the late ninth century AD by a mixed stock of Norsemen from Scandinavia and Celts from the British Isles. When the country had been more or less settled by the year 930, the *Althing* (General Assembly) was formed at Thingvellir, 50 kilometres east of Reykjavík, inaugurating the so-called Icelandic Commonwealth, made up of thirty-nine independent chieftaincies. This lasted without any kind of central or executive authority until 1262, when Iceland came under Norwegian rule, followed by Danish rule in 1380.

In the year 1000, Christianity was peacefully adopted by the *Althing* through a shrewd and far-seeing compromise between two bellicose forces. The *Althing* met for two weeks every summer, in late June, attracting a large proportion of the population, since the legislative proceedings were accompanied by a kind of national festival where games, recitals, match-makings, trading and various contests were important ingredients. Christianity in due time brought writing to Iceland, with consequences that nobody could have foreseen.

The early blending of Nordic and Celtic blood may partly explain the fact that the Icelanders, alone of all the Nordic peoples, produced great literature in the Middle Ages. One remarkable branch of that literature was the mythological and heroic poems of the *Poetic Edda*, the only extant source of the cosmology and religion of the pagan ancestors of the Germanic nations. Another and perhaps even more remarkable branch was the so-called *Sagas of Icelanders*, realistic and secular prose novels based on historical fact and written in the vernacular in the twelfth and thirteenth centuries (when the rest of Europe was dominated by Latin), constituting the sole original contribution of Scandinavia to World Literature. The anonymous authors of those Sagas, some forty in number and of various length (there are also some forty short stories from the same period), were 'the fathers of modern novels and short stories', in the words of the Argentinian author Jorge Luis Borges.

No doubt insularity and remoteness from religion-ridden medieval Europe enabled the Icelanders to pursue their independent course and create conditions for a unified indigenous culture. The Church played a significant role in preserving the heritage of the heathen past – a procedure not to be found in the rest of Europe – and was instrumental in shaping the literary taste, style and ideals of the early Icelanders.

They also had another salient trait, which was their mobility, both outside and inside their native land. They were indefatigable globetrotters, travelling far and wide in Europe and the Middle East, serving as mercenaries with the Byzantine Emperor in Constantinople, braving the Atlantic to discover new lands in the Western hemisphere, essentially regarding the globe as their private playground. The result was an eminently cosmopolitan

outlook and a vast knowledge of the ways of other men. The steadily growing store of knowledge of domestic as well as international affairs, orally transmitted from one generation to the next during the first centuries of the settlement, in due time became raw material for those literary works which culminated in the *Sagas of Icelanders*.

The literary activities of the Icelanders during the twelfth, thirteenth and fourteenth centuries were far from confined to the *Sagas of Icelanders*. The greatest writer of the period, Snorri Sturluson (1179-1241), was one of the wealthiest chieftains of the country, a man who combined the vast knowledge of a great historian with a creative mind, artistic instincts and independent judgement. He wrote two of the most significant works of Icelandic literature, the *Prose Edda*, a text-book of mythology, poetic diction and metrics intended for young poets, and *Heimskringla*, the history of the Kings of Norway from prehistoric times down to 1177. Snorri was probably also the author of *Egil's Saga*, one of the best and most renowned of the *Sagas of Icelanders*.

Snorri's nephew, Sturla Thórðarson (1214-1284), also wrote biographies of Norwegian Kings and some Skaldic (court) poetry with which he won royal favours in Norway, but his major work is the *Íslendinga Saga*, which is part of a larger work covering the period from the beginning of the twelfth century to the end of the Icelandic Commonwealth. The objectivity of this work is truly admirable, as it centres upon the struggles of Sturla's own family, in which he himself had taken part. This work is pure history and therefore only carries the name *Saga* in the very widest sense, which is the Icelandic sense.

To these monumental historical works, unique in the Middle Ages, may be added quite a large body of so-called *Sagas of Ancient Times*, more or less fantastic tales from prehistoric times in Scandinavia and on the Continent. These were from the beginning told for entertainment: they existed in oral form as early as the twelfth century and were probably not written down until late in the thirteenth century. There are thirty-five such Sagas of differing size, the most important being the *Völsunga Saga* which in the nineteenth century inspired both Richard Wagner and William Morris. It is largely based on the heroic Eddic poems and is especially valuable for having preserved in prose many of the lost poems of the heroic cycles.

Added to these were romances of chivalry which were translated, adapted and concocted in enormous quantities from about the second quarter of the thirteenth century onwards. There are extant some 265 of these tales, varying greatly in length and subject-matter. There are French and Anglo-Saxon romances in Icelandic as well as Greek, Roman and Oriental tales.

From the twelfth century onwards a great bulk of religious literature was produced in Iceland, including homilies, miracle books, exempla, saints' lives, sacred poetry and biographies of renowned indigenous bishops. Two sacred poems soar above the rest and rank among the great achievements of Icelandic literature for their visionary force and poetic brilliance. One is the anonymous *Song of the Sun* from about 1200, where a father, returned from death, relates to his son the story of his erring but pleasant life, and the fate of evil or blundering men after death. This poem is thought by some scholars to reflect the troubled and crime-infested thirteenth century. The other poem, *The Lily*, composed by the unruly monk Eysteinn Ásgrímsson about 1350, surveys the history of the world as understood by Western Christianity in 100 inspired stanzas, dwelling mainly on sin and grace. This brilliant poem was the envy of every verse-maker in Iceland for many centuries and found its first match in Hallgrímur Pétursson's *Passion Hymns* in the seventeenth century.

Around the turn of the fourteenth century the Icelanders began to cultivate a verse form called *rímur*, a hybrid of ancient Skaldic poetry and popular medieval European verse (ballads). The *rímur*-poets used alliteration and *kennings*, but added end-rhyme and kept to very rigid three- and four-line stanzas which in time became so elaborate that over 2,000 varieties have been recorded. The *rímur* are mainly narrative poems, often running into hundreds of stanzas and divided into groups of cantos, corresponding to chapters in prose. The subject-matter of the *rímur* was mostly the *Sagas of Ancient Times*, the chivalric romances, the Sagas of the Kings of Norway and Biblical stories. From before 1600 we have some 115 *rímur*-cycles, and after 1600 about 900 *rímur*-cycles by nearly 330 known poets, so that the same tales were used many times by different verse-makers. The Hamlet story, for instance, was treated in five different cycles by as many poets, before Shakespeare dealt with it.

Even though the *rímur* were the predominant literary form from the fourteenth to the nineteenth century, various other forms were cultivated as well. The Reformation in 1550 brought about an upsurge in religious poetry, which was quite uneven but culminated in Hallgrímur Pétursson (1614-1674), a poetic genius whose

Guðmundur Ingólfsson

principal work, *Fifty Passion Hymns*, has been published more than sixty times since it appeared, which is a record in the annals of Icelandic publishing. It has also been translated into dozens of languages, even into Chinese and Japanese. As in the rest of Europe, the seventeenth century saw a flowering of good poetry in Iceland, both religious and secular. It also produced the greatest preacher in Icelandic history, Bishop Jón Vídalín (1666-1720), whose *Book of Sermons* was printed twelve times in 120 years and read in every household in the country. These two books had a tremendous impact on the general education and training of the minds of the Icelanders during their most difficult times.

Their difficult times started soon after the collapse of the Icelandic Commonwealth in the late thirteenth century and continued with very few remissions until the late nineteenth century. The darkness and misery of those six centuries was such that often the very existence of the people was in jeopardy. An indication of the calamities of those centuries is the awesome fact that the population of the country fell from an estimated 70,000 around the year 1100 to below 40,000 in the eighteenth century, which was the most calamitous. Rarely, if ever, has the process of natural selection been so harsh or unremitting. Only the very fittest had any chance of surviving.

During those dark centuries the dominant concern of the Icelanders was physical survival, which demanded the better part of their energies, mental as well as physical. But it went hand-in-hand with another preoccupation going back to the Eddic poems,

namely the ideal of surviving one's death by leaving behind a reputation that would ensure immortality. This intense concern with excellence and personal survival in the literary or other artistic annals of the country lies at the very core of the various cultural endeavours, which for practical reasons mostly took the form of literature, there being no social or physical conditions for the pursuit of other art forms, such as music, painting, sculpture, or the theatre. It is no exaggeration to maintain that the people were in large part artistically starved, even though efforts to make good the deficiency, mainly in tapestries, woodcarving and metalwork, can be traced throughout the centuries.

Living conditions during those centuries strain one's imagination. On top of the scarce and unwholesome food, housing was such that the peasants' hovels were a breeding-ground of all sorts of diseases which spread rapidly and further sapped the mental and physical energy of the people.

The eighteenth century marked the ebb of Iceland's history in every respect, material and climatic as well as cultural and spiritual. All the institutions symbolising ancient culture and national traditions, such as the two bishoprics of Skálholt and Hólar, with their Latin schools, and the *Althing* at Thingvellir, were eclipsed. The two sees and their school were amalgamated and moved to Reykjavík, while the *Althing* was discontinued until 1845. The eighteenth century produced only two noteworthy poets who both made their mark as translators, of such works as Pope's *Temple of Fame* and *Essay on Man*, Milton's *Paradise Lost*, and

Klopstock's *Messiah*, rendering them into Eddic metres, thus endeavouring to break the age-old cultural isolation of their country.

With the advent of Romanticism in Iceland in the early nineteenth century, a new kind of poetry came to the fore. The nineteenth century produced a long line of fine and accomplished poets who, true to the new tradition, celebrated the glorious past of the 'golden age' and the natural beauties of their country, refashioning the language and urging the nation to awake to a new age of hope and brighter prospects after ages of gloom and despondency. Most of the leading poets of the nineteenth century had studied in Copenhagen and received fresh impulses both from Scandinavia and Germany. Thus the great pioneer of Romanticism in Iceland, Bjarni Thorarensen (1786-1841), had come under the influence of the Danish poet Oehlenschläger and the philosopher Henrik Steffens, while his younger contemporary, Jónas Hallgrímsson (1808-1845), the greatest innovator and most beloved of all Icelandic poets, was strongly influenced by Heinrich Heine and Scandinavian poets of his generation. A natural scientist, Jónas Hallgrímsson was a formal master possessing delicate perception and keen observation. No poet equals him in describing the Icelandic scenery or conjuring up episodes from the distant and resplendent golden age. He brought new diction to Icelandic prosody as well as many metrical innovations. The preoccupation with the golden age led to a new appraisal of Eddic poetry which from then on exerted a strong and lasting influence, as regards both form and diction.

This whole development was characterised by a long and sometimes bitter struggle between the time-hallowed and popular *rímur* tradition and the new poetry, which many regarded as alien and even dangerous to the national culture. Jónas Hallgrímsson made a blistering attack on the whole *rímur* tradition, which did considerable damage to the national versifying sport. As is the case with most insular nations, there is a tendency among the Icelanders to be conservative and backward-looking.

The leading poets of the nineteenth century had a great vision and a sacred mission. The glorious past, the beauties of their country, and the purity of the Icelandic language was the holy trinity with which they endeavoured and finally managed to awaken their countrymen and stir their national pride. Their goals having been largely reached by the turn of the century, the Romantic-national poetry was followed by a brief spell of realist poetry, superseded by neo-Romantic poetry which lasted roughly until the First World War, at the end of which Iceland attained her sovereignty. The first Icelandic Minister under Home Rule in 1904 was a celebrated poet, Hannes Hafstein (1861-1922), but the outstanding poet of the early part of the century was Einar Benediktsson (1864-1940), a giant and cosmopolitan among poets. He was the first to bring foreign subjects into Icelandic poetry, describing his experiences of great cities such as Rome and London, and also expressing in majestic and sometimes almost pantheistic poems his vision of the human condition. In Canada, Stephan G Stephansson (1853-1927), a poor farmer, spent wakeful nights composing several volumes of poems that are landmarks in Icelandic literature.

Ever since their country was granted Home Rule in 1904, two main tendencies may be said to have dominated the cultural endeavours of the Icelanders. First, a steady preoccupation with defining, crystallising and deepening the peculiar features of the nation's history and character, with constant reference to the natural environment of the people. Second, a more recent and deeply felt need to synchronise Icelandic culture with contemporary reality, to validate it in a modern context and in the world at large.

The first tendency is reflected in the artistic output of the pioneers in every field and at all levels, in music and painting no less than in fiction. The pioneers of Icelandic painting at the turn of the century, Thórarinn B Thorláksson (1867-1924), Ásgrímur Jónsson (1876-1958), Jón Stefánsson (1881-1962), and Jóhannes S Kjarval (1885-1972), sought their motifs in the country's nature and virtually taught their compatriots to *see* their country in a fresh way. Composers sought inspiration in the old and very distinctive folk melodies and often made them the basis of more modernistic compositions. This is especially true of Jón Leifs (1899-1968), Thórarinn Jónsson (1900-1974), Hallgrímur Helgason (*b.*1914) and Jón Nordal (*b.*1926). Novelists found their stylistic models in the medieval Sagas and sometimes treated themes from the heroic times or from past centuries, but their main concern, after the novel was resurrected in the middle of the nineteenth century, was the perennial struggle between man and the blind forces of nature in a harsh and inhospitable land. This is true of such pioneers of Icelandic fiction as Jón Trausti (1873-1918), Guðmundur Kamban (1888-1945), Gunnar Gunnarsson (1889-1975), Guðmundur

Hagalín (1898-1985), and Nobel laureate Halldór Laxness (b.1902). It is also to be found in the first and most successful theatre works of such playwrights as Matthías Jochumsson (1835-1920), Indriði Einarsson (1851-1939), Jóhann Sigurjónsson (1880-1919), and Guðmundur Kamban.

Viewed from the present, it is as if the pioneers in the various artistic fields felt constrained to come to terms with their grim history and their inhospitable environment in order to effect a kind of truce between man and nature, or perhaps in order to teach their compatriots in a devious way to overcome their mental obstacles so that they might make their island respond to their requirements.

The second tendency, that of synchronising Icelandic culture with contemporary reality, came to the fore after Iceland had gained sovereignty in 1918, an important step towards full independence in 1944, and mainly during the Great Depression of the 1930s, which was a period of radical re-evaluation in every sphere of life. Now artists and writers alike had to face the ruthless facts of life. The avant-garde in art and fiction turned from magnificent landscapes and historical romances to man's contemporary social environment and predicament. Artists and writers felt compelled to look inward, to explore the everyday reality around them. This was coupled with a great shift in the structure of society, which in a few decades had changed from a purely rural to a predominantly urban one, based on fishing, industry, and commerce, with strong trade unions and increasing conflicts between capital and labour. This also led to strong conflicts between tradition and renovation within the ranks of the artists and writers themselves.

During the Second World War Iceland experienced the shock of having to come to terms with the world at large, being thrown largely unprepared into the maelstrom of international affairs with all attendant complications, problems and hazards, obscure responsibilities and imminent frustrations. It was in most respects a revolutionary experience. Old traditions were thrown overboard almost overnight and replaced by something amorphous and undefined, without substance or contours. After a thousand years of almost constant isolation and long centuries of stagnation this great shock left the nation as a whole dazed for several decades, and resulted in the gradual social and moral disintegration of the traditional Icelandic community. In the various arts this was reflec-

ted in a certain confusion regarding aims and intents and a notable tenuity of substance in the early post-war period, but since the mid-1960s there has been a kind of renaissance in all the arts accompanied by new definitions of purposes and a stronger awareness of what Icelandic culture is all about.

Of course, it verges on the improbable that a nation of roughly 250,000 souls should presume to maintain a highly modern and quite prosperous welfare state, keeping up with the rest of the world in all spheres of cultural as well as social, economic, commercial, political and diplomatic activity, but the Icelanders have managed rather well since attaining full independence in 1944. There certainly is an awareness of the dangers besetting a tiny nation in a world of growing international communication where supranational institutions and cartels are trying to replace national states, but there is also a determination to face the hazards and use them as spurs to concentrate on the essentials of the Icelandic cultural heritage.

The collision between the native legacy with its deep-rooted traditions and the foreign cultural currents flooding the country from all directions may well be one of the gravest challenges Iceland has ever met, but it may also be a potent catalyst in the modern crucible, compelling every creative individual to take stock of old attitudes and review the premises of his or her endeavours. It seems to have been an axiom in Icelandic culture, in modern times as well as in the early centuries after the settlement, that its fertility and significance was in direct proportion to its contacts with the outside world.

Sigurður A Magnússon (b.1928) is a distinguished author whose work spans social history, novels, poetry, drama and travel. His books in English include The Iceland Horse, Iceland: Country and People and Icelandic Writing Today. In 1982 he translated and edited the important volume The Post-War Poetry of Iceland. A former critic and magazine editor, he was Chairman of the Writers' Union of Iceland from 1971 to 1978. His poems, short stories and literary articles have appeared in anthologies and periodicals in all the Nordic countries, Britain, Germany, France, Belgium, the Netherlands, Spain, Italy, Greece and in North America. He is also the translator of Hans Christian Andersen, James Joyce, Bertolt Brecht and others into Icelandic.

Guðmundur Ingólfsson

Halldór Björn Runólfsson

Reflections on Icelandic Art

Modern Icelandic art has a character of its own, though its roots are to be found in those international movements in art which emerged during the second half of the nineteenth century. It is special because Iceland and the Icelanders are, in their way, quite unique. When an outsider asks whether there is such a thing as an 'Icelandic' way of thinking, he can always be directed to our art, since it contains a process of thought that cannot be found anywhere else.

Icelanders are proud of their art, and their pride derives, consciously or unconsciously, from their belief in its uniqueness. But this singularity, if it exists, has nothing to do with subject-matter: that never determines the quality of art. Even if it did, Icelandic art would not be much better off, since its content is rarely original, and, generally speaking, consists of variations on some basic, uncomplicated themes.

For example, although landscapes, and particularly landscapes with mountains, are produced in great quantities in Iceland, they do not contribute to the uniqueness of Icelandic art. Every mountainous country produces great quantities of pictures of mountains, which does not mean that their pictures are any better, or more unique, than those that are produced in the lowlands. Few nations can boast of a more splendid artistic heritage than the Dutch, who have no mountains to speak of.

It is therefore absurd to presume that subject-matter has anything to do with the special character of Icelandic art. It would be more relevant to say that the special character of the Icelandic art public is demonstrated in its avid and tedious interest in pictures of mountains. This local fascination with mountain pictures has led some people to assume that in them we have something akin to a 'national' art, rooted in tradition. But those who have read their art history may feel that our landscape art is no more 'national' or 'traditional' than the rest of our art. There is an argument that our landscapes-cum-mountains are to a great extent imported goods, mostly from the South of France, and are therefore about as 'national' in character as the 'vin rouge', Brie and the 'petits pains' that worldly housewives in Iceland serve their guests to supplement an international, three-course dinner.

Admittedly, these imports have been adapted to local conditions. The mountains are demonstrably Icelandic, and to some extent the same can be said of the artists' techniques and choice of colours. Those who are interested in that kind of thing will no doubt find it there. But then they will also have to concede that this so-called 'national' trait is a technical matter, and an artist's technique does not change, even when he is painting something besides mountains. The same is true of writing; an Icelandic writer does not change his style when he writes about events that happen outside Iceland. No one would seriously claim that the account in Halldór Laxness' novel, *The Bell of Iceland*, of Jón Hreggviðsson's adventures at Thingvellir is in any way more 'national' in character than the descriptions of his travels in Holland and Denmark.

But when it comes to Icelandic art, outsiders are often struck by our artists' choice of colours, no matter whether the subject-matter is representational, a mountain or a boat, or abstract. 'Cool' colours predominate, particularly all sorts of blues. These cool blues are often to be found in the art of other nations. But it is unusual to find such bright, undiluted blues anywhere but in Icelandic art. One thinks of Dutch artists like Vermeer and Van Gogh, the former with his veils of translucent colours, the latter with his intense palette.

No one can fail to notice the abundance of blues in the Icelandic environment. They are found not only in the mountains, but also in the sky, the clouds and the sea. This blueness is not only tied to our objective reality, it becomes an abstract entity permeating the entire atmosphere around us. Because of the moisture that surrounds an ocean island like Iceland, and the relative absence of pollution, we live in an overwhelming and intense blueness, which is so clear as to be almost transparent.

We are also surrounded by other bright and transparent colours. We are constantly confronted by greens, reds and yellows of an almost painful intensity. Which is probably why Icelandic painters rely on a few and intense primary colours. And not only

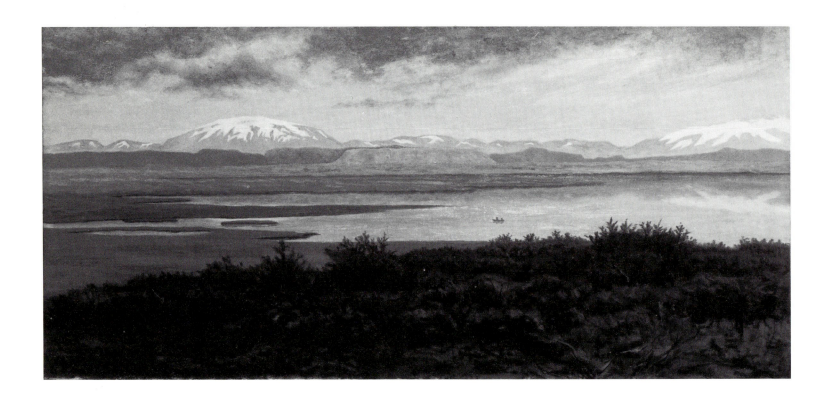

1 Thórarinn B Thorláksson
Hekla seen from Laugarvatn, 1917
Listasafn Íslands (cat.1)

the artists; look at the way ordinary Icelanders paint their houses. Foreigners are surprised by the bright, gypsy-like colours that characterise Icelandic towns.

They are apt to confuse this exuberance in the use of colour with Expressionism. It has surely nothing to do with the emotional needs of the Icelandic painters. In any case, many Icelandic painters have openly stated that nature exaggerates more than they do. In this instance one can hardly talk about Expressionism, except in a few isolated instances. Icelandic art is largely a Post-Impressionist phenomenon. It has come into being through the imprint of the natural world on the optical nerves of our painters.

The transparency of natural colours in Iceland leads one to think in terms of watercolours. The essence of the Icelandic natural scene can probably be rendered with greater accuracy through watercolours, than through opaque oil paints. Curiously enough, watercolours have never enjoyed a great popularity in Iceland. This brings us back to our earlier speculations on the 'Icelandic character', as reflected in the technical proficiency of our painters.

Nothing is more alien to our rough temperament than the medium of watercolour. A medium which was admirably suited to the needs of cultivated Englishmen during the second half of the eighteenth century has never agreed with artists from such an unsophisticated farming culture as ours. Watercolour is a contemplative, orderly as well as an impulsive medium. It needs to be, since the slightest mistake can throw a whole picture out of balance. The medium of oils suits the slow worker, who proceeds with the utmost preparation and care. He thinks only of doing his best, never of being the best. Though many of our painters have tried their hand at watercolours, the medium has not played an important part in Icelandic art. It has most often been used for sketches or other preparatory work. Ásgrímur Jónsson (1876-1958) was one of the few Icelandic artists to master this difficult medium. He was pre-eminent among those artists who gave Icelandic art an identity of its own, an identity which it did not have before – which is not ignoring the contribution of Thórarinn B Thorláksson (1867-1924).

Thorláksson was mostly content with interpreting the Icelandic landscape with a painterly technique better suited to the Danish natural scene. At the same time he was well aware of the role that light and colours played in the Icelandic landscape. In this respect he was a true pioneer who influenced his contemporaries, not least Ásgrímur Jónsson. His sensitivity to the 'blueness' of the Icelandic landscape was quite unique. Thorláksson was also the first painter to grasp the tonal variations found in the Icelandic summer nights, and to interpret them in a personal and convincing way in his art. Though his technique is of the nineteenth century, he nevertheless belongs to our times in his direct and unaffected expression. Thorláksson has had less attention than he deserves. It is time to re-evaluate his contribution to Icelandic art, and to put him in his rightful place.

Ásgrímur Jónsson understood better than Thorláksson the need for a more dramatic technical approach than that offered by academism, if a painter was to come to terms with the wonders of the Icelandic environment. All his life he searched for a painterly approach which would help him capture the underlying meaning of the Icelandic way of life, to say something about our temperament as well as our surroundings. He found watercolours and oils had mutual qualities, and tried to use their attributes to the full. The two media often affected each other, for example, in the thinly painted, semi-transparent oils that Jónsson did in the 1920s and 1930s.

Ásgrímur Jónsson's stylistic range is a large one. It goes from a romantic kind of realism to Post-Impressionism, which was influenced by Cézanne and Van Gogh, whose work Jónsson got to know on his travels in Europe. But it took him some time to find an acceptable compromise between the demands of form and colour. Sometimes his colours take over, especially when nature and the climate were at their most variable. Jón Stefánsson (1881-1962) was well aware of this weakness of his colleague's, and warned Thorvaldur Skúlason (1906-1984), who had studied with both of them, not to succumb to what Jónsson called 'the air in the colours'. Stefánsson himself never used any colour which was not linked to objective reality.

But Ásgrímur Jónsson was a complex artist, who belonged to two distinct historical periods and who in many ways was divided in his attitude to art. A romantic storyteller with a penchant for dramatic revelations, he was also an impressionistic observer of nature. Perhaps he was too honest to attempt to weld the two together. Which may be the reason why he kept these two facets of his personality in separate compartments, and found outlet for his story-telling in illustrations to Icelandic folk-tales.

These illustrations are characterised more by ingenuity than fertile imagination. Yet there is a romantic and psychological dimension to them, which comes out especially in the artist's

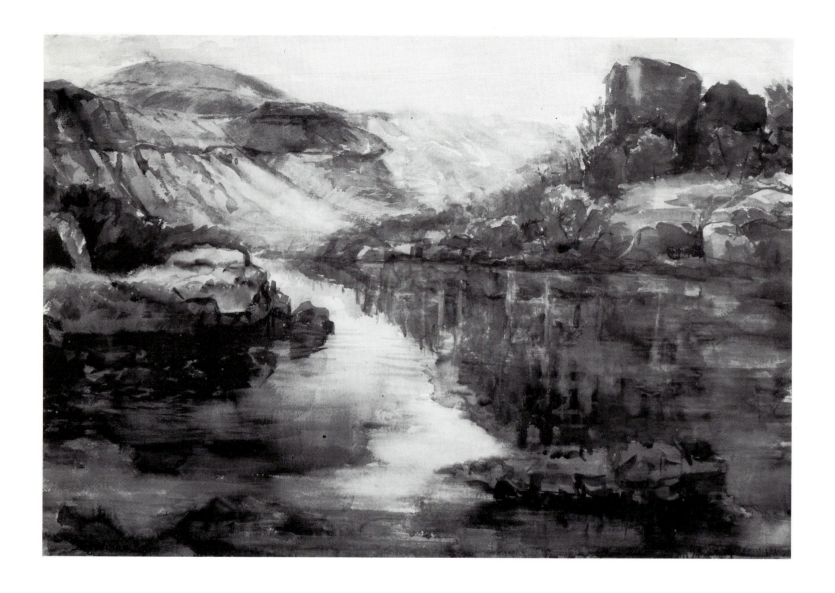

2 Ásgrímur Jónsson
Kiðárbotnar (Húsafell), 1948
Listasafn Íslands (cat.7)

obsession with tales of pursuit, where defenceless damsels are threatened by supernatural beings. Psychological 'humour' of this kind is very rare in Icelandic art and the interesting thing about these illustrations is that the artist himself is often the pursuer, at least many of the trolls, elves and ghosts that he drew are obviously distorted self-portraits.

The troll-motifs in Icelandic folk-tales are reminders of the ambiguous feelings the inhabitants fostered towards their hostile surroundings at times when they were totally at nature's mercy.

If this seems naïve, one must bear in mind that when Iceland was settled, nothing could have been more hostile to such a fragile community than a difficult and alien nature, with few utilitarian possibilities and a climate unfavourable to their old agrarian practice. Until recently Icelanders were unable to use the environment to their advantage. Nearly all manufactured goods had to be imported, as well as all timber for construction and other industry. After the conversion to Lutheranism, visual arts and crafts, which were mainly religious, rapidly declined. They stayed unrestored until the beginning of the twentieth century.

These are the reasons for such scarce national traits in Icelandic architecture and other handmade objects. Icelandic nature was never a fertile source of traditional industry and manufacture as was the soil in most other European countries. The countryside never became 'civilised', and only a very small percentage of it was, and is exploitable. Through the ages it rather figured as a hindrance to the expansion of the population, as well as a constant threat to our precarious civilisation. The only people who profited from such an environment were poets. Through the centuries they would heap up epic myths, Sagas, romances and tales, either of legendary people, real or fictitious, or of imaginary beings, good or evil, who populated the landscape. It did not matter whether they were living or dead, since their spirits kept roaming through the various counties and shires.

When an Englishman wants to stress the facts of history he can point at real and material things like a castle or a church as evidence of what actually happened. The Icelander has to content himself with such unreal and insubstantial things as tales and legends, supposed to have taken place in this or that part of the country. But nothing is left to verify his story. There is only unspoilt nature, determined not to reveal any solid evidence. So what we consider real, does not necessarily have to be actual.

It is hard to grasp some of Ásgrímur Jónsson's visions, without bearing this in mind. But it is quite impossible for anyone who has not got an inkling of the aforementioned folklore to understand the content of Jóhannes S Kjarval's (1885 - 1972) works. His approach was no less complex than Ásgrímur Jónsson's, but he was younger and started his artistic career relatively late in life. This meant that Kjarval was not burdened with the role of 'pioneer' to the same extent as his predecessors. During the last years of the First World War, the fledgling Icelandic art seemed to be moving mostly in one direction: towards landscape painting. Kjarval was first and foremost a landscape painter, but he also became proficient in a number of other fields.

He was a labourer and a fisherman, and as such he fell under the spell of Turner. Often witnessing the impression of a sunset over a calm sea, Kjarval decided to become a painter. 'Turner got me started', was a remark he uttered when he was filmed in old age. So he left the sea and went to London in 1911, hoping to gain admission as a student at the Royal Academy Schools. It did not affect him much when he was rejected on grounds of his late arrival. Instead of waiting for the next academic year, he plunged into a personal study of Turner in the London museums and then in Copenhagen. There, he completed his studies in 1917.

Kjarval had much in common with Turner. An eccentric lone wolf, who constantly had to put himself to the test of nature, for example by sleeping out in variable weather. Kjarval was not fussy when rain poured down his canvases and water-colour pads. Messy supports were definitely truer to nature than clean ones. Anyhow, he used to keep a good deal of his materials in clefts and fissures in the different lava-zones, which were his favourite sort of landscape. His technique, as well, was in many ways akin to Turner's. As one of the best draughtsmen in the history of Icelandic art, he was a quick and spontaneous sketcher, but finishing a painting was often a major feat. Kjarval could apply layer after layer of colour and alter the surface endlessly without ever being prey to dryness or dull practice.

His unusual gift as a draughtsman bore early fruits. But it took him much longer to mature as a painter. He had reached middle age when he finally succeeded in uniting the two major tendencies that characterised his art. On the one hand were the landscapes and on the other, the dream-like rendering of human figures. It seems that right from the beginning his aim was to join the two in a single work of art. But only in the late 1930s, at the age of

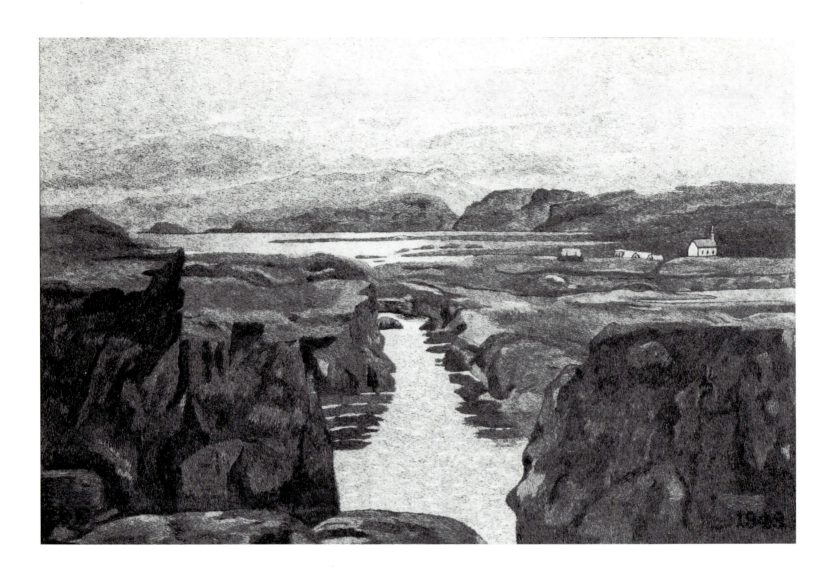

3 Thórdís Egilsdóttir
Thingvellir, 1949
The Parliament of Iceland (cat.9)

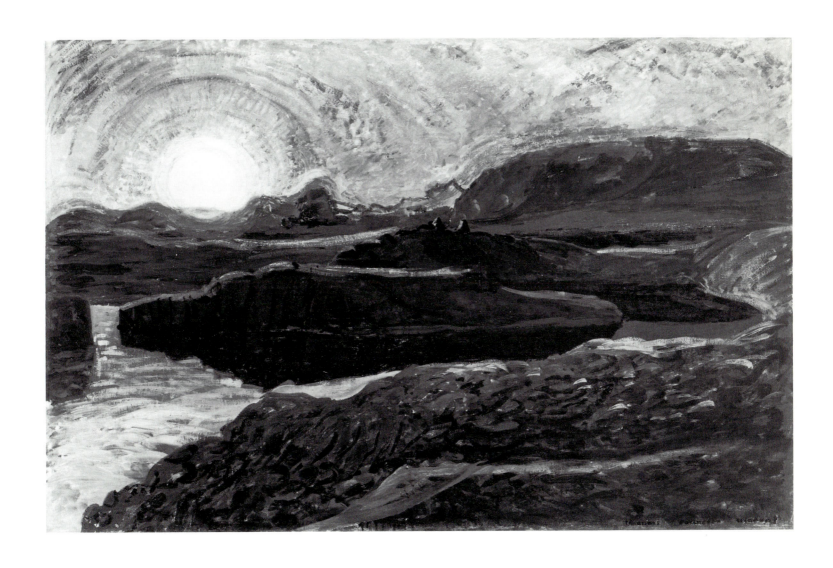

4 Jóhannes S Kjarval
Summer Night at Thingvellir, 1931
Listasafn Íslands (cat.13)

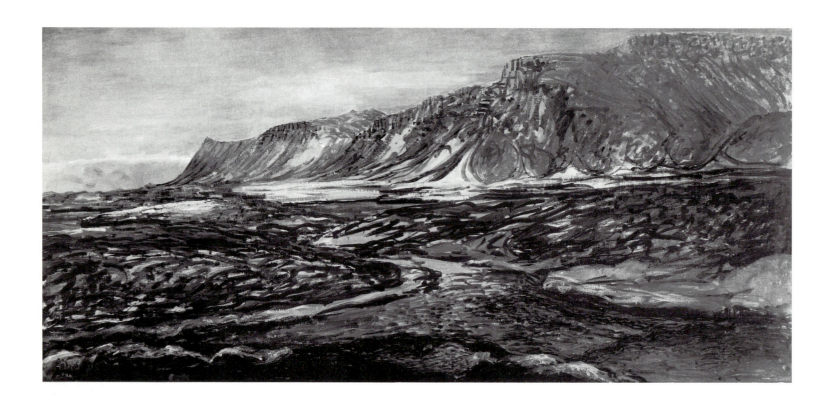

5 Jóhannes S Kjarval
Esjan and Úlfarsá, 1934
Collection Thorvaldur Guðmundsson/Háholt (cat.15)

6 Jóhannes S Kjarval
Lava, 1949
Listasafn Íslands (cat.17)

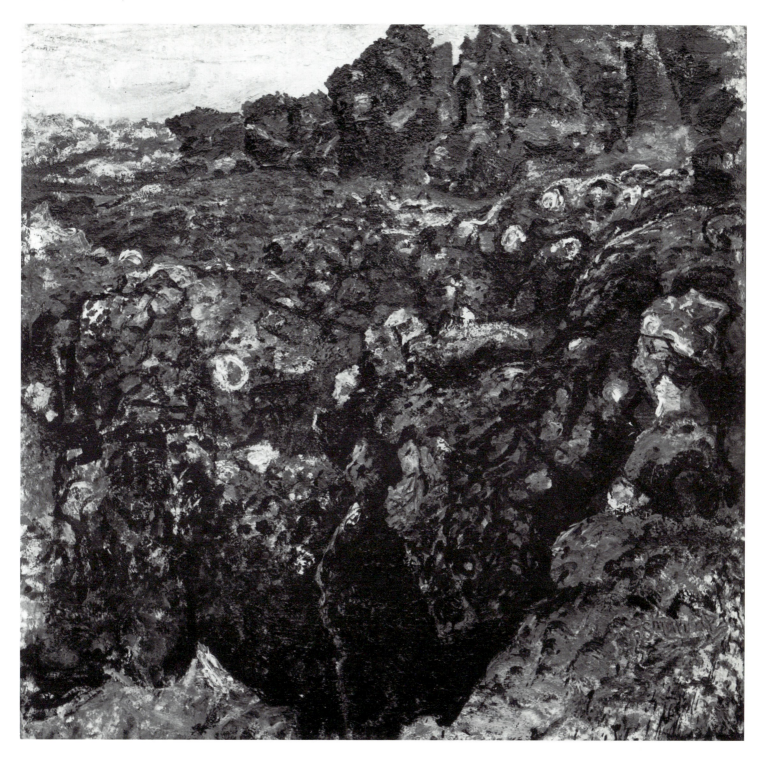

fifty, did he happily overcome the obstructions to this venture. Armed with an unswerving patience, Kjarval managed to give his landscapes an imaginative dimension unique in Icelandic art, except perhaps in the works of sculptor Einar Jónsson (1874 - 1954). But unlike Einar Jónsson, he found a forceful and spontaneous outlet for his symbolic imagination, which had little to do with the refined and realistic Symbolism at the end of the last century.

Kjarval's symbolic cast of mind was highly unusual. It was not unrelated to the spirit of *fin de siècle* art, as found in certain works by Paul Gauguin, the French Nabis, Odilon Redon, Munch and, last but not least, the sculptures and paintings of Einar Jónsson. But his reworking of all these sources was nevertheless so personal, so different from late nineteenth-century Symbolist art, that the viewer is hardly aware of the connection. More interesting still is that Kjarval's symbolic approach to art was completely in accordance with the imaginative backbone of Icelandic popular culture, whose basis is in a body of folklore unsurpassed for its vitality and imaginative qualities.

However, despite its possibilities as a source of inspiration for those more romantically inclined, the majority of Icelanders see in the landscape no more than is obvious : a rich source of shapes and colours.

Impressionism was embraced by those who were searching for a way to express their sensation in front of a rough and unspoilt nature. Descriptive art, which relied on the keen observation of landscape in all its multiple aspects, was something Icelandic artists were more than ready to adopt. If Ásgrímur Jónsson was responsible for the introduction of Impressionism in Icelandic art, it was Jón Stefánsson who enriched it with Post-Impressionism. If Kjarval corresponded to Turner in Icelandic art, Jón Stefánsson definitely figured as our Constable. He wanted to rid art of all its unreal and idealistic aspects, and order it instead in a firm and solid manner. But unlike Constable, Stefánsson opted for an expression of dramatic and noble grandeur, somewhat in line with the classicism of the Old Masters.

Jón Stefánsson was slightly older than Kjarval, but also began his career towards the end of the First World War. No two artists were more unlike. Like every artist who attempts to express the inexpressible, Kjarval left a trail of mistakes and false starts. Stefánsson hardly ever made a mistake, since he always dealt with a concrete reality. Stefánsson was classical in temperament while Kjarval was the quintessential romantic.

Stefánsson's intelligence and his insistence on formal values gave him an influence which neither Ásgrímur Jónsson nor Kjarval enjoyed. It would be fair to say that formalism, which permeated Icelandic art well into the 1960s, was largely due to Stefánsson's theories and example. Stefánsson had originally intended to study engineering, and even when he had switched to painting after his arrival in Denmark, he retained the temperament of an engineer.

Stefánsson was very impressed by the theories of Paul Cézanne, whose art and opinions he got to know in Paris in 1908 - 1910, when he studied with Henri Matisse. Though Cézanne was a Post-Impressionist, he dreamt of building his own art on the firm classical foundations that Poussin had established, thus giving it a more permanent and intellectual structure. Cézanne's ideas suited Stefánsson's logical turn of mind and when he settled in Iceland in 1924, something which we might term 'Cézannism' took root in Icelandic art. This phenomenon became an all-important yardstick for Icelandic painters during the next decades. The technique of building up forms through separate yet related colour planes, the construction of pictures through a systematic balancing of light planes and dark planes, as well as hot and cold colours, comes from Cézanne via Stefánsson. Because of its logic, this method became the basis for art education, in Iceland as well as elsewhere.

One could rephrase Delacroix's famous dictum and say that Cézanne was Iceland's most famous landscape painter. His theories and methods were appropriated by others and used as a foundation for their own art. Kristín Jónsdóttir (1888 - 1959), Júlíana Sveinsdóttir (1889 - 1966) and Jón Thorleifsson (1891 - 1961) were all under the influence of Stefánsson and 'Cézannism'. The two women, Iceland's first professional women artists, helped to consolidate the self-sufficient vision that characterised Icelandic art until the Second World War. This vision called for the rejection of romantic idealism and emphasised instead a kind of severity, in composition, choice of colours and subject-matter.

Each subject was pared down to its essentials. Colours were generally low-key, and formal construction was subject to simple but absolute rules. This was a typical 'peasant art', solid, earthy and plain. It was an offshoot of the coarse self-sufficiency that Cézanne was credited with having reintroduced into French art, and was considered a symbol of everything that was 'genuine' and 'unspoilt'. It was in effect a puritan reaction to bourgeois self-

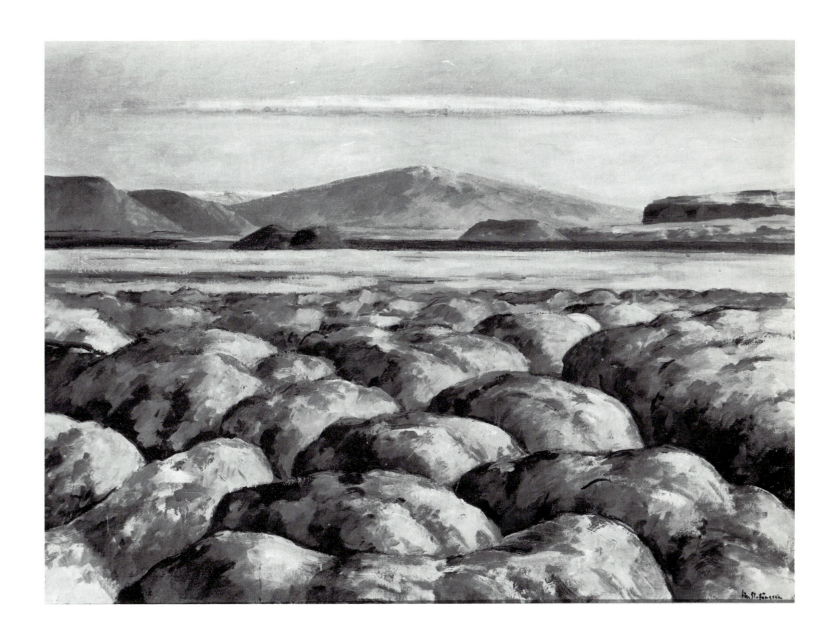

7 Jón Stefánsson
Skjaldbreiður, 1937
Oil
Listasafn Íslands

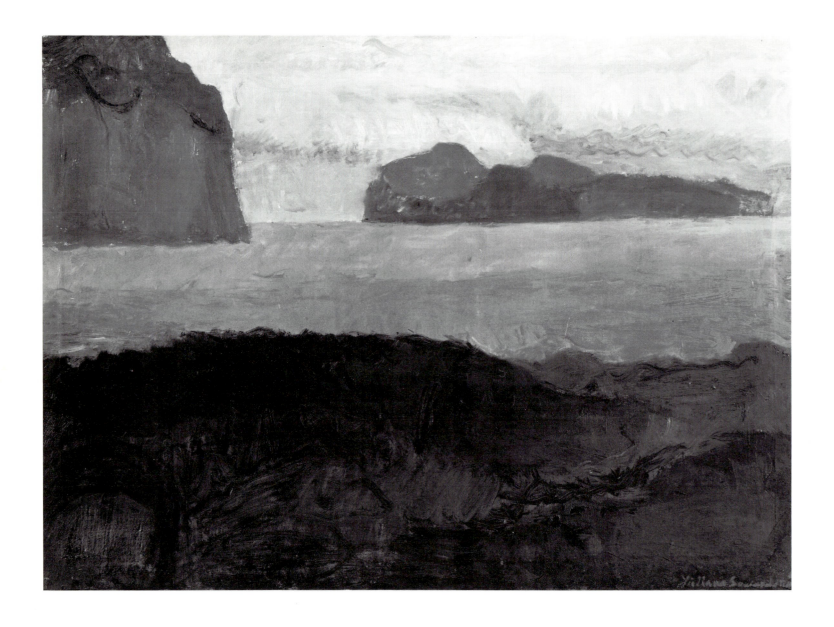

8 Júlíana Sveinsdóttir
From the Westman Islands, 1956
Leifur Sveinsson (cat.22)

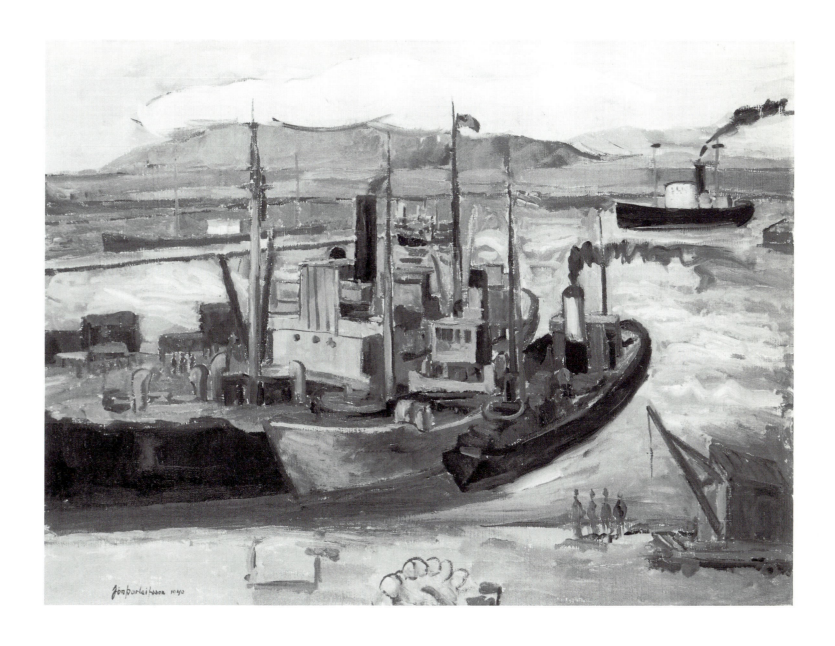

9 Jón Thorleifsson
Ships in Reykjavík Harbour, 1940
Oil
Listasafn Íslands

indulgence, and as such it echoed to some extent the clashes between Protestant and Catholic art in the seventeenth-century Baroque period. This plain, inelegant and spare form of expression became a permanent feature of modern Icelandic art, though the influence of Cézanne slowly diminished.

Kristín Jónsdóttir and Júlíana Sveinsdóttir were unlike Jón Stefánsson in their choice of subject-matter. They looked to their domestic surroundings, rather than to the rugged landscape of the Icelandic highlands. Both of them painted a great number of still-lifes and figurative compositions. Inevitably their art is less dramatic than Jón Stefánsson's, and more intimate, showing Jónsdóttir's use of a 'cool' palette in many of her pictures. Both of them also tend to give their pictures a unity by keeping to one dominant colour or pictorial rhythm.

Kristín Jónsdóttir's art developed in a more ordered fashion than Júlíana Sveinsdóttir's. Slowly but surely she moved away from her early sources of influence and created a personal style, characterised by a swift and deliberate brushwork, which rarely descends into routine. Júlíana Sveinsdóttir's career was more uneven, but perhaps more eventful. Early on she developed an aptitude for portraits, and became one of Iceland's finest portrait painters. But it was not until the 1930s that she produced work that won her deserved acclaim. Her understanding of tonal values increased as she became older, and she is now considered one of Iceland's most sensitive colourist painters, as well as one of its most unassuming artists.

Júlíana Sveinsdóttir was born in the Westman Islands, off the southern coast of Iceland. The mist that often surrounds the islands and blurs the vista seems to have increasingly affected her handling of paints. She made her colours more thin and fluid, reduced her palette to dominant browns and blue-greys, and stressed the atmospheric mood with pronounced shading. In 1946, she returned to the Westman Islands after many years in Denmark. From then on, she would visit regularly to paint in Iceland. Sveinsdóttir's style – a sort of neo-Venetianism, because of its dependence upon vaporous effects of light and shade – influenced other painters from the Westman Islands as well as those from similar places around Iceland.

Jón Thorleifsson (1891 - 1961) was also much indebted to Jón Stefánsson's theories and practice. He was a prolific and wide-ranging painter, who introduced many new ideas from French art to Iceland. In his work the Fauvist traits in his paintings of the late 1930s are probably the most important, and the spontaneous eruptions of colour in Thorleifsson's harbour paintings of the early 1940s are reminders of his interest in this early modern movement.

Icelandic sculpture evolved in a different way from painting. Being a more physically demanding art, it does not attract as many practitioners. Sculptors' raw materials are more unwieldy than those used by other artists, be they stone, plaster, steel or concrete, or lighter materials such as wood, aluminium or papier maché. Although Icelandic art lovers seem to have a lot of wall space in their homes in order to hang their art works, they have limited floor space. Thus people very rarely buy sculptures to decorate their homes.

This means that the sculptor's position has changed very little from the beginning of modern times, although now he is no longer forced to comply with other people's ideas about the eventual form and content of his sculptures. He has to rely on commissions from the State and public institutions, or private companies. Usually such commissions are decided through competitions, whose conditions have hardly changed since the Renaissance. There are many competitors, but only one prize.

Sculptors therefore have been fewer than painters in Icelandic art, and in relation to the development of Icelandic painting, the story of Icelandic sculpture seems like a series of abrupt changes. Each sculptor is on his own, and the best ones are like lonely rulers of a small kingdom. In spite of that, Icelandic sculpture is generally of a more consistent quality than Icelandic painting. The greater demands made on the sculptor call for an exceptional dedication, ruling out the faint-hearted.

But even though there have always been fewer sculptors than painters in Iceland, the country's first professional artist Einar Jónsson (1894 - 1954) was a sculptor, mentioned earlier in connection with Kjarval's art. Actually, Jónsson exerted some influence on all his contemporaries, on Ásgrímur Jónsson as well as on Kjarval. But since his artistic roots lie in the nineteenth century, he was essentially a loner, though he lived and worked well into the present century. He was a follower of Symbolism and as such was isolated from nearly all his colleagues. They were mostly formalists, who rejected Jónsson's idealism out of hand and did not bother to understand his attitude. And while Jónsson was revered by the Icelandic public at large, this reverence was based on the misconception that he was a realist artist. All of this makes Jónsson the most misunderstood of our artistic pioneers.

10 Einar Jónsson
The Wave of Ages, 1902-05
Plaster
Listasafn Einars Jónssonar

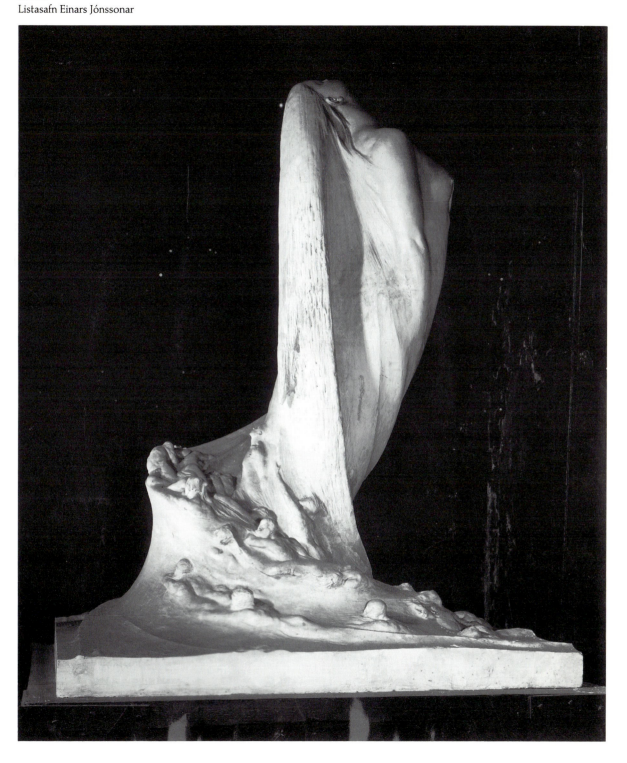

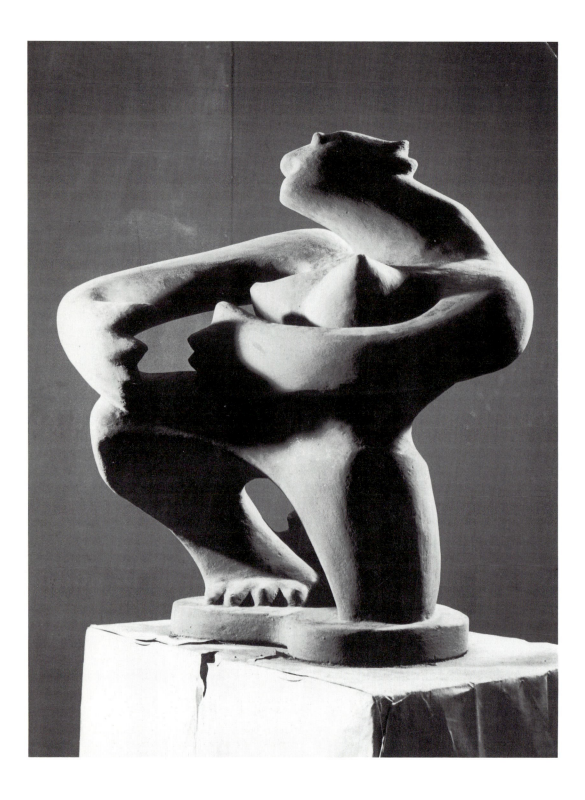

LEFT
11 Ásmundur Sveinsson
Black Clouds, 1947-48
Listasafn Reykjavíkur,
Ásmundarsafn (cat.27)

RIGHT
12 Ásmundur Sveinsson
Lament, 1948
Listasafn Reykjavíkur,
Ásmundarsafn (cat.30)

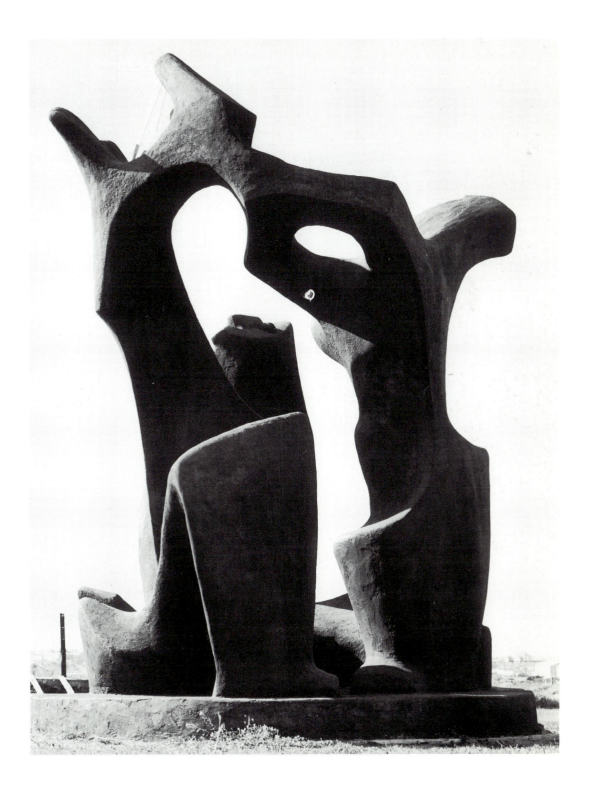

13 Ásmundur Sveinsson
Sæmundur on the Seal, 1927
Bronze
City of Reykjavík

Sæmundur 'the Wise' Sigfússon (1056-1133) was the first Nordic student in Paris, probably at the Notre-Dame Church School. He was the author of the first historical work written in Iceland, and thus a pioneer of the Icelandic literary tradition of the twelfth to fourteenth centuries.

Sæmundur's reputation was such that numerous legends about him developed, including several describing his dealings with the Devil. In these, Sæmundur always held the upper hand in the end.

When Sæmundur wished to return to Iceland, he wanted to save time, and offered a deal to the Devil. If the Devil could get him home quickly, without Sæmundur's cloak becoming wet, Sæmundur would serve him ever after. The Devil transformed himself into a Seal, took Sæmundur on his back, and set off. It was not long before they approached the Icelandic coast when Sæmundur – who had read from the Psalms unceasingly en route – hit the Seal on the head with his Psalter. The Seal sank, but Sæmundur swam the short distance to the shore, and the Devil lost his reward.

The sculpture was appropriately executed in Paris by Ásmundur Sveinsson in 1928, and an enlargement – made by the Morris Singer Foundry, Basingstoke – is now placed in front of the main building of the University of Iceland, in Reykjavík.

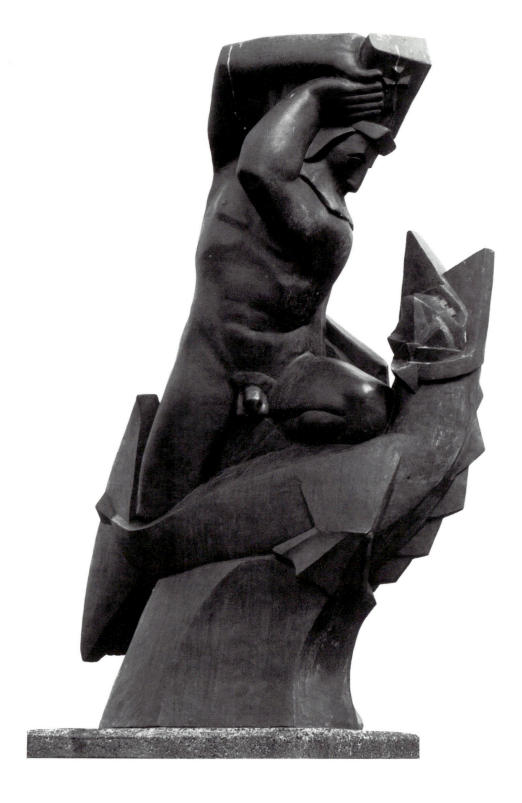

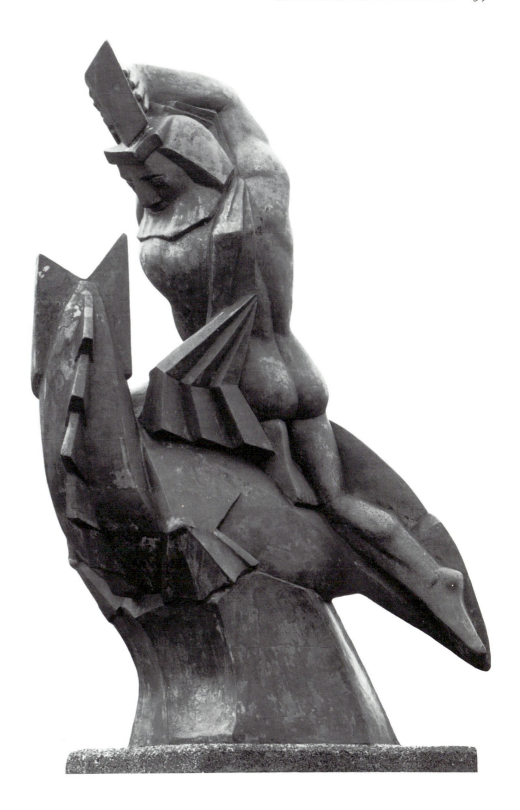

Though Icelanders are no less imaginative than other nations, Jónsson's philosophical musings, interspersed with Oriental theosophy, have hitherto not appealed to those of a more positivist cast of mind. They have not sought to appreciate his most complex sculptures, which are undoubtedly his finest, and they instead are content to admire the realism of his most straightforward creations, THE OUTLAW, the monument to political leader Jón Sigurðsson and the statue of the Viking hero Thorfinnur Karlsefni.

We still refuse to come to terms with visual enigmas like THE REVERIES OF YGGDRASILL, one of Jónsson's most complex sculptures. But eventually we have come to perceive the connections between Jónsson's conceptual thinking and the sculptures of our contemporary conceptualists, in particular those who have lived and worked in Holland. However, Jónsson's most complicated sculptures, which make up an elaborate world of their own, are perfectly in accordance with the developments of more recent European sculpture. In the future, Jónsson's work will without doubt undergo a re-evaluation. The sculptor will then be considered one of Iceland's most progressive artists.

Iceland's next generation of sculptors, Nína Sæmundsson (1892-1965) and Ásmundur Sveinsson (1893-1982) produced their first mature works in the 1930s, which showed clearly the wide rift that existed between modern sculpture and the sculpture of Einar Jónsson. Both sculptors started out in the classical style which originated in nineteenth-century Neoclassicism. This modern classicism had many followers in the 1920s, among them Pablo Picasso. They concentrated on the naked human body, emphasised its solidity and bulk, but also its softness and grace.

Sveinsson put this classicism to more personal ends. At the outset he favoured generous and energetic expression, even while employing a classical formal vocabulary. His handling is vigorous and increases in dramatic intensity.

Inevitably Sveinsson outgrew this modern classicism. He began to supplement it with Cubist elements in order to satisfy his need for a concrete and immediate expression. This seems to be borne out by a seminal work of his, SÆMUNDUR ON THE SEAL, which was made in Paris in 1927. In the 1930s, when Sveinsson went on to tackle a vocabulary of curved forms, he was clearly not interested in classical or delicate effects, but in a primitive, almost clumsy kind of beauty, harsh and troll-like, as can be seen in his first semi-archaic female figures.

This 'primitive' style reached its apex in HELLRIDE, perhaps the most moving piece of sculpture in the whole of Icelandic art. This sculpture is a landmark in Sveinsson's development, especially in the way he opens up the solid masses to the surrounding space. Eventually Sveinsson recreated this sculpture in plaster, wood and concrete, which demonstrates his willingness to tackle different materials, experiment with different textures, scale and effects.

HELLRIDE relates directly to the Second World War, even though the original idea came from a well-known Icelandic folktale. The sculpture is clearly an Expressionist piece, since it has an existential content consistent with all true Expressionist art. After the war Sveinsson continued to develop his art along this Expressionist path, and ended up embracing abstraction. At a later stage he included both metals and glass among his materials, while at the same time making his sculptures more symbolic and allusive by the use of cosmic and allegorical imagery.

Perhaps Sigurjón Ólafsson (1908-1982) should not be mentioned directly after Sveinsson. He belongs to the generation of artists who came to maturity during the Great Depression. But because of Ólafsson's precocity, he became the direct successor to Sveinsson and Nína Sæmundsson. Sveinsson and Ólafsson even died within a week of each other. From the beginning of his career during the early 1930s, and until the end of the Second World War, Ólafsson was regarded both as a Danish and Icelandic artist, since he lived in Copenhagen and exhibited regularly with Danish artists until the end of the occupation of Denmark.

Ólafsson was utterly unlike his predecessors in Icelandic sculpture. For a start, he was a sculptor in the full meaning of the word, since he worked directly in stone and later in wood. Einar Jónsson, Nína Sæmundsson and Ásmundur Sveinsson were primarily modellers who worked in clay or plaster of Paris, not carvers.

Ólafsson's artistic ingenuity quickly became apparent. He was above all a transformer of materials, allowing them to dictate or suggest the form and content of his sculptures. Unlike the sculptors mentioned earlier, Ólafsson did not work from preconceived ideas, but improvised, after examining the nature and shape of the materials. His ideas were clarified in the actual working process.

This kind of intuitive sculpture depended on the technical ability of the artist, and was a new phenomenon. It was comparable to the working methods of the abstract-expressionist painters, who stepped up to the empty canvas to improvise from an inner need, something which demanded expression, limited only by the medium itself.

14 Ásmundur Sveinsson
The Hellride, 1944
Wood
Listasafn Íslands

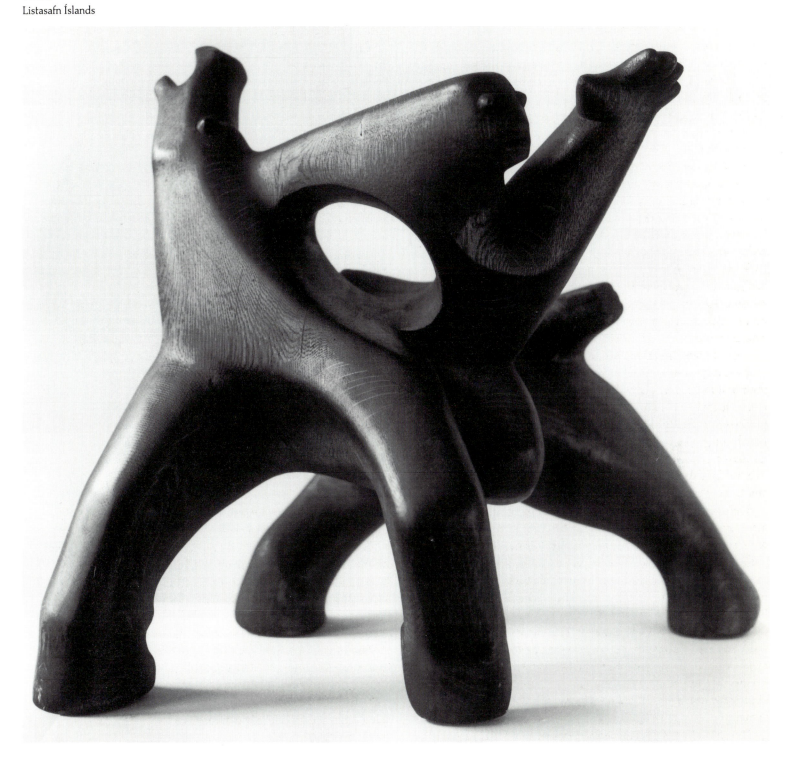

Ólafsson belonged to that group of Icelandic and Danish artists who sought inspiration in Surrealist theories about automatic expression in art and literature. They wished to discover the primitive and original foundation of their cultural heritage, and tried to bring it out directly, without premeditation, as they imagined their ancestors had done during the earliest period of Nordic culture. This search for primitive expression, supposedly hidden by a veneer of modern sophistication, derived from a number of sources, the psychoanalytical theories of Freud and Jung, Dada, and early Nordic art. It was given an added stimulus by the outbreak of the Second World War and the occupation of Denmark in 1940.

Early in his career Ólafsson had proved himself to be a consummate portrait sculptor. Although he was forced to work on a number of commissions unsuited to his art and temperament upon his return to Iceland, he was also able to execute some fine figurative sculptures for public places. Later, when illness forced him to stop carving in stone, he turned to wood carving and modelling. The imaginative richness of his work made him an inspiration to a younger generation of sculptors.

This short summary of Icelandic sculpture in the first half of the twentieth century demonstrates the independence and ambition of the few home-based sculptors. Their work showed a keen awareness of new currents in international art, and an attunement to developments in it. Given the difficulties they faced, this work is unusually powerful and personal – almost miraculous.

The general approbation offered to the pioneers of Icelandic painting was none too evident during the later 1920s and the 1930s. Younger artists had to exert considerable effort in proving their worth, and in defending their increasingly abstract work against widespread public hostility to such content. It is indeed curious that such an eminently sensible nation, generally well-read and forward-looking, should never have bothered to acquaint itself with some of the basic facts of art history, in order to be able to appreciate the art that a few of their compatriots were making.

Though many genuine progressives came to the support of our artists and fought for an enlightened attitude in cultural matters, they were unable to prevent the widespread public outrage which was first manifest at the time of Finnur Jónsson's (1892 - 1989) 1925 exhibition in Reykjavík. The exhibition contained a number of abstract works – a first in Icelandic art history – which were

the result of the artist's six years in Dresden and Berlin. Since Icelanders were ill-equipped to deal with such radical art, the exhibition caused a great deal of commotion. The Reykjavík newspapers fuelled the fire by reprinting in their pages small oils, painted in a symbolic/geometric abstract style. These works were a compendium of influences, but mostly seem to have been derived from the artist's interest in Russian Constructivism, and in El Lissitzky, one of its key figures.

Though Finnur Jónsson's abstracts were filled with objective references, which corresponded with their titles and made them accessible to serious viewers, their formal aspect turned people away. Jónsson suffered the same fate as his spiritual brethren in Soviet Russia, in that he had to conform to more traditional ideas if he wanted to stay in his mother country. In effect, his conversion bears some similarity to theirs, for he began to paint more socially acceptable pictures of fishermen.

These pictures were marked by a cool directness. They were also different from the pictures of similar subjects which Icelanders were used to. Behind the stern surface of these paintings lay hidden a dramatic aggression, which was more in line with German artistic thinking than French. Moreover, Jónsson concentrated on subject-matter which suited his need for dramatic narrative and existential symbolism. His painting Stjarna's Bones of 1934 is a good example of this marriage of directness and symbolic content. Evidently he never entirely turned his back on his origins, for at the beginning of the 1960s he reverted to abstract painting, using symbolic, existential and cosmic imagery. These pictures are closer to German abstraction than Russian, akin to the art of the pre-1914 Blaue Reiter group.

Finnur Jónsson was not alone in his pursuit of a wholly personal style at the beginning of the 1920s. The year before his abstract exhibition in Reykjavík saw the death of Guðmundur Thorsteinsson, usually known as Muggur (1891 - 1924). Muggur was an unusual artist, not least in his attitude to his art. He was the first Icelandic artist to actively seek the Bohemian lifestyle of European artists.

Actually, Muggur soon came to understand the harsh truth about the freedom which this life style was supposed to celebrate. He nevertheless documented his Bohemian life with a delicate touch, giving his Icelandic public a glimpse of a world which Toulouse-Lautrec had celebrated at the turn of the nineteenth century. Doubtless Muggur played a part in making his countrymen

15 Sigurjón Ólafsson
Búrfell Hydro-electric Station
Stone relief and sculpture

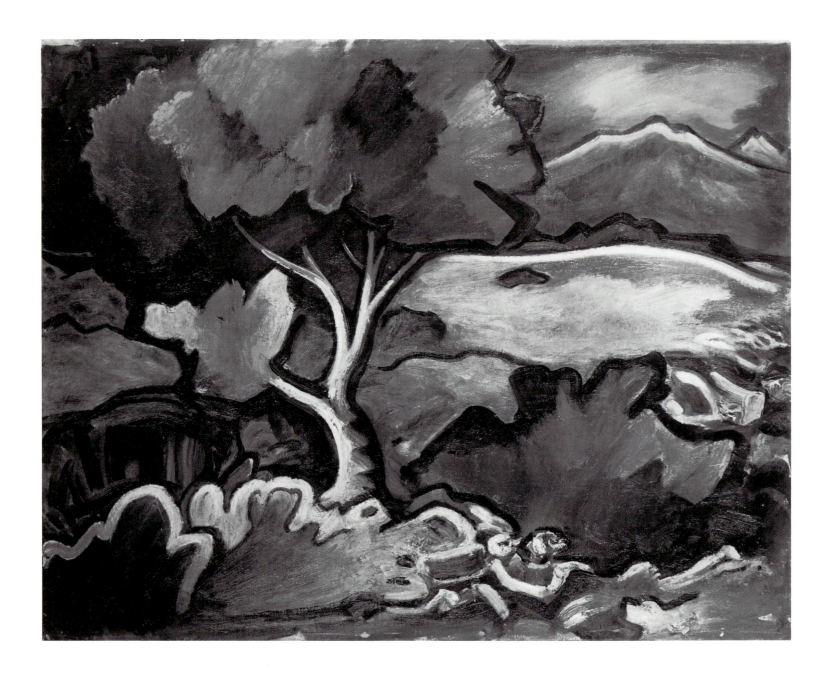

16 Finnur Jónsson
The Lava at Thingvellir, 1953
Listasafn Íslands (cat.24)

aware of the nature of European sophistication, thus encouraging them to seek it out for themselves.

Muggur's art is unusual in that he tackled subject-matter unexplored by most other Icelandic artists. It is characterised by a kind of timelessness, both with regard to content and technique, so that it could as easily belong to the eighteenth or nineteenth centuries as to the beginning of the twentieth. No matter whether Muggur painted a Parisian cabaret or the Icelandic countryside, his works are always pervaded by an aura of fantasy. At the same time they exude a kind of Proustian melancholy, not dissimilar to that which we find in the short stories of Katherine Mansfield, a melancholy which we associate with the uncertainty of youth, which finds no purpose in a world recently torn asunder by a world war.

While Muggur belongs to European culture during the years before the First World War, Gunnlaugur Blöndal (1893 - 1962) was a product of the years between the wars. His works are of the same ilk as the poems of Tómas Guðmundsson, or the more lyrical and accessible poetry of Einar Benediktsson, two poets who were portrayed by Blöndal. Like Muggur, Blöndal was fascinated by some of the more playful and decorative European artists, who were little known in Iceland at the time. He was first and foremost drawn to cosmopolitan culture, unknown in Iceland, except perhaps in a few select circles in Reykjavík.

Blöndal must have been aware of this difference between 'home' and 'abroad', and delayed returning to Iceland as long as he could. His art was heavily influenced by some of the painters of the School of Paris, Kees van Dongen and Amedeo Modigliani in particular, and one can also see traces in it of Cézanne, Matisse, and Raoul Dufy.

It must have been difficult for an Icelandic painter to absorb an art so rooted in an utterly different way of life, as celebrated by the likes of Henry Miller and Scott Fitzgerald. But Blöndal was able to put his art to good use in dealing with some aspects of Icelandic society. His best pictures are both low-key and tasteful, in spite of the richness of his tones. In his work Blöndal introduced a new kind of gaiety into Icelandic art, a trait which appealed to a growing middle class. It also played on a vaguely erotic romanticism, which hitherto had only been found in Icelandic lyrical poetry.

In their different ways Finnur Jónsson, Muggur and Gunnlaugur Blöndal infused the local tradition with new and exotic ideas from foreign art, making it both more vivid and varied, though they did not play a vital part in its development.

The generation of artists born around the turn of the century took its lead from Jón Stefánsson and added Cubism to its terms of reference. Although Cubism had ceased to be a movement when Snorri Arinbjarnar (1901 - 1958), Gunnlaugur Scheving (1904 - 1972) and Thorvaldur Skúlason came under its influence during the 1930s, these three artists were greatly interested in certain Cubistic elements, which would enable them to tighten their pictorial structure, and give it a stable and rhythmic foundation. They made a particular study of Braque's and Picasso's proto-Cubism, where objective reality is still unfragmented, only simplified and given a strong three-dimensional emphasis. Arinbjarnar and Skúlason even studied Picasso's transitional period, from the Pink pictures to the creation of the DEMOISELLES D'AVIGNON and in some pictures they constructed their forms in the manner of the Spanish master and restricted themselves to earthy colours.

Icelanders consider Spain as being very far from their world: their language even has a saying: 'It looks Spanish to me', meaning 'it looks strange to me'. But Arinbjarnar and Skúlason quickly equated some typical Catalonian colours — such as ochres — with the colours found in Icelandic nature. In any case, they did not hesitate to adopt them, shortly before Icelanders adopted another product of Spain, Spanish wines, much to the chagrin of the local temperance societies.

Gunnlaugur Scheving took a different route. Early on he developed a semi-realist style, which owes something to Van Gogh's pictures of labourers, and to the international style of socially conscious realism. Van Gogh had taught his followers to exaggerate the hands and feet of their figures, and equally to make the body itself correspondingly thin and squat in structure. The people who inhabit these pictures walk along in rough wooden clogs, looking emaciated and exhausted, casting their eyes about with a sorrowful expression. In Stalin's Russia, paintings were full of the well-fed, laughing proletariat. Thus social realism lost something in seriousness, except in historical tableaux.

The high point of this period is the ROWING BOAT of 1928 - 1929. The artist was twenty-five at the time of its execution. No wonder people predicted a great future for him, for the ROWING BOAT is without doubt the most significant realist work to come out of Icelandic art. But Scheving was not about to continue in

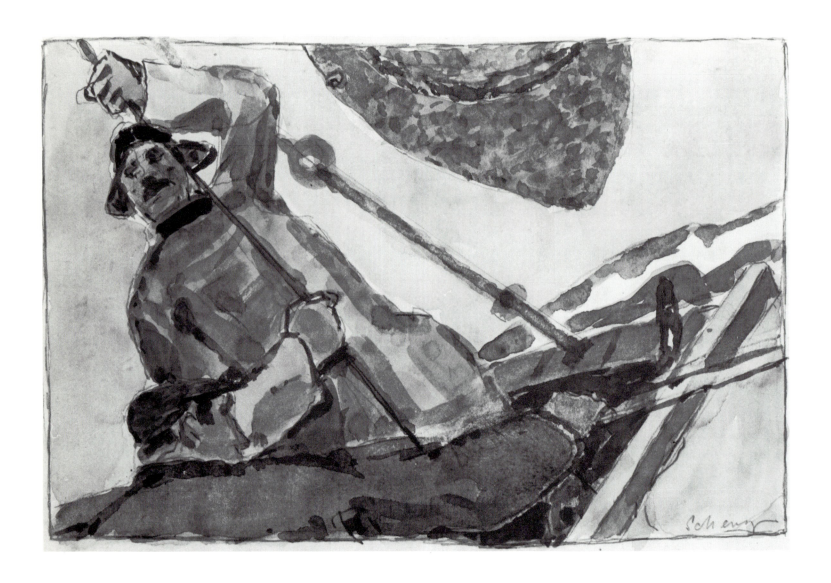

17 Gunnlaugur Scheving
Fishermen Hauling in a Shark, c.1950s
Listasafn Íslands (cat.33)

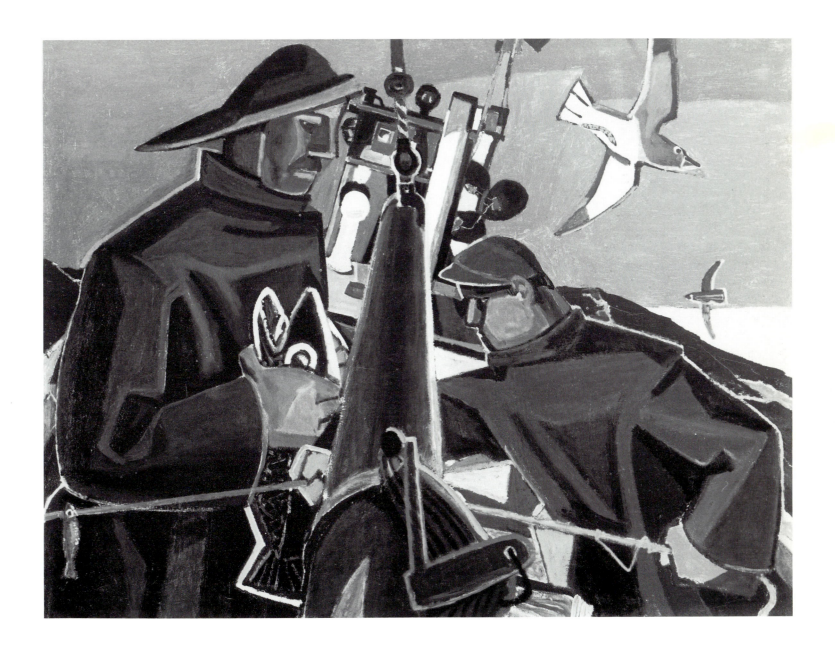

18 Gunnlaugur Scheving
Fishing Boat, 1958
Listasafn Íslands (cat.32)

a mode which he knew belonged to the past. Instead, he took elements from early and late Cubism to build up his monumental paintings of Icelandic workers, on land and at sea.

Scheving's painterly intelligence is apparent in his use of broken diagonal lines to suggest the kind of floating horizon known to those who have been at sea. His original use of colour, unique in Icelandic art, merits further discussion. It is also something of an enigma that his stylised paintings of fishermen have such a strong realistic presence, while his scenes of Icelandic country life are so heavily laden with folkloristic or religious references.

Nevertheless, Scheving never betrayed his social conscience, privately or as an artist, and he deserves to be called Iceland's most authentic social realist. It is doubtful whether the other Scandinavian nations can boast of a more impressive example of that genre. It contains nothing of the insidious and sentimental propaganda which has disfigured most of what passes for social realism in international art during the last fifty years. Scheving's paintings of working people are both profound and true, because he himself had experienced what he painted.

Of the three, Arinbjarnar has most often been associated with so-called Depression painting. He was the first to condense the Icelandic coastal villages and their harbours into tight painterly units, turning them into tableaux. He tightened up the compositional elements in his pictures, and by doing so he emphasised the special world of small houses and ships. Arinbjarnar was an uncommonly sensitive artist, which is brought out in his marshalling of colours and treatment of light. His colours are perhaps more personal and responsive than either Scheving's or Skúlason's. His solitary figures, wandering through the empty village streets, have an aura of melancholy about them, and echo the Depression poetry of modernist pioneer Steinn Steinarr. In the early 1930s, town squares all around the country were indeed the refuge of lonely, unloved men, looking for work.

Arinbjarnar's development of colour was very successful. He was able to deploy novel colour modulations to an extent unmatched by any other Icelandic painter. There was one type of compositional feature which Arinbjarnar excelled at, namely circular composition. During the 1940s and 1950s Arinbjarnar gradually simplified his paintings, until they began to look like objective minimalist works. In spite of this, his acute sensitivity to colour never let him down. His pictures, though spare in the extreme, are radiant with coloured light.

Skúlason was the most complex and intellectual of the three. He was also an ambitious and perceptive artist, aware both of his abilities and of every wind of change that blew through the art world. While Scheving and Arinbjarnar developed their painting very gradually, keeping their distance from some of the more extreme aspects of modern art, Skúlason plunged in at will, changing his palette as often as a chameleon, a fact due to restlessness rather than inconsistency.

This virtuosity and intelligence enabled Skúlason to range widely in his art, which he saw as solving a number of technical problems within the context of a particular art movement. When the problems in question were solved, he turned to some other context. To borrow a Hegelian term, the development of his art was more dialectical than that of his colleagues. From the time he emerged as a fully-fledged artist at the end of the 1920s, Skúlason was constantly making a new start.

Skúlason was equally comfortable with formal construction and colour, and was particularly adept at orchestrating these elements to suggest depth of field. Consequently he excelled in three-dimensional scenes, which give his figures a weighty presence. During his long stay in Europe during the 1930s, Skúlason developed a great liking for French art and artistic philosophy. His own palette was influenced by the subtle colours of Georges Braque, evident in his repeated use of greys and greyish-blues, which act as a kind of neutral element amidst other formal and colouristic manœuvres. This served to give his paintings a classical structure, a kind of stability, even though they were otherwise ablaze with bright, complementary colours.

Skúlason returned to Iceland shortly after the beginning of the Second World War. Soon he came to be seen as one of the country's most promising artists, and a bearer of new truths in painting. Poet Steinn Steinarr was one of his first admirers. Steinarr was particularly taken with the interplay of new and old in Skúlason's figurative pictures, as well as their combination of deliberation and spontaneity. Through his art, as well as his facility for expressing himself in print, Skúlason became the uncrowned leader of a new iconoclastic movement in Icelandic art. In time his opinions became an essential ingredient of Icelandic artistic thinking. In this he was a natural successor to Jón Stefánsson, and one of the people who established the educational criteria for the art schools that were set up in Iceland during the 1940s.

The post-war September Exhibitions and the geometric

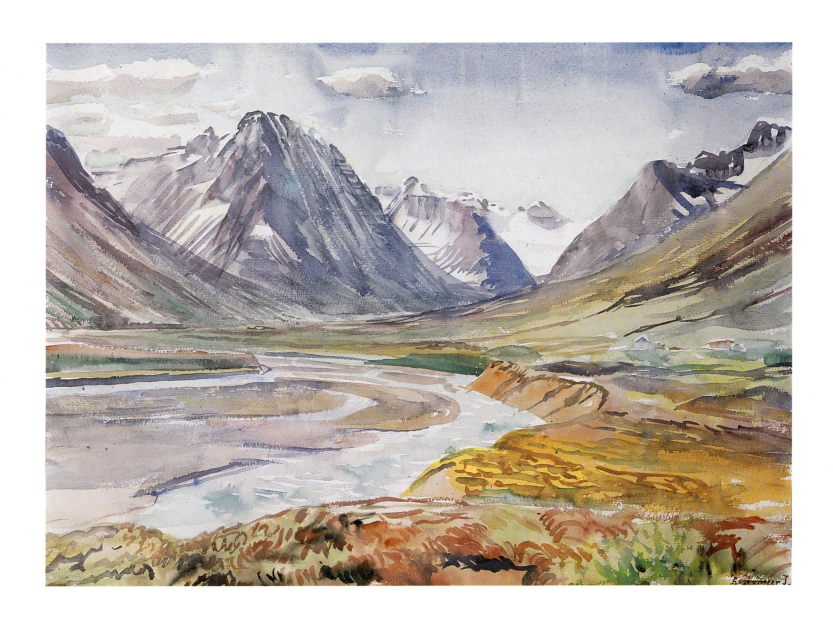

PLATE I
Ásgrímur Jónsson *Skíðadalur, 1951*
Listasafn Íslands (cat.8)

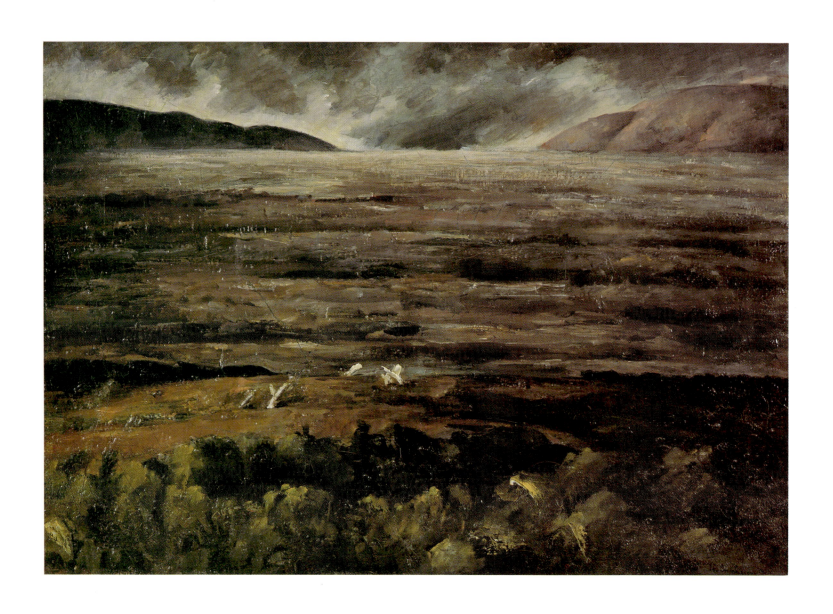

PLATE II
Jón Stefánsson *Hallmundarhraun*
Listasafn ASÍ (cat.10)

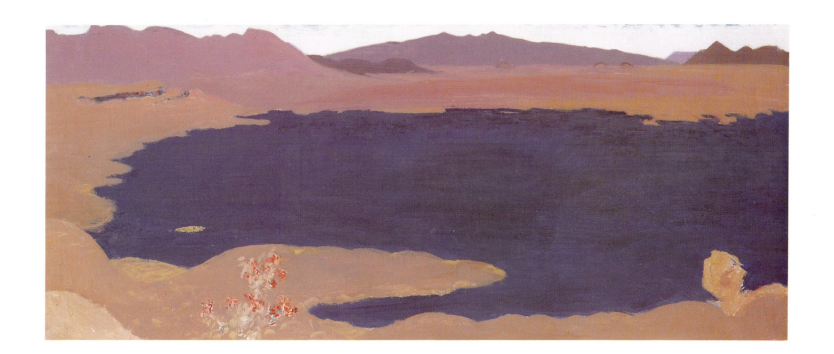

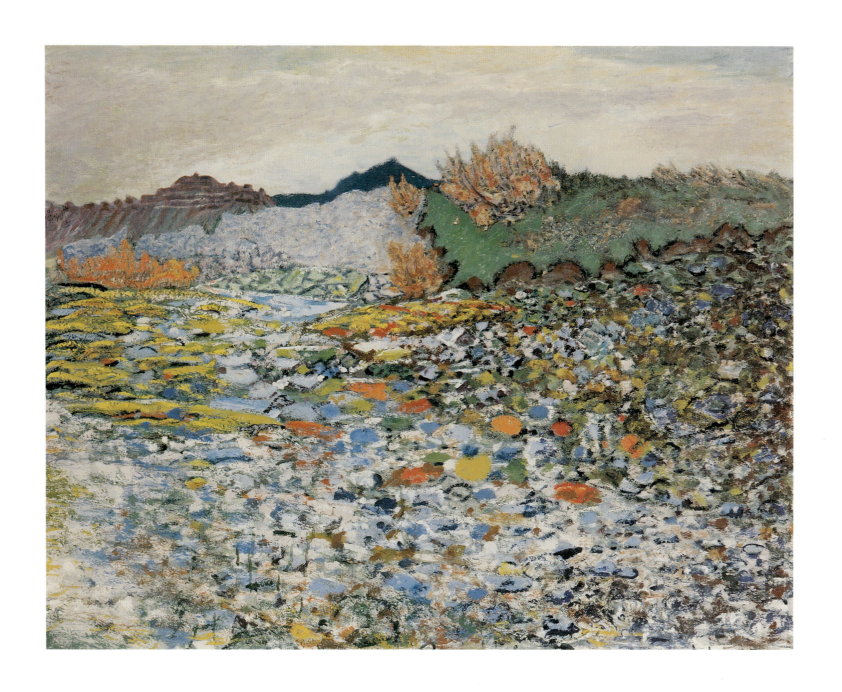

PLATE IV
Jóhannes S Kjarval *Bláskógaheiði*, 1953
Listasafn Reykjavíkur, Kjarvalsstaðir (cat.18)

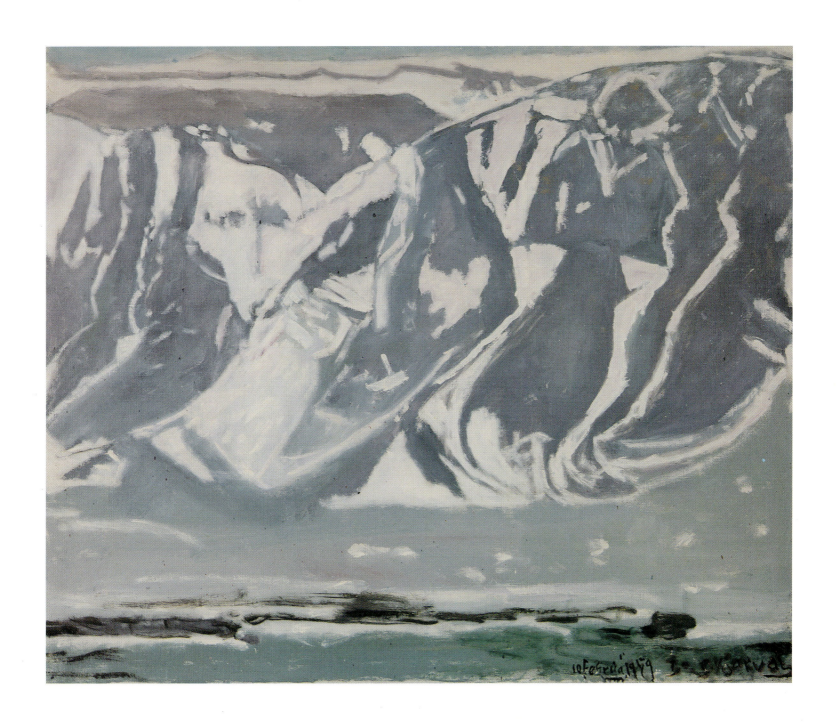

PLATE V
Jóhannes S Kjarval *Esja in February, 1959*
Listasafn Reykjavíkur, Kjarvalsstaðir (cat.19)

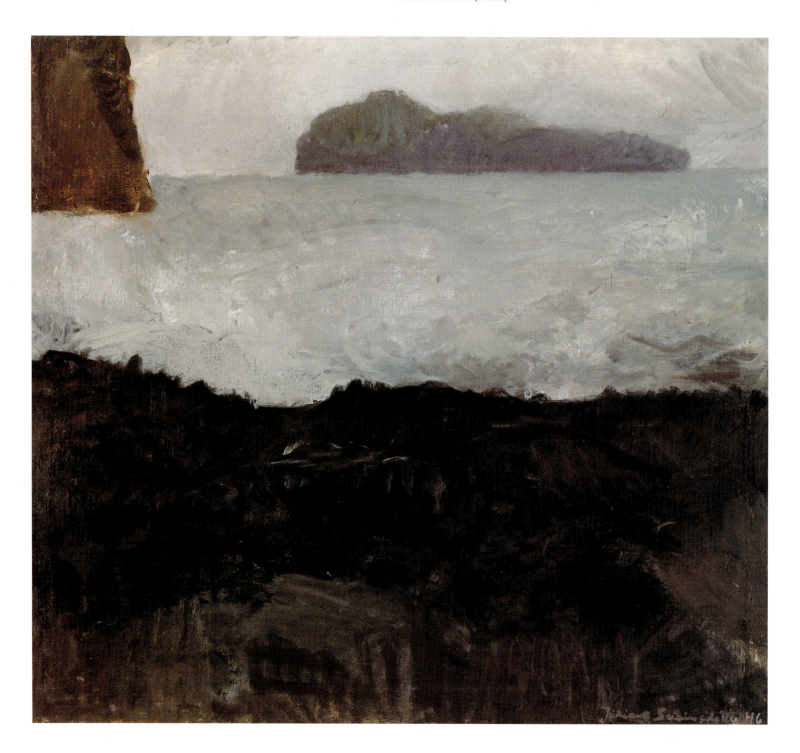

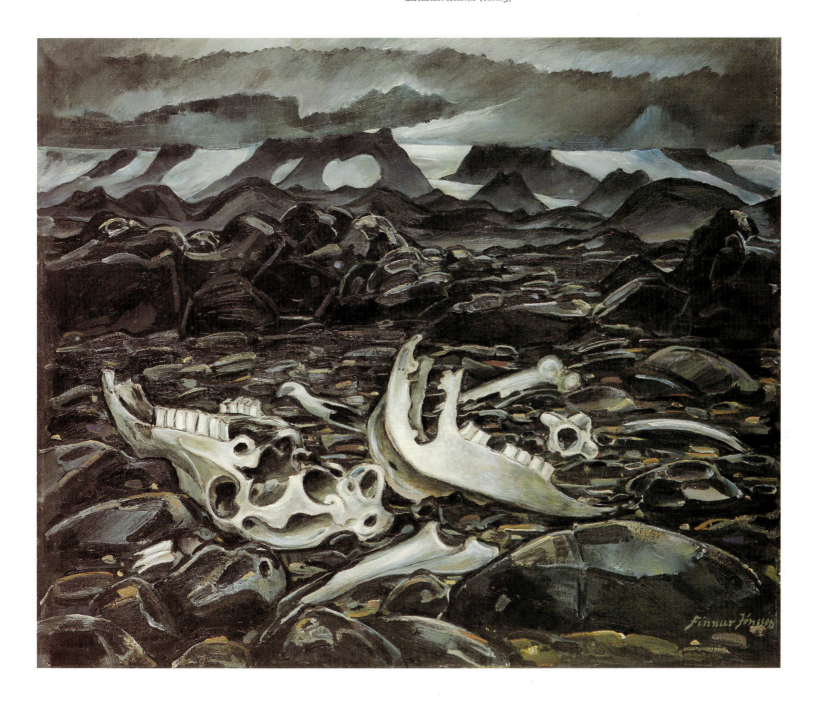

PLATE VIII
Finnur Jónsson *Three Suns, 1966*
Listasafn Íslands (cat.25)

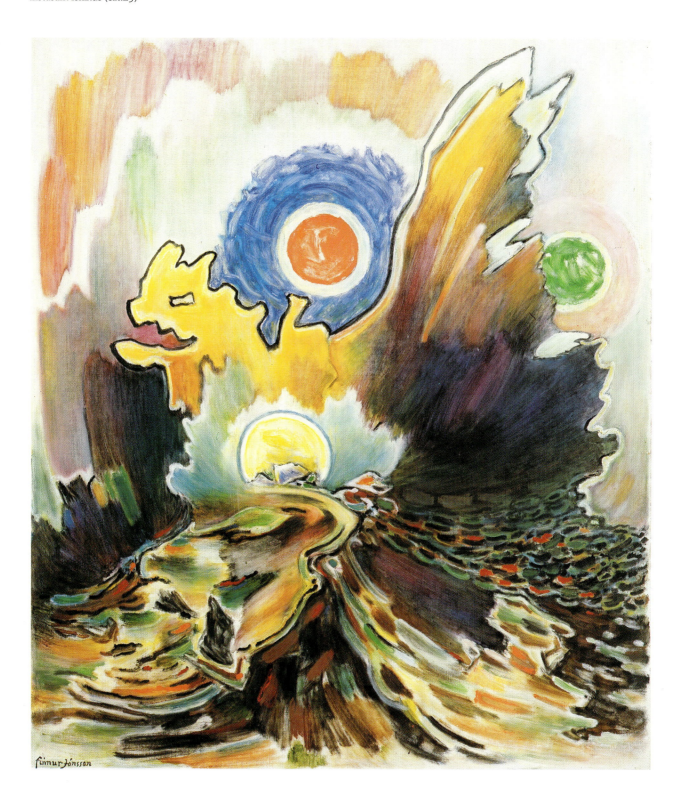

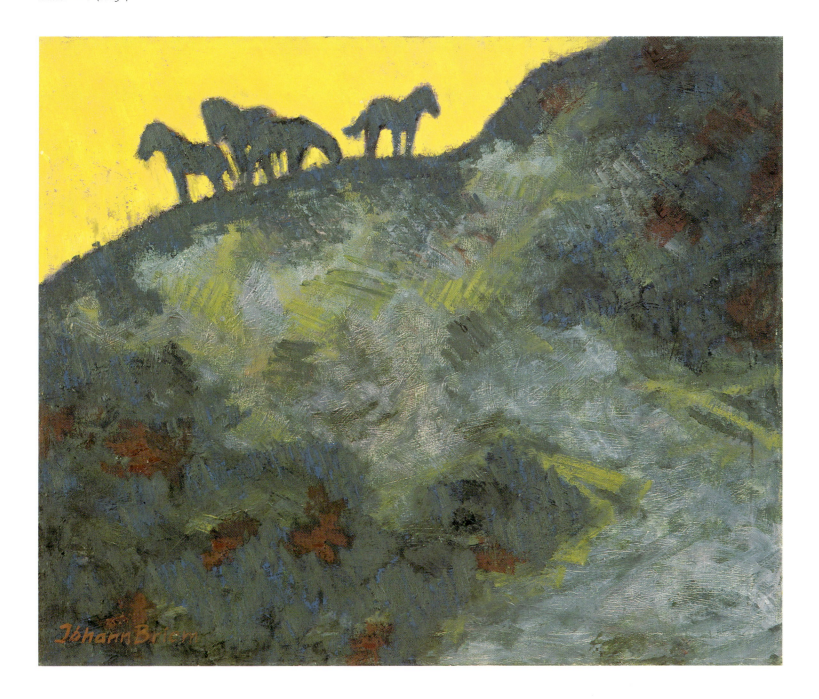

PLATE X
Svavar Guðnason *Mount Hágöngur,* 1947
Listasafn ASÍ (cat.39)

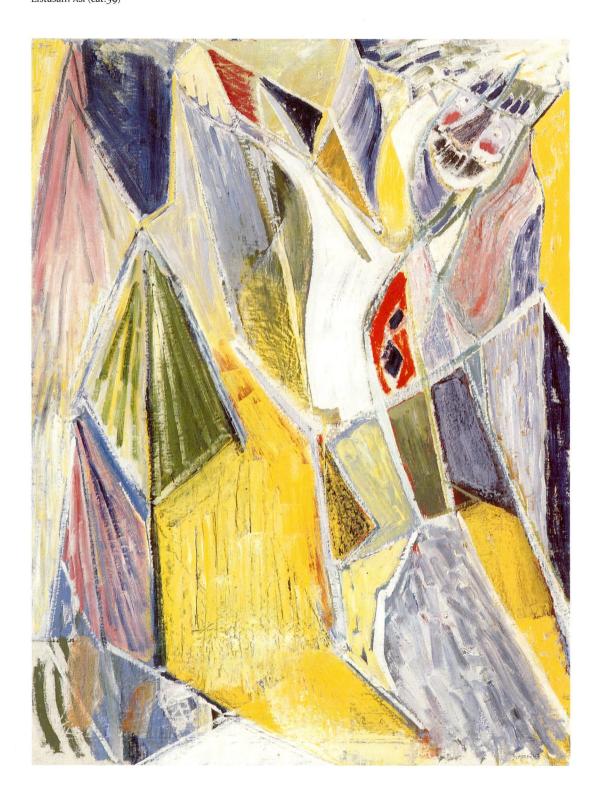

PLATE XI
Nína Tryggvadóttir *Abstract*, 1956
Listasafn Íslands (cat.41)

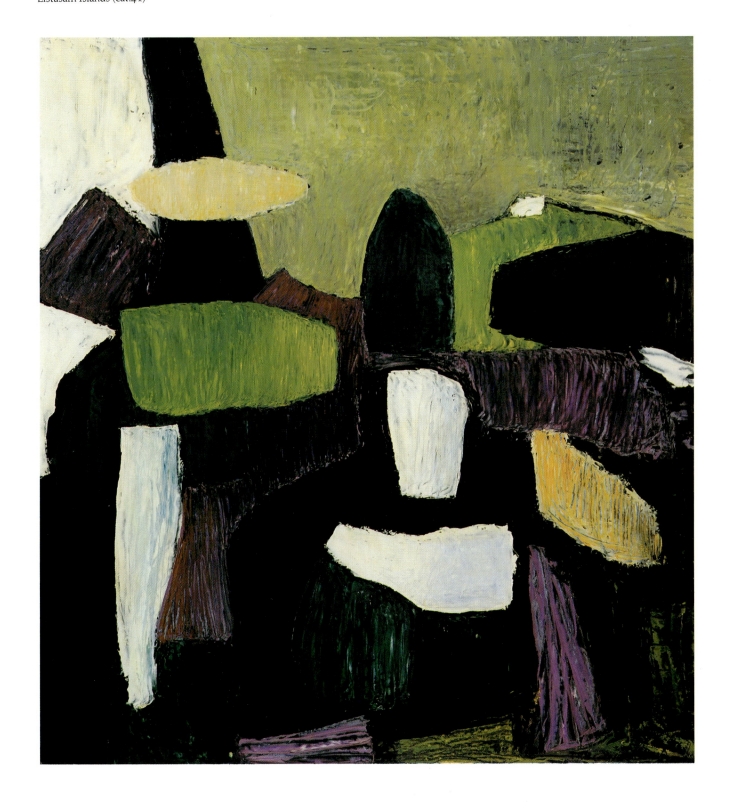

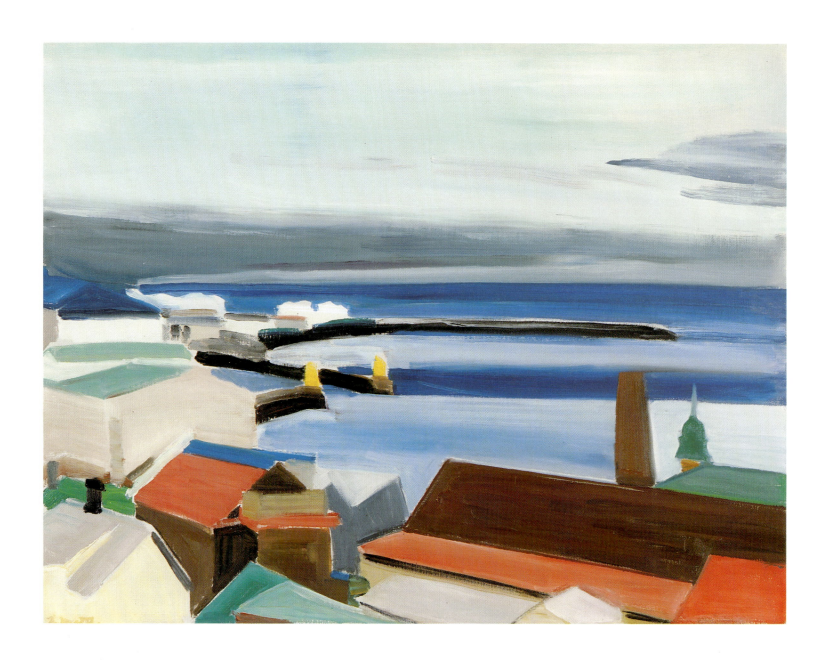

PLATE XII
Louisa Matthíasdóttir *The Harbour of Reykjavík, 1987*
The Artist (cat.46)

PLATE XIII
Ásgerður Búadóttir *Ice and Fire, 1975-78*
The Artist (cat.49)

PLATE XIV
Ása Ólafsdóttir *Light and Shadows, 1987-88*
Menntaskólinn á Laugarvatni (cat.65)

abstraction, or Concrete painting, of the 1950s both drew on Skúlason's theories and art, which undoubtedly influenced Icelandic art, especially during the formative years of abstraction.

In this period the Icelandic artistic community was divided to an unprecedented extent. Artists no longer argued about 'professional' art *versus* 'dilettantism', but about their respective 'movements'. The disputes centred not only on 'abstract' *versus* 'figurative' art, but also on 'lyrical' (or 'tachiste') *versus* 'geometric' abstraction. Instead of strong individuals like Skúlason and his predecessors, who had gone their own way, Icelandic artists now tended to form groups or cliques with clearly-defined, narrow artistic objectives. This division into camps did not make for variety. It brought with it a narrow-minded attitude, not unlike the political in-fighting of the 1930s. Above all it demonstrated how little people seemed to have learnt from the recent World War and the hysteria that had been the cause of it.

Those artists who declined to join any group often had a difficult time, suffering considerable pressure from colleagues, who urged them, both discreetly and openly, to change their stance, no matter how they felt about the new art. Painter Jóhann Briem (b.1907) was one of the more independent spirits among the outsiders. Like Finnur Jónsson he had studied in Germany during the 1920s and 1930s. Though he had absorbed much of German artistic philosophy, he was also an open-minded and imaginative artist who took part in many a skirmish on behalf of Icelandic art and artists.

In the 1930s Briem ran an evening art school with Finnur Jónsson on the premises of the Reykjavík College. The British occupation of Iceland in 1940 put an end to the teaching, since the British troops decided to turn the school building into their headquarters. But among Briem's and Jónsson's pupils were such future artists as Nína Tryggvadóttir (1913 - 1968) and Kristján Davíðsson (b.1917), who later became leading representatives of lyrical abstraction in Icelandic art. Jóhann Briem was the chairman of the Icelandic Federation of Artists when Jónas Jónsson, then minister of Culture and Education, embarked on a crusade against 'unIcelandic' art – a crusade uncomfortably reminiscent of Rosenberg's and Göbbels's attack on 'degenerate art' in Germany.

The resulting commotion, usually called 'the Great Art Debate of 1942', united Icelandic artists as never before, and not only visual artists, but also writers and musicians. All of them were firm in their support of the artists discredited by Minister Jónsson. Led by Jóhann Briem, the Federation of Artists brought this affair to a successful conclusion, in the process founding 'Listamannaskálinn' (The Artists' Gallery), the first Icelandic exhibition hall especially designed for Icelandic artists.

An effective propagandist for the artistic and social rights of Icelandic artists, as well as a lecturer on modern art for the State Radio, Briem had developed a very personal style of painting. It was characterised by thickly painted, heavily stylised versions of figures and animals, which seemed to be posing questions about the Icelandic artist's position in the modern world, wedged as he was between national and international values. Briem's work is about man's search for a meaning in a nature teeming with a life of its own, actual as well as supernatural.

Although Briem often came perilously close to non-objectivity in his painting, he never abandoned visual reality altogether. He took the same route as many of the pioneers of international modernism, such as Matisse, Picasso and Chagall. Briem preferred to bypass the debate about abstract art rather than betray his own convictions. For over a decade he lay low and only took part in group shows. But from the middle of the 1950s onward he again entered the fray with a new and personal pictorial language.

Jón Engilberts (1908 - 1972) also experienced certain difficulties during the tumultuous post-war period. Engilberts was an impulsive artist, working with a rich palette. Like so many Icelandic artists of his generation Engilberts came to maturity towards the end of the 1920s and lived abroad all through the 1930s, experiencing some indecision about his art. On the one hand, like so many Scandinavian artists of the period, he was drawn to a socially responsible Expressionism; on the other he sought to vent his feelings about intimate experiences. In time this division of his artistic personality led to a clash between dramatic expression and lyricism in his art. This was also reflected in his formal language, compositional technique and use of colour. His pictures exhibit a combination of emphatic outlines, often done in a thick impasto and 'cloisonné' manner, and sombre, softly applied and 'hot' colours.

Concurrently, Engilberts played a leading role in the development of Icelandic printmaking. His woodcuts and linocuts were heavily indebted to Norwegian printmaking, especially Edvard Munch's prints, but they were nevertheless personal. His drawings are both fluid and vigorous. Though Engilberts was in a sense a typical Scandinavian Expressionist, he was also interested in late

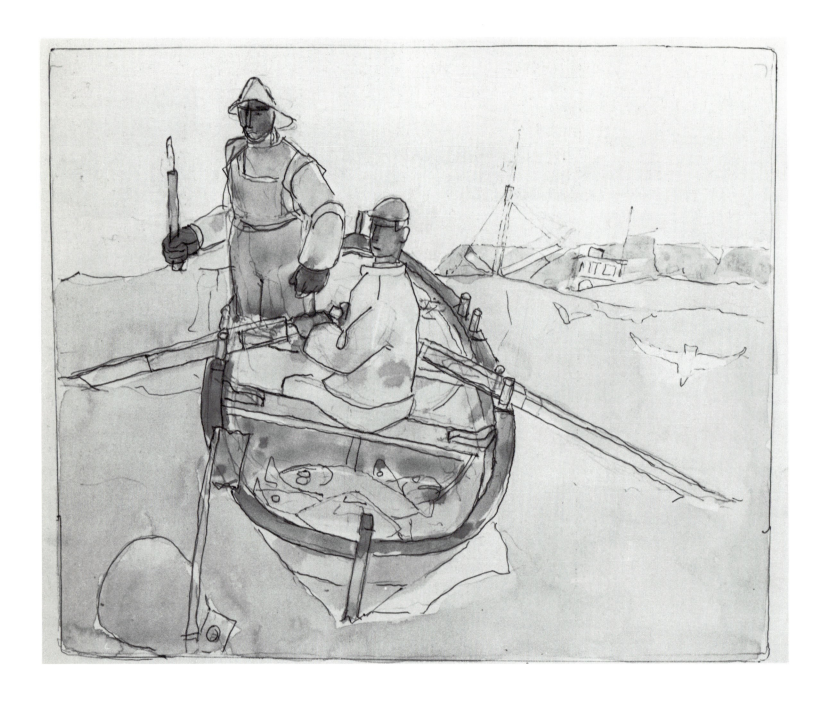

19 Gunnlaugur Scheving
Two Fishermen in a Boat, c.1950s
Listasafn Íslands (cat.35)

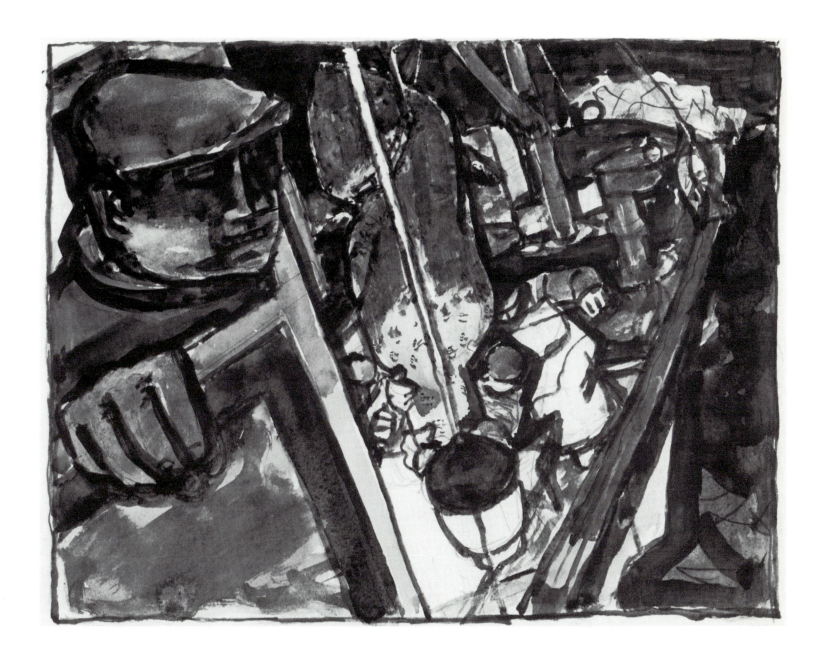

20 Gunnlaugur Scheving
Fisherman in a Boat, c.1950s
Listasafn Íslands (cat.34)

21 Jóhann Briem
Black Mountains, 1963
Listasafn Íslands (cat.37)

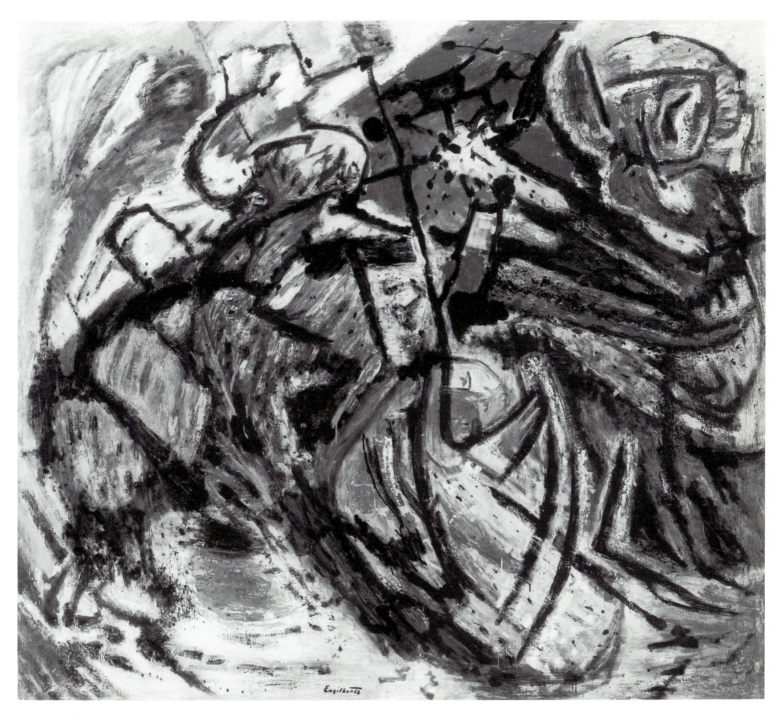

22 Jón Engilberts
Iceland No.5, 1964
Oil
Listasafn Íslands

Cubism. Thus he was able to avoid some of the harshness that characterises the work of Munch and the German Expressionists.

During the 1940s, Engilberts' art took on a more lyrical aspect. His palette became brighter and more vibrant. MORNING, a painting from 1940, is an outstanding example of Engilberts' lyrical Expressionist style. Though reminiscent of Kirchner's Brücke period, it is nevertheless more akin to the French tradition, confirming the indebtedness of Icelandic art to the School of Paris.

During the debate between the followers of abstract and representational art, Engilberts experienced a crisis in his own art which took him a long time to resolve. At the end of the 1950s he emerged with a new abstract style, both monumental and lyrical. Through this new style Engilberts finally succeeded in uniting the two opposite tendencies in his artistic make-up. His abstract paintings have a dream-like as well as a dramatic atmosphere.

The third 'loner' of the generation of artists born before the First World War was Svavar Guðnason (1909-1988). He studied in Copenhagen during the late 1930s and did not return to Iceland until the end of the Second World War. By then, like Sigurjón Ólafsson before him, he had become known in Denmark as one of the leading lights of new abstract expression in Scandinavia. His main asset as a painter was his vigorous and sensitive use of colour. No other Icelandic artist was his equal in this respect.

Guðnason was the first Icelandic painter to reject objectively-based expression in favour of an emotional rendering of personal experiences through colour alone. He left objective reality behind during the late 1930s, while he also kept in touch with the formal language of surrealist abstraction. Guðnason named his first period of abstraction the 'fugue period'. It was based on an open composition of biomorphic and geometric forms, which were used as a kind of scaffolding for the artist's blazing colours.

During the years of the German occupation of Denmark Guðnason's 'fugue' style gradually turned into a personal kind of abstract expressionism, where the artist seemed more interested in automatism and improvisation than a firm compositional structure. Everything hinged on the impact of the raw colours that Guðnason spread over his canvases. He tried out different painterly rhythms and frequently used a palette knife to shape his colours on the canvas. After his return to Iceland in 1945, he continued to experiment with an ever richer surface structure.

Guðnason's first exhibition in Iceland was also held in 1945. It was the first exhibition of abstract art in Iceland since Finnur Jóns-son's show twenty years earlier. Very few of those who attended Guðnason's show had ever seen such a spontaneous and open-form abstraction. Nevertheless, it caused less of an uproar than one might have expected, much less than the 1947-1951 September Exhibitions. Perhaps this absence of dissension was due to the fact that his exhibition was not accompanied by any radical manifesto. But certainly it helped to create a new artistic vision in Iceland, and prepared the ground for the growth of abstract art. Many young Icelandic artists saw Guðnason's show as a challenge, which they were more than eager to accept.

During the early 1950s, Guðnason's paintings became more structured, and his application of colours more regular. His colours kept their vitality and his use of textures became more imaginative than ever. Nature had always played a large part in his work, and it continued to occupy the artist to an increasing degree. Eventually he turned his attention to geological formations and rock structures. Soon this new interest in structured forms led to a period of geometric abstractions. This was undoubtedly due to the pressure exerted on the artist by his colleagues, geometric abstraction being the dominant trend in Iceland during the 1950s.

Later Guðnason broke away from geometry and began to employ a freer technique in his paintings, which also began to exhibit a concern with dramatic confrontations and monumental forms. It was as if the rapid changes in Icelandic weather had insinuated themselves into his paintings, providing him with a new, predominantly horizontal structure. But these paintings also carried irregular tornado-like forms, which provided the counterpoint to the regular, horizontal compositions. Guðnason's very personal compositional technique and his bold use of colours make him into a pivotal figure in modern Icelandic art.

Nína Tryggvadóttir (1913-1968) was younger than Guðnason, but turned to abstract art very early on, after a period of experimentation with a flat, semi-Cubist framework. Tryggvadóttir possessed an intuitive understanding of structure and knew how to pare her paintings down to the bare essentials. These gifts are nowhere more apparent than in her portraits from the war years. Tryggvadóttir depicted the artists she met in the now legendary Unuhús, a gathering place for artists and intellectuals between the wars. She painted their features in a simple yet profoundly sensitive manner, so that no one was in doubt as to the character of the person portrayed.

She used a similar procedure in her paintings of landscapes and

23 Svavar Guðnason
The Dictator, 1949
Listasafn ASÍ (cat.40)

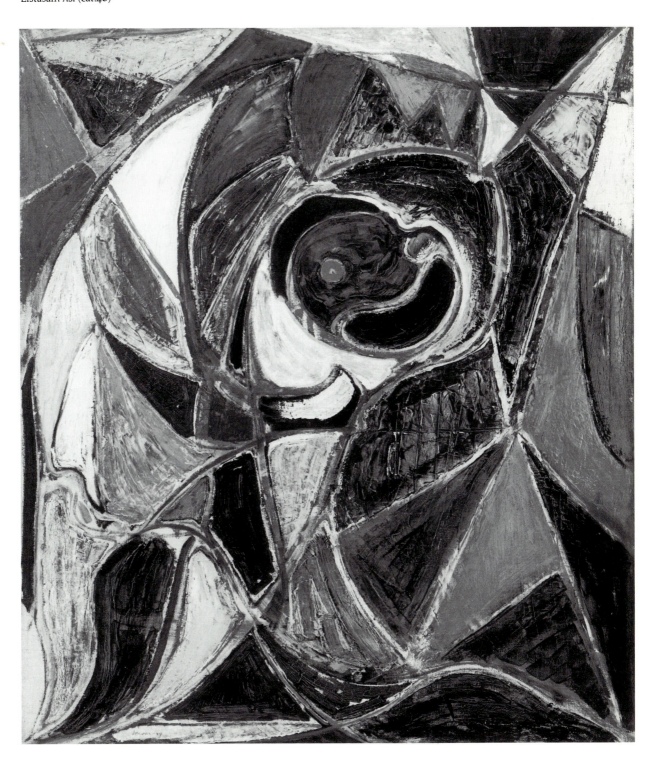

interiors, which suggested that she would soon leave objective reality behind. Not unlike the French-Russian painter de Staël, who clearly had some influence on her work, Tryggvadóttir was for a while trapped in a no-man's land between objective and abstract art, until she opted for the latter. Around 1950 her paintings were finely balanced on a knife-edge, between lyric and geometric abstraction. They contained oblique references to Icelandic nature, rock formations and mountains.

Tryggvadóttir's reliance on Icelandic natural imagery increased with time, though she lived mostly abroad, in Paris, London and New York, from 1952 until her death in 1968. Abstract art made it possible for her to take something of her mother country along with her wherever she went. Her style of painting became more concise, and yet softer, through her use of a spatula to spread her colours in large sweeps. In this way she was able to interpret various natural phenomena in her work – waterfalls, rain – in a convincing manner. Tryggvadóttir's abstractions could be termed a kind of abstract Impressionism.

Although Tryggvadóttir was closely associated with the art debates of the late 1940s and early 1950s, and was affected both by Skúlason's art and geometric abstraction in general, she was by nature far too independent to accept any kind of group directive, especially if it contradicted her own artistic convictions. Thus she was ready to use some aspects of geometric art, though without pledging allegiance to the 'movement'. It was appropriate that Tryggvadóttir should have become the one to predict the demise of geometric abstraction and to charge her colleagues with a narrow-mindedness with regard to other movements in international art.

Her views on the situation of Icelandic art were undoubtedly coloured by her long exposure to foreign art. They were well received by those artists in Iceland who had little sympathy for geometry, painters like Kristján Davíðsson (b.1917) and Eiríkur Smith (b.1925), who were for a time the only abstract artists working in a lyrical vein.

Louisa Matthíasdóttir (b.1917) was a friend and a close follower of Nína Tryggvadóttir. But whereas Tryggvadóttir studied with Fernand Léger, Matthíasdóttir opted for Marcel Gromaire. Both became students of Hans Hofmann in New York during the Second World War. But Matthíasdóttir, who settled in New York in 1941, never became an abstract artist. Instead, she kept following the narrow road between figurative and abstract art, which

Nína Tryggvadóttir had paved in the 1940s. This led her to a personal kind of realism, which she reduced to bare essentials, using cool colours and flat brush-strokes. Recently, she started revisiting Iceland, where she gathers traditional motifs which she renders with an American kind of technique.

Ragnheiður Jónsdóttir Ream (1917-1977) was also influenced by her stay and studies in the United States. Educated to become a concert pianist, she changed to painting in the 1950s. After her studies at the American University in Washington DC, she developed a style midway between figuration and abstract art, sometimes reminiscent of Richard Diepenkorn's semi-objective paintings. In the 1970s, she returned to Iceland, where landscape became her favourite theme. She also excelled in small and clean-cut still-lifes. In most of Ream's paintings, there is a strong feeling for directional lines, which usually accord with the limits of the frame.

The 1947 September Exhibition proved to be a watershed in the relationship between modern Icelandic artists and their public. The works on show were hardly of a kind to cause outrage. Though many of the participants were of a radical temperament, their works were considerably less radical than those exhibited by Guðnason two years before. The ensuing public indignation probably had a lot to do with the manifesto published in the exhibition catalogue, which was in two parts. On the one hand there was an eloquent essay by Kjartan Guðjónsson, the youngest artist in the show (b.1921) and on the other was Thorvaldur Skúlason's translation of an article about Picasso by the French art critic Christian Zervos.

Guðjónsson's essay was in fact more extreme than the show warranted. It took the artists three or four years to live up to its premises. For the next two years, the September Exhibitions were mostly a forum for experimentation. There were attempts to work in the late-Cubist manner of Picasso, in the Expressionist manner of Klee, or to try out the primitivist abstract expressionism of the COBRA group.

Through his association with the Danish 'Linien' group and the *Helhesten* review, Svavar Guðnason had played a significant part in the development of the COBRA movement. But he was not much interested in the primitive aspect of COBRA. Though he did a few works based on primitive artefacts, especially masks and fantastic birds, he was mostly uninterested in ancient Nordic art. Skúlason

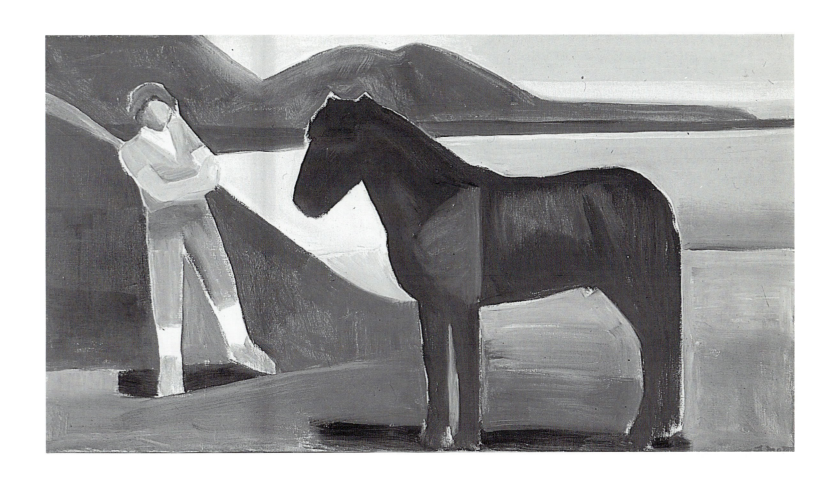

24 Louisa Matthíasdóttir
Girl with a Horse, 1987
The Artist (cat.47)

was much more interested, as is evident from his 1946 illustrations for *Grettir's Saga*, and a few primitivist paintings of 1947-1949.

Skúlason was also acquainted with Danish painters such as Ejler Bille and Egill Jacobsen, who tended to refer to primitive masks in their works. After a show of the Danish COBRA group in Iceland in 1948, this Nordic primitivism affected many Icelandic painters. For some of them it became a kind of half-way house between objective expression and abstraction. Apart from Skúlason and Ólafsson, Valtýr Pétursson (b.1919) and Jóhannes Jóhannesson (b.1921) also used the mask in their work.

This loose combination of late Cubism and COBRA art was only a kind of prelude to the ordered abstract art which appeared at the beginning of the 1950s. In the same way that Skúlason had acted as a leading propagandist for the ideas behind the September Exhibitions, Pétursson became a leading proponent of geometric abstraction. He had just come back to Iceland after a period of study in the USA, Italy and Paris, bearing with him all the latest ideas. He soon became the chief apologist for these new ideas, influencing a number of his colleagues, not least Skúlason, who was always keenly aware of changing attitudes.

Together Pétursson and Skúlason spread the message about geometric abstraction. They immersed themselves in the theories of Léon Degand, one of the most influential propagandists for geometric abstraction in Paris, where he published the art and architectural review *Art d'aujourd'hui*. Soon younger Icelandic artists joined the ranks of the geometric abstractionists, mostly those who had studied in Paris. Karl Kvaran (1924-1989) and Hjörleifur Sigurðsson (b.1925) both showed geometric abstractions in the last September Exhibition, 1952, along with Pétursson and Skúlason. Kvaran was admittedly an exception among the young abstract painters, in that he had not gone to Paris after studying at the Royal Academy in Copenhagen. Sigurðsson had however lived abroad, in Paris for instance, during the 1940s. He did not begin to paint in the geometric style until after his return to Iceland in 1953.

These four painters were nevertheless very dissimilar. Pétursson and Skúlason were primarily interested in spatial construction and varied their colours according to structure. Kvaran and Sigurðsson sought to enliven the surface of their paintings, and used complementary colours.

In 1953 geometric abstraction had spread to such an extent that it inspired two group shows in Reykjavík, one in the spring, the

other in the autumn. Three other artists took part in the autumn show, Hörður Ágústsson (b.1922), Eiríkur Smith (b.1925) and Sverrir Haraldsson (1930-1985). They were joined by Karl Kvaran and Svavar Guðnason, who had been specially invited. New colouristic and structural combinations were being added to the basic ideas of geometric abstraction. Each artist found a variation of his own to develop, be it composition, colours or linear structure.

In the spring of 1953 Skúlason, Pétursson and Sigurðsson showed their latest geometric abstractions, along with a newcomer, Benedikt Gunnarsson (b.1929) and two sculptors, Ásmundur Sveinsson and Gerður Helgadóttir (1928-1975). Helgadóttir was the first Icelandic sculptor to work with non-objective structures. She lived abroad for most of her working life, where she got to know progressive sculptors, such as the Dane Robert Jacobsen. Their friendship contributed to Helgadóttir's first abstract sculptures, the black-painted metal structures of 1951, which provided a three-dimensional equivalent to painted geometric abstractions.

Thanks to Helgadóttir, geometric sculpture quickly caught on in Iceland. It affected Ásmundur Sveinsson, who was soon to concentrate on abstract sculptures out of junk metal. Admittedly Sveinsson was never fully committed to geometric abstraction. However, two of his pupils, the brothers Jón (b.1916) and Guðmundur (b.1920) Benediktsson, began where Helgadóttir left off, by making open-work metal abstractions from the middle of the 1950s onwards. Jón Benediktsson put found objects to good use in his sculpture, but cared less for their overall clarity. Guðmundur worked with greater precision, creating sophisticated and highly organised sculptures.

No movement in Icelandic art enjoyed a more thorough theoretical backing than geometric abstraction. New cultural reviews, *Vaki* and *Birtingur*, which sprang up early in the 1950s, did their best to inform the general public about the new art, and to bring other international developments in modern art to its attention, giving Icelanders a sense of being in touch with the outside world.

Hörður Ágústsson was among the most active writers for the two reviews in question, being very aware that Icelandic art needed constant support from those who could wield a pen. *Birtingur* came out at regular intervals until 1968, and had great influence on the attitude of Icelanders to new art, Icelandic as well as foreign.

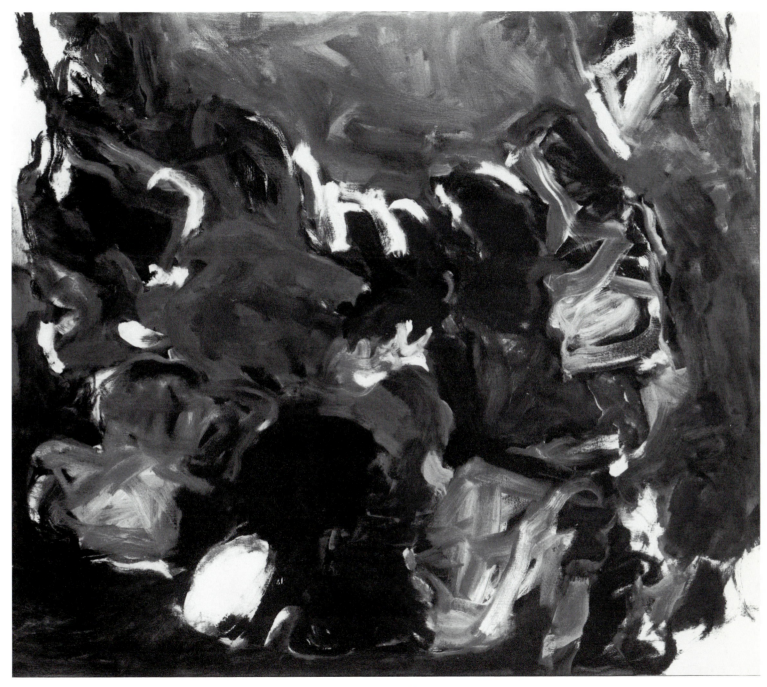

25 Kristján Davíðsson
Land and Water in the Spring, 1989
Verzlunarskóli Íslands (cat.45a)

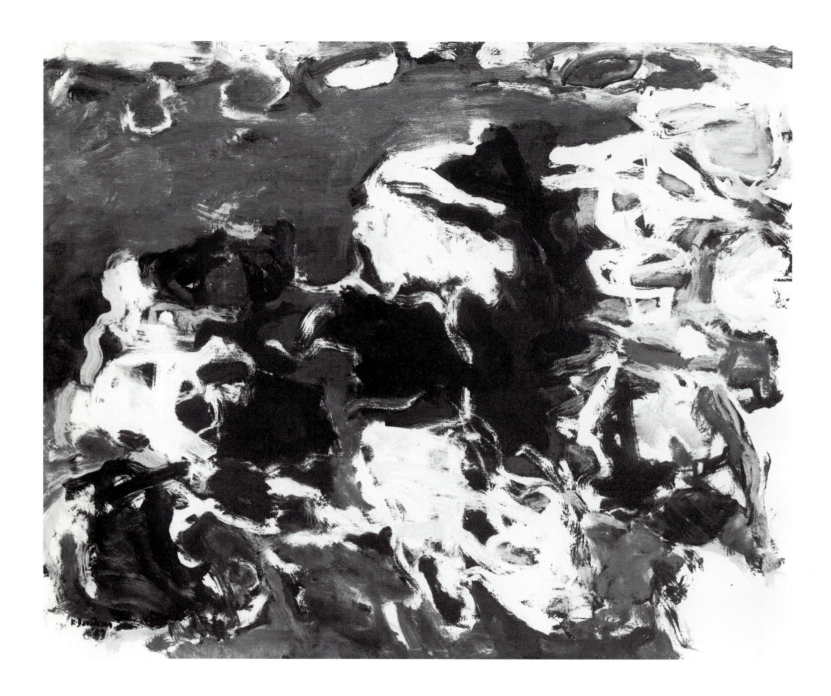

26 Kristján Davíðsson
Untitled, 1989
Oil
The Artist

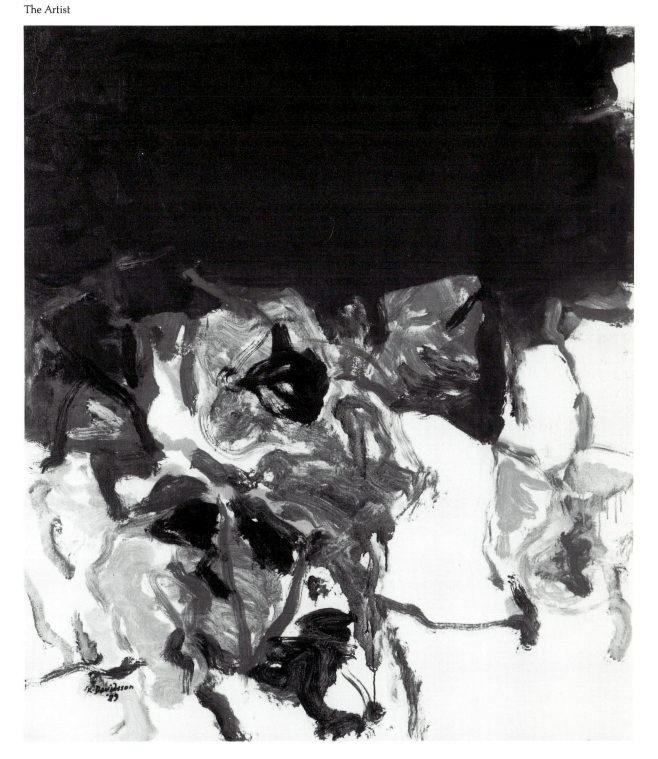

The new art not only had the support of the art reviews, but the artists themselves developed a common front in political matters. Thus they were united in opposing the Icelandic Parliament when it sought to curb the authority of the Federation of Icelandic Artists. This happened in connection with the debate that followed the selection of works that were to be sent to Rome in 1955, for an exhibition of Nordic art. The Federation won the day, and its victory was at the same time a victory of the new art over traditional art forms.

The Rome exhibition showed the new Icelandic art at its most vigorous. During the second half of the decade, there was a parting of the ways for many of the artists who had been involved in it. There was a shift to a more lyrical abstraction, which owed less to French art than before. Paris slowly gave way to the influence of New York and its new and energetic abstract expressionism. Painters such as Kristján Davíðsson and, later, Eiríkur Smith, began to extend the boundaries of their art and infuse it with a new and unexpected vitality.

In spite of having studied in the USA during the post-war years, Davíðsson was not particularly affected by American art. On the other hand he was the only notable painter of his generation to bypass geometric abstraction completely. Instead he found artistic sustenance in the work of some of the French *informel* painters. He was acquainted with one of the leaders of this movement, Michel Tapiés, and through him he got to know the work of artists such as Fautrier, Wols and Jean Dubuffet. Tapiés was also instrumental in introducing American artists like Pollock and de Kooning to France.

From the time of the first September Exhibitions, Davíðsson continued to develop his open and improvisational style of painting, until his brushwork seemed to reflect the workings of his mind, within the boundaries of large and impressive canvases. He was inspired by the unbridled forces of Icelandic nature, as can be seen in his fiery reds, icy blues, and dark greens.

Eiríkur Smith's art developed more quickly, but not as consistently as Davíðsson's. He could never see the point of keeping just to one mode of expression, and thus he became the first Icelandic painter to turn his back on geometric abstraction. So absolute was his conversion that he burned most of his early work, which was of a high quality. Subsequently he experimented with some of the different forms of informal art, for instance dripping and action painting, until he had perfected a style of broad and powerful brush-strokes, in the manner of American Abstract Expressionism. Smith painted some of his best work of this kind during the mid-1960s, using both a broad brush and a palette knife. Shortly afterwards he moved towards his present semi-figurative Expressionism.

One after another the younger artists abandoned geometric abstraction and began to explore other and open-ended styles of painting, though within the confines of lyrical abstraction. These changes took place during the late 1950s and early 1960s, by which time most of the artists involved had jettisoned the artistic criteria they had respected a decade earlier. Pétursson moved away from geometric abstraction in the second half of the 1950s, when he experimented with mosaic reliefs, made from fragments of Icelandic rock. By and by his painting took on a more lyrical look and eventually he began to include references to objective reality.

Skúlason was the last of the group to abandon geometry. Not until the 1960s did he deviate from the strict framework he had embraced for so long and begin to evolve more lyrical compositions. He had for some time favoured a type of composition based on interlocking circles. Now he broke up this self-contained structure and began to work with more rhythmical, cosmic imagery, which gradually turned into a formal language of what looked like interlocking arrow-heads.

Of all the painters involved in it, only Kvaran and Ágústsson seem to have drawn logical conclusions from geometric art. Kvaran's compositions lost some of their severity and became more lyrical, while he never gave up composing in two dimensions only. His colour planes are consistently monochromatic, so that any hint of depth or three dimensions is banished. The depth of the colours alone suggests their relative position on the canvas. Thus Kvaran has never deviated from one of the central precepts of geometric abstraction, which states that the painted canvas is no place for optical illusions.

Ágústsson also moved away from the severity of geometric art into a more lyrical period, with an occasional foray into figurative painting. All the while he continued with systematic investigations of geometric art forms, evolving an increasingly minimal style, mostly through the influence of French Op Art and American minimalism. Whether his profession of lecturer or his interest in architecture had something to do with it, Ágústsson developed an increasingly theoretical attitude to his own art, which parallels

the attempts of the Bauhaus artists to obliterate the boundaries between art and research.

Similar things were happening in Icelandic sculpture towards the end of the 1950s. Gerður Helgadóttir left geometry for a kind of lyrical abstraction, which in her case could be termed neo-Gothic abstraction. Her sculptures became more biomorphic and splayed in structure, to the point of looking like molten wax. She worked spontaneously until shortly before her death, when she reintroduced some of the features of her earlier work, curbing the filigree fantasies she had brought into some of her sculptures.

Guðmundur Benediktsson also began to employ softer, curvilinear forms, which gradually became more massive. Neither Sveinsson nor Ólafsson ever took to geometric composition. But they were able to put some of its features to good use, as is evident in their effective deployment of metal bars and wires, as well as mass-produced materials, which contributed to a greater transparency.

If one may assume that abstract art was fully introduced to Iceland through Svavar Guðnason's exhibition of 1945, it definitely consolidated its position at that of 1958. Subsequently abstract art ceased to infuriate the more conservative elements in Icelandic society. Abstract art continued to be practised, especially the more lyrical variety, but no one queried its importance. In the 1960s it dominated the Reykjavík galleries, and new recruits such as Hafsteinn Austmann (b.1934) and Steinthór Sigurðsson (b.1933) were added to the roster. Painters such as Sverrir Haraldsson and Bragi Ásgeirsson (b.1931) added a new dimension to it through their combination of a geometric framework and a lyrical application of colour.

In the early 1960s most Icelandic abstract artists still looked to Paris for new ideas, especially the lyrical or *informel* painters. Elsewhere, abstract painters also adhered to this open, introspective style. Lyrical abstraction was perhaps the last truly international movement in art. Painters and sculptors were at home wherever they went. In effect, this movement had turned into a style which each artist used in his own fashion.

Jóhannes Jóhannesson (b.1921) and Guðmunda Andrésdóttir (b.1922) were perhaps the diehards of Icelandic lyrical abstraction. In their work they attempted to redefine this kind of abstraction, and thus save it from becoming simply a repetitious style. They were of the 'September generation', with its emphasis on geometric composition.

Both of them began their careers by working in accordance with the criteria established by the École de Paris, and went on to develop personal and logical variations on those precepts, submitting to a similar discipline to that of the geometric painters. But they never availed themselves of the liberty to experiment or radically change the direction of their art, nor did they succumb to an artistic stasis or mindless repetition. They occupied a kind of middle ground, on which they met some of their colleagues who had moved away from geometric abstraction.

With the final triumph of abstract art, formalism had run its course. It was impossible to travel further along the road which Impressionism had opened just over a century earlier. All over the world artists began to look for ways to break out of the formalist impasse. During the 1950s, certain new developments in the USA seemed to suggest a way out for artists, for example the attempt of artists such as John Cage and Robert Rauschenberg to break through the boundaries of modernist art through their happenings. They had drawn some important conclusions from Jackson Pollock's action painting, not least the idea that his way of painting was at least as important as the end result.

Towards the end of the decade it was clear that these new ideas had spawned an international movement. The work of art was now less important than the creative act. The same questions that Marcel Duchamp had asked himself during the second decade of the century were now being asked by an increasing number of post-war artists, namely: What is art? What is creativity? Does a work necessarily have to take the form of a painting or a sculpture? Does art have to be permanent? Is art not more an idea than form, an action rather than a state?

Instead of creating palpable art objects, consisting of a certain shape and colour, artists began to present their public with succinct philosophical discourses. The French artist Yves Klein and the Italian Piero Manzoni drew attention to their antics, which were meant to parody the traditional role of the artist, or to widen the references of art. The artist himself and his peregrinations were now in the limelight, not his technical ability or good taste.

Two artists were largely instrumental in introducing this new art to Iceland. One of them was the Swiss-German multimedia artist Dieter Roth (b.1930), the other Jóhann Eyfells (b.1923). In spite of his relatively short stay in Reykjavík during the late 1950s and the early 1960s, Roth impressed all those who knew him. He

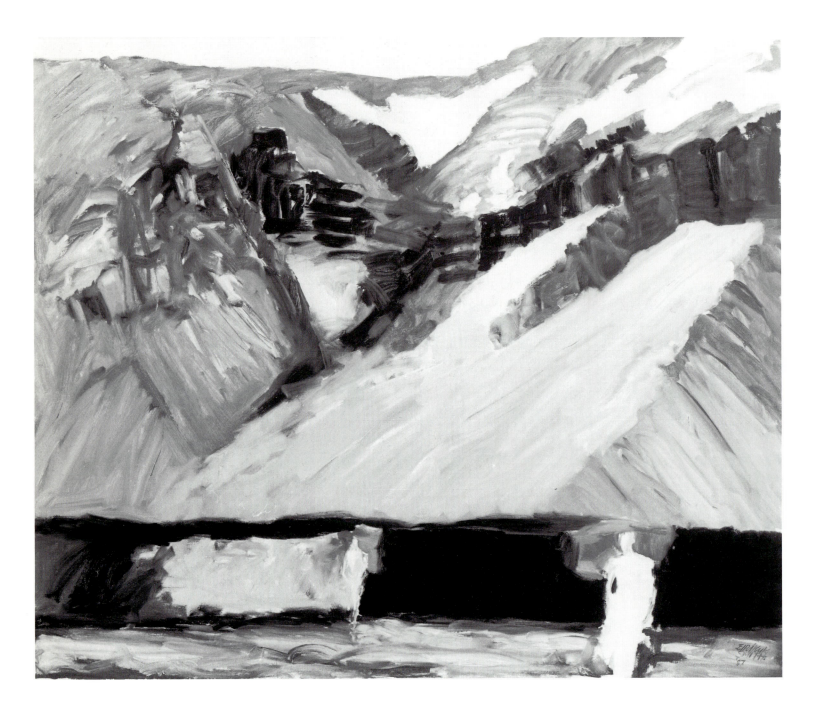

28 Eiríkur Smith
Two Figures and Grey Mountains, 1987
The Artist (cat.51)

29 Eiríkur Smith
Mountain in Winter, 1989
The Artist (cat.52)

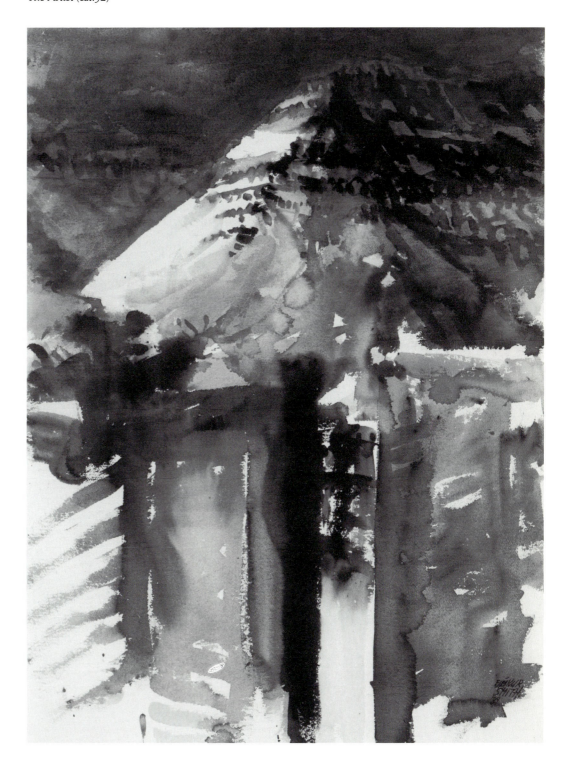

was a tireless inventor in a number of disciplines. The end result, the work itself, mattered less to him than the creative act. Whether he produced prints, drawings, books, audio-tapes, ceramic objects, design work, sculptures or paintings, he was able to switch from spontaneous gestures to systematic methods at a drop of a hat, in accordance with the demands of his materials or his fancy.

Roth produced a vast quantity of some very diverse work. No matter how humble the material, it was transformed into a work of art, though it did not always last for very long. Roth's manic kind of methodology startled and alienated a lot of people in Iceland, but at the same time it opened up a vast number of creative byroads, which were bound to have an impact beyond the confines of the Icelandic art scene. In time young artists in Iceland began to sense that 'art' was a concept without limits.

Jóhann Eyfells was also instrumental in directing attention from the work to the art process. He started out as an *informel* abstractionist, but around 1960 he became disillusioned with formalism and began to approach sculpture from a more scientific angle. Eyfells worked rather like the alchemists of old, by melting and mixing all sorts of metal alloys. The end result was a kind of compromise between the artist's physical energy and natural processes.

After moving to the USA, Eyfells became more expansive in his deployment of molten metals. He would employ huge excavating equipment, dig holes in the earth, and use them as 'natural moulds' which determined the eventual look of his sculptures. Thus the title 'art worker', which many land-artists of the 1960s proudly assumed, is also particularly appropriate in Eyfells' case.

Magnús Pálsson (b.1929) followed hard on the heels of Roth and Eyfells. At the beginning of the 1960s he worked closely with Roth on a number of unusual art projects. Later he became a most effective proselytiser for the cause of 'new art' in Iceland, a term which encompassed a wide variety of artistic experimentation. Pálsson came to artistic maturity under Roth's aegis, but became more and more inclined towards a pure conceptualism. He went on to making imaginative sculptural objects based on transient or abstract natural phenomena, but tinged with an irony all his own.

It would take too long to list all of Pálsson's manifold experiments and conceptual inventions. But equally relevant is the fact that in the 1970s he became a teacher and an uncrowned leader of a group of young conceptual artists, who founded the Living Art Museum. The LAM is an institution devoted to the collecting and exhibiting of 'new art', and is still in existence.

Sculptor Jón Gunnar Árnason (1931‑1989) also fell under Dieter Roth's spell in the early 1960s. Árnason was a trained mechanic, and had worked as such before he was converted to sculpture. His friendship with Roth led to an interest in kinetic art, which was very influential in Europe at the time. Because of his mechanical skills and knowledge of electrical engineering, Árnason soon became one of the country's most exciting sculptors. In a short time he radically changed the attitude of his public to the oldest of the visual arts.

Árnason's ingenuity and knowledge of metals, as well as his fertile imagination, impressed a lot of people, including those who had no time for 'new art'. As one of the original members of the SÚM group, and a teacher of sculpture, he was able to interest a whole generation of young artists in the unlimited possibilities of 'new art'. Along with Magnús Pálsson he became a leading figure for those young artists who wanted to renovate Icelandic art through new and unconventional methods.

The spread of the 'new art' movement resulted in a sharper distinction between sculpture and painting. When formalism went out of fashion, painting inevitably suffered. Its critics charged it with being outmoded and unable to renew itself. Painting became the chief *bête noire* of the 'new artists'. Photographic techniques and video art were supposed to supplant brushes and the old palette and thus to become the art of the future.

Nevertheless, people kept on painting, both in Iceland and abroad. Here the arguments of the 'new artists' largely fell on deaf ears, Icelanders being unfit for seeing art in a conceptual or philosophical context. At Guðmundur Guðmundsson's (known as Erró) 1965 exhibition in Reykjavík, the Icelandic public saw the kind of painting which had risen out of the ashes of formalism. Basically Erró was experimenting with a kind of Pop Art which he had assembled from many sources, not least the late-Surrealist paintings of the Chilean Robert Matta and the religious fantasies of Hieronymus Bosch.

Erró had no direct effect upon Icelandic painting. The realist and photo-realist aspect of his work impressed those who had never ceased to believe that art was largely a question of virtuosity. But no other Icelandic artist took up Erró's proto-Surrealist style, nor his photographic Pop Art which he later expanded by painting from a private collection of visual mementoes, using an episcope.

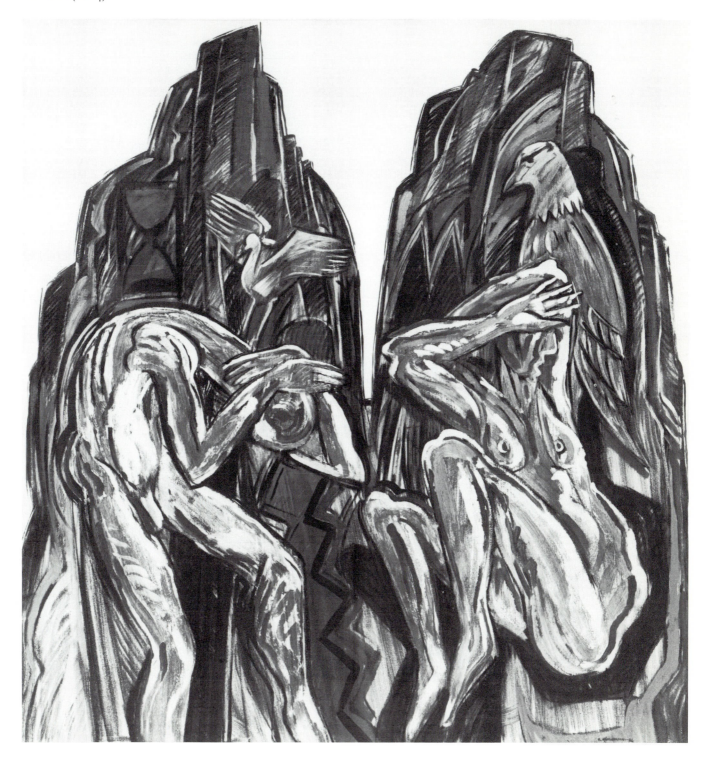

31 Hringur Jóhannesson
View into a Barn, 1988
The Artist (cat.53)

His use of the episcope excited those artists who had been waiting for the come-back of realist art. Others were also taken with his critical attitude to social and political ills, for instance his trenchant ridicule of modern excesses.

About the same time Icelandic artists again came into direct contact with new movements in international art. They got wind of some of these new ideas through foreign art journals, or through their studies in continental Europe. A few Icelanders even got to know some of the key figures in these movements. At the first súm show in 1965, Pop Art was mixed with other experimental art. But it was not until two years later that Einar Hákonarson (b.1945) and Hringur Jóhannesson (b.1932) were producing work that was more in line with mainstream Pop Art.

Hákonarson's paintings lay mid-way between abstraction and figuration and were often overlaid with three-dimensional materials which gave them the appearance of reliefs. The artist also tended to refer to mass-produced machinery, which was used to comment on the human condition in modern society. This was partly a response to British Pop Art, which seemed to appeal much more to Icelandic artists than the American variety. In time, Hákonarson's work centred more and more on the figure and he began to look to French modernists like Matisse and Jean Hélion. Hákonarson was an early practitioner of printmaking in Iceland. This medium has acquired great strength, with some individuals – like Edda Jónsdóttir and Ragnheiður Jónsdóttir – achieving international recognition. Hringur Jóhannesson was less dependent on Pop Art than Hákonarson. Actually, his art had more in common with New Realism and kept up a running commentary on life in the city *versus* life in the country. Since then Jóhannesson's visual expression has been strengthened through his paring down of his composition, changing a complex style into a plain one. At the same time he has been able to infuse his art with a measure of lyrical intimacy.

Eiríkur Smith and Thorbjörg Höskuldsdóttir (b.1939) were both influenced by the realist wing of the Pop Art movement, without actually becoming Pop Artists. Both of them employed this realism to create a kind of surrealism, dream-like and nostalgic, through a mixture of elements from both past and present.

The súm group was increasingly affected by Pop Art, especially after the emergence of painters Vilhjálmur Bergsson (b.1937) and Tryggvi Ólafsson (b.1940). Bergsson is actually more of a Surrealist in the manner of Tanguy than a Pop Artist. His art is both abstract and objective. His biomorphic imagery derives from the vast world revealed by the microscope. Though it is painted with great precision, it defies classification. Bergsson uses classical technique to create three-dimensional imagery. The imagery itself seems to float in an indeterminate space, which could be either the macrocosm or the microcosm. Bergsson's work also has a philosophical dimension, posing as it does questions about the meaning of life.

Tryggvi Ólafsson was more thoroughly influenced by both the technical innovations and imagery of Pop Art. He developed a painting that was both two-dimensional and figurative, using the episcope for accuracy. His works exhibit a balanced combination of personal experiences and images of the outside world, in particular the world of international politics. After a while Ólafsson moved away from the automatic and slightly impersonal technique of Pop Art and adopted a more sensitive and lyrical attitude, though without breaking out of the figurative and two-dimensional style he had made his own.

During the 1970s Icelandic painting became increasingly object-orientated, most likely through the influence of Pop Art. Admittedly, this art had next to nothing in common with Pop Art of the industrialised societies of the Western world, since Icelandic society was at that time not as consumer-orientated as it is now – consumerism being one of the mainstays of Pop Art. Nevertheless, many Icelanders were affected by the technique and formal vocabulary of certain Pop Artists, not least in the field of printmaking, which had become a very popular art in the early 1970s.

Painters Gunnar Örn Gunnarsson (b.1946), Sigurður Örlygsson (b.1946) and Magnús Kjartansson (b.1949) all started out their careers in the early 1970s. All three also looked to the international art of the previous decade. Gunnar Örn was at first under the influence of some British painters, Bacon in particular. His early paintings were existential battlefields, showing variously deformed figures locked in conflict. Later his style changed and became much more spontaneous and expressionistic. He gave his imagination and his brush full rein, which resulted in monumental compositions of great passion.

Örlygsson and Kjartansson were more interested in what American art had to offer. They were essentially abstract painters who enriched their compositions with references to the world of objects, culled from advertising or photographs. Their paintings commented on the outside world and the changes that took place

32 Sigurður Örlygsson
Situation Vacant, 1988
Listasafn Reykjavíkur, Kjarvalsstaðir (cat.69)

in Icelandic society during the 1970s. Later both these painters became more interested in the inner world, the world of the imagination.

Many painters who had started out as abstract artists also began to look for objective imagery to give their work a kind of ballast. On of these was Sverrir Haraldsson, who turned to surrealist landscape painting in the early 1960s. Another was Bragi Ásgeirsson who, after toying with relief painting, started to add all sorts of *objets trouvés* to his canvases, mostly debris he picked up on the seashore. Ásgeirsson's pictures occupy a position on the borderline between Surrealism and a decorative kind of Pop Art.

Mention must also be made of the sculpture of Hallsteinn Sigurðsson (b.1945) and Helgi Gíslason (b.1947), who in their different ways attempted to give their work a greater formal coherence in the 1970s and early 1980s. Sigurðsson experimented with mobiles, while Gíslason sought inspiration in figurative sculpture. Thus their work became a direct continuation of the formalist sculpture of the 1950s.

Pop Art had little impact on Icelandic sculpture. Magnús Tómasson (b.1943), one of the more colourful of the súm group members, probably came closest to Pop Art in his three-dimensional pieces, which also have a Surrealist as well as an ironic content. Through advanced technique and a plain formal structure Tómasson managed to imbue everyday objects with a symbolic and frequently critical content which everyone could understand. He enlarged ordinary phenomena like the common housefly and tin cans to huge dimensions, making a point about the psychology of the masses.

As one of the most active members of the súm group, occupying a position mid-way between Surrealism and Pop Art, Tómasson became a kind of mediator between two contrasting attitudes which divided 1970s art in Iceland. He took up a position somewhere in between the new realists and the conceptual artists, who had become the arbitrators of 'new art' in Iceland.

The opening of the súm gallery in 1969 and the beginning of the annual sculpture exhibitions on Skólavörðuholt, in the centre of Reykjavík (organised by Ragnar Kjartansson (1923 - 1989) and Jón Gunnar Árnason), represent important landmarks in modern Icelandic art, comparable to the emergence of abstract art after the Second World War. These events helped to break the ice for Ice-landic conceptual art, and led to an increased co-operation between Icelandic artists and artists from abroad.

The most important result of súm activity was doubtless the close cultural relationship between Iceland and Holland. Three founder-members of the súm movement and the Skólavörðuholt exhibitions – Hreinn Friðfinnsson (b.1943) and the brothers Krist-ján (b.1941) and Sigurður (b.1942) Guðmundsson – settled in Amsterdam, where they made careers for themselves. Kristján Guðmundsson moved back to Iceland in 1979.

The first two evolved a highly personal conceptual style in Holland, out of lyrical, even romantic premises. Their works, which often consisted of photographs, were closely related to the lyrics of the more introspective Icelandic poets. Friðfinnsson's and Sigurður Guðmundsson's most impressive pieces are imbued with a profound understanding of everyday thought processes, which they turned into objects. Their refined and sensitive art had a profound influence on the development of new art in Iceland in the 1970s. The rough-edged and spontaneous expression which characterised the Skólavörðuholt sculpture exhibitions, was succeeded by more affective and delicate modes of expression.

There were some young artists such as Níels Hafstein (b.1947), Ólafur Lárusson (b.1951) and Rúrí (b.1951), who continued practising a very physical form of expression such as performances, land-art and minimal sculpture. But conceptual art seemed to be moving inexorably towards the immaterial. By the time Gallery Suðurgata 7 was founded in 1977, followed closely by the Living Art Museum, the making of artists' books had become a very popular conceptual activity. Art could hardly become more immaterial than that.

Kristján Guðmundsson's art developed differently from that of the others. He was preoccupied with the concepts of time and space, which he explored in a number of ways, for example in book art and drawings. This kind of work established him as the most uncompromising and intelligent of the Icelandic conceptual artists. Unlike so many other conceptual artists in Iceland, Guðmundsson was not averse to tackling philosophical problems, as in his 'measurements' of time. Thus his art developed a range which extended far beyond the world-view which his Icelandic colleagues accepted.

In the late 1970s it became evident that Friðfinnsson and the brothers Guðmundsson had strong inclinations towards three-dimensional expression. Soon they devoted themselves entirely to

33 Magnús Tómasson
The History of Aviation, 1977
The Artist (cat.60)

34 Magnús Tómasson
The History of Aviation, 1977
The Artist (cat.61)

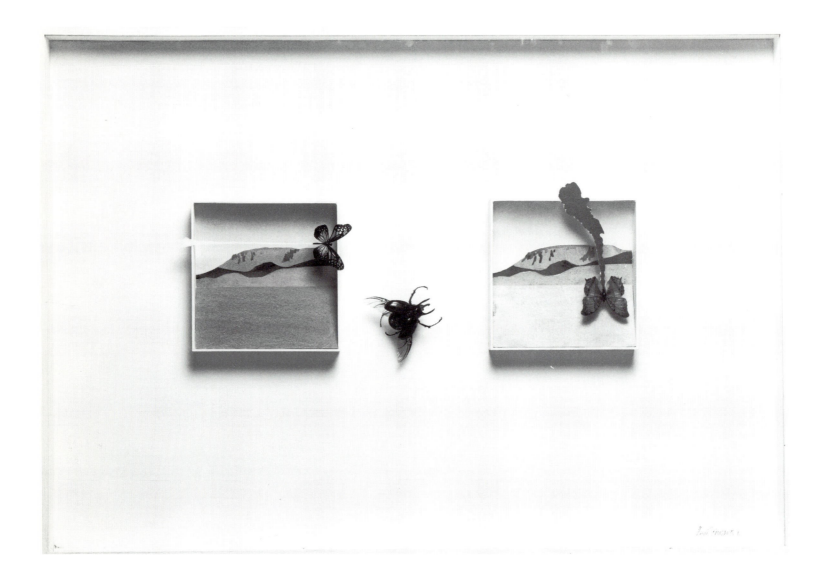

35 Magnús Tómasson
The History of Aviation, 1975 - 81
The Artist (cat.62)

sculpture and established themselves as masters of the art. Their achievements in the field of three-dimensional expression will undoubtedly change the course of Icelandic sculpture. With their work the reputation of Icelandic art has been carried to other countries, encouraging younger Icelandic artists to seek recognition abroad.

Around 1980 Icelandic conceptual art began to be channelled into painting. The influence of Dutch art gave way to German and Italian ideas. Soon afterwards it was as if conceptual art had never existed, for most of the conceptual artists had turned to painting. No one style of painting predominated, but rather the Icelandic art scene seemed to absorb different painterly elements which had made their mark on European and American painting a few decades before. Some aspects of Post-Modernist theory entered Icelandic art. It manifested itself in a more critical attitude to avant-garde art in general, which had evolved from Post-Impressionism and permeated every aspect of twentieth-century art.

The large-scale exhibition *The Breath of the Gold Coast*, which was held early in 1983, announced the triumph of new attitudes in art, which were alternatively termed 'new painting' or the 'new wave'. These basically Post-Modernist attitudes are still too recent for one to be able to list all of the artists who represented them. But it can be stated with some certainty that Gallery Suðurgata 7 and the Living Art Museum played a large part in the development of these attitudes. Most of the artists in question were members of or participants in one or other of these galleries, even both of them. Along with this recent emphasis on painting, there was renewed interest in a new kind of sculpture, marked by a Post-Modern sensibility. Young sculptors have emerged who approach their art in a very fresh and original way.

Even if landscape has not been the main concern of the new painting in the 1980s, at least one of the most promising young painters in Iceland, Georg Guðni Hauksson (*b.*1961), has made it his central theme. By rendering its structures in a minimalistic way, *ie* by reducing the mountain to a mere silhouette against the sky, Hauksson has added a new dimension to this popular subject.

But besides painting and sculpture, Icelandic landscape has played a major role in almost all fields of visual arts. Following the example of Ásgerður Búadóttir (*b.*1920), who is by far the greatest weaver of textiles in the history of modern Icelandic art, Ása Ólafsdóttir (*b.*1945) reserves an important place for landscape in her works. Even when she deals with other subjects, landscape is never far off. And so it is with most Icelandic artists and their art: leaving out landscape is far more difficult than accepting it.

HALLDÓR BJÖRN RUNÓLFSSON (*b.*1950) is an Art Historian and Lecturer, specialising in twentieth-century Icelandic art, and in European art of this century. His art criticism has been wide-ranging and penetrating, but perhaps his most important recent text was the broad and detailed survey of Icelandic art produced for The National Gallery of Iceland in 1987-88, when it moved into modern, purpose-built premises in Reykjavík. In 1989 Halldór Runólfsson took up the major post of Director of Exhibitions at the Nordic Arts Centre at Sveaborg, near Helsinki.

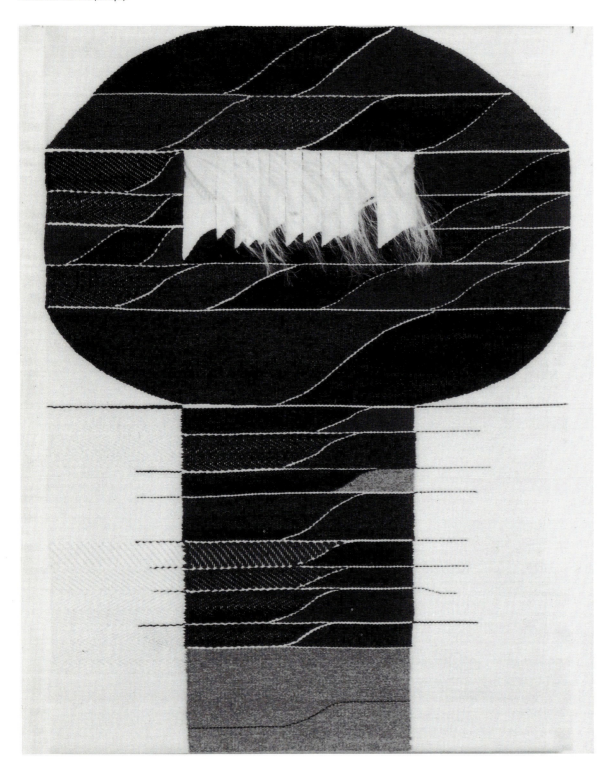

John Russell Taylor

Symbolism: The Constant Strain in Icelandic Art

Symbolism in art is easier felt than seen, easier detected than defined. Which is no doubt all as it should be, since the true symbol lurks on the borderlines of perception: now you see it, now you don't, and as in trying to remember a smell, the closer you home in on it, the more inexorably it melts away and eludes you. If we think of Symbolism as an organised movement with a body of theory informing it, naturally we think of France in the 1880s, and sometimes it seems that the Symbolist tinge was so pervasive then, in the backwash of Impressionist 'objectivity', that maybe we are reacting simply to a period flavour, we are recognising the date of an art-work rather than its aesthetic and philosophical allegiances. But there is surely more to it than that. In terms of French art, it is a pendulum swing from overriding concern for the outward appearance of things to the inner, emotional significance attributed to them. It is not so much painting a tree and the play of light in its branches, as painting how the painter feels about it, what deeper resonances he gets from it and wishes to transmit, through his painting, to the spectator.

In French art, which tends to be crisp and Cartesian, in tune with conventional notions of the national character, this hazy mysticism was a passing phase, though of an importance and lasting influence which are only just coming to be recognised. But elsewhere in the world there have been nations much more naturally attuned to seeing a world in a grain of sand: Wordsworth was not the only Englishman who could say:

> There was a time when meadow, grove, and stream,
> The earth, and every common sight,
> To me did seem
> Apparelled in celestial light,
> The glory and the freshness of a dream.

And if there has been one constant in the art of Britain through the years, it has been this sense that something lies beyond the scene, that physical realities are translucent and that artists are especially skilled at picking up these rays from another world and enabling more prosaic persons to feel the warmth of their glow or shiver vicariously in their mortuary chill.

It may not be coincidental that the art of another, not so far distant island seems irradiated with the same transcendental spirit. Much has been written about the uniqueness of Icelandic art, but beyond that most is concerned with saying where it does not reside. It is not, apparently, in the landscape which pervades much Icelandic painting, extraordinary though that is. It is not in the folkloric elements of local culture, as fitfully mirrored in local art. But then, what is it? There is no arguing with the basic subject-matter of Icelandic art, its nearness or removal from the facts of life and landscape. But if we sense a special unity and coherence in what we see, to explain it we have to look deeper than the artist's choice or eschewal of subject, into what he or she actually feels about the nature of life and the way art should record and respond to it.

Whichever way one looks, in Iceland landscape always seems to be the bottom line. During the eighteenth century, when European consciousness of Iceland began to be fully renewed, it was the extraordinary landscape above all which fired the imagination of outsiders: Iceland's geysers, its volcanoes, its amazing rock formations, its unpredictable combinations of bleakness and lushness did more to impress intrepid travellers than even its romantically isolated history and its origins in the heroic past of the Sagas. And on-the-spot travellers contrived, through even the dullest and most scientific prose and then through graphic depictions which, even if they began as topographic record, ended as Sublime and apocalyptic visions, to print a remote and magical image on the inner eye of the armchair traveller too, and thence on the consciousness of the general public.

Of course, it is quite possible that what seems vividly exotic to the tourist will remain boringly commonplace to the resident. But in a community which has been as cut off for as long as Iceland was, and which depended in an extraordinarily intimate manner on the vagaries of weather and even of the land itself for bare sustenance, Nature must be apprehended as something with a mind and personality of its own. Despite Christianity, an element of nature worship, or at least superstitious observation of natural

signs and portents, must have been a deeply entrenched part of the Icelandic world-view even before eighteenth-century illuminism made pantheism respectable again. And constant reinforcement from outside of fear and wonder at the unbridled power of Nature in these parts certainly did nothing to weaken such attitudes.

Thus it is not surprising that even the very earliest Icelandic artists who were in any way professionals, such as the emigré Thorsteinn Hjaltalín (1771 - 1817), remained (unconsciously) aware of the mysterious and unknowable elements in landscape, even before such visiting artists as Charles Giraud and Heinrich Hasselhorst had made the Sublime aspects of Icelandic landscape explicit around mid-century. In this context it might seem inevitable that the founder of modern art in Iceland, Thórarinn B Thorláksson (1867 - 1924) would be a landscape painter and imbue his landscapes with a pantheistic feeling. Indeed he did do just that, but it was not so inevitable he would as one might suppose. A bookbinder by training and profession, son of a Lutheran minister, he had to fight against circumstances and local expectations in order to become a professional painter at all, and virtually all his artistic formation took place in Denmark, where he went first to complete his training in bookbinding and then, at the age of thirty, to devote himself completely to the study of art.

The works of his Danish period are symptomatic of his deep admiration for Danish contemporaries, notably Krøyer, and would be impossible to distinguish from the mass of native Danish painting. The work that he did in Iceland, both during a brief return in 1900 (when he had a one-man show which was the first private exhibition of an artist in Iceland), and after his definitive return in 1902, is a very different matter. Much of its distinctive character can be seen already in his famous 1900 painting of THINGVELLIR, where the complex realities are reduced to a monumental simplicity vibrating with inner life. The colour scheme is virtually confined to blues and browns, and the formal construction ensures that the evidence of humanity, in the shape of the church and houses in the middle distance, is minimal and deprived of all personal connotation. The only signs of life are two horses, their significance (especially that of the brown horse in the foreground, looking towards the spectator) kept to a Wordsworthian minimum which equates them with rocks and stones and trees.

The same attitude is carried to extremes in Thorláksson's 1905 SUNSET BY THE LAKE. The very title is evasively generalised, though it is not difficult to recognise that the lake in question is that hard by Reykjavík and the built-up skyline which dominates the picture that of Reykjavík itself. Thorláksson, however, is not interested in the accidents, but the essence. There are no lights anywhere in the buildings before us, no evidence of the presence of humanity beneath the apocalyptic sky, but merely the grand silhouette reduced virtually to abstraction. This is very much a *fin de siècle* painting, tempting to relate to the intense, Symbolist landscapes of the Swede Eugène Jansson or the Norwegian Edvard Munch, though it is not clear how far Thorláksson would have known the work of either. Much more likely, this quality in his work results from the tone of the times, which has a curious way of penetrating what seem to be almost insuperable geographical barriers, and from the very special atmosphere into which Thorláksson plunged on his return to live and work in Iceland.

Thorláksson had only a very slight chronological priority over the next generation of important figures in Icelandic art, the painters Ásgrímur Jónsson (1876 - 1958), Jón Stefánsson (1881 - 1962) and Jóhannes S Kjarval (1885 - 1972) and the sculptor Einar Jónsson (1874 - 1954). Though this priority was reduced by Thorláksson's late start, delayed until he was almost thirty, it has been exaggerated in the eyes of posterity by his relatively early death, which makes him into a much more remote figure. It must also be admitted that his technique, though he turns it to distinctive and therefore timeless ends, remains resolutely backward-looking up to the end of his life, whereas his immediate successors begin in the full flood of European avant-gardism. This was partly because they too tended to start their artistic careers fairly late, mostly not getting into the swing of things until the end of the First World War. But also because they often travelled extensively in Europe – much more than Thorláksson ever did – and were there at just the right time to be hit by the successive waves of Post-Impressionism, Fauvism and Cubism (in its milder, less rigorously analytical forms).

Which is not to say that any of them returned to Iceland as slavish imitators of contemporary European trends. It is rather a question of what artistic tools they acquired on their travels, and how they adapted and redesigned them for use in peculiarly Icelandic circumstances. The potential split between means and ends is most clearly seen in the work of Ásgrímur Jónsson. Though he was, during his long career, a very various artist, there is always a fundamental division between his 'mainstream' landscape work

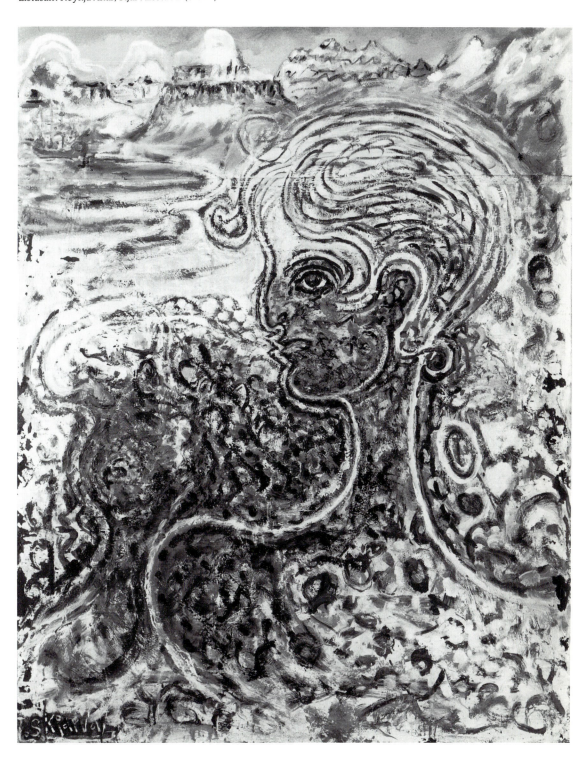

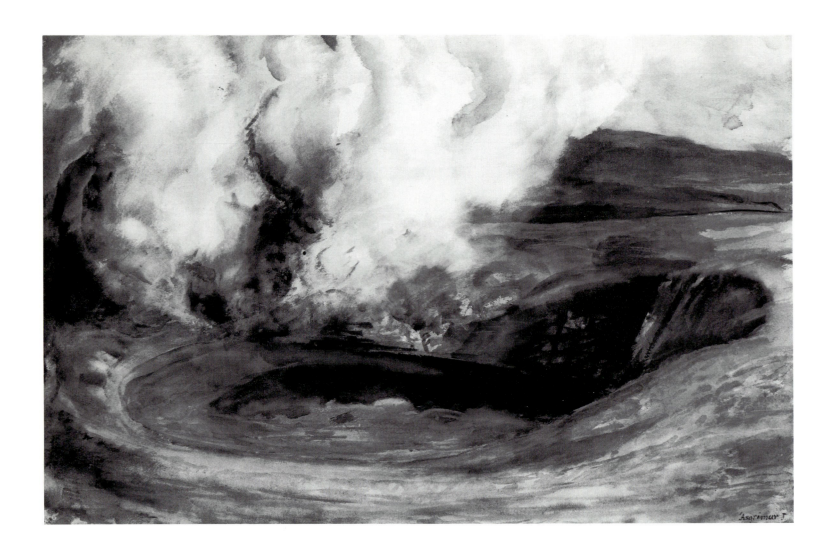

38 Ásgrímur Jónsson
Hot Spring in Krýsuvík, 1948
Listasafn Íslands (cat.5)

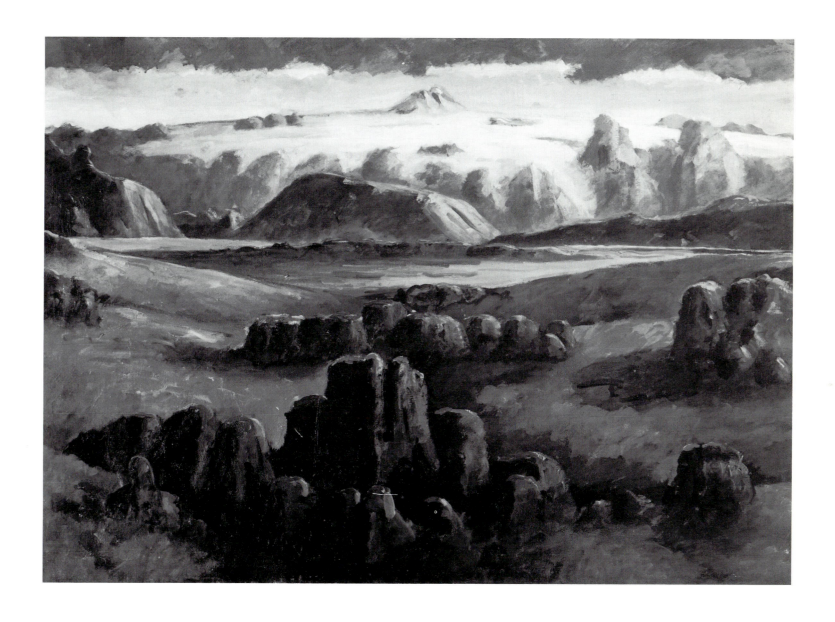

39 Jón Stefánsson
Tindafjallajökull, 1936
Listasafn Íslands (cat.11)

and his very local illustrative work, which is much concerned with Nordic folklore and the mythical figures through which it could best, at a deeper level, embody his own personal dreams and neuroses. But since he was, for all his diversity, one man painting out of one sensibility, the split is more apparent than real. And the link between the two halves seems to be, once again, what we must call for want of a better term Symbolism.

Ásgrímur Jónsson added to the technical resources available to Thorláksson the colours of Van Gogh and Matisse, and the analytical awareness of volume from late Cézanne. But just as his trolls and elves in the illustrative part of his work are fundamentally portraits of himself, and the devilish pursuit of innocent maidens in which they regularly engage are a bodying-forth of his own complex and frustration-prone emotional life, so his landscapes end up by telling us more of what he felt about them than the objective realities of their locations. His bolder, more fluid technique enables him to go a lot farther in this direction than Thorláksson, but the underlying purpose of his golden-pink, sunlight-after-storm EVENING IN REYKJAVÍK (1916) is not so different from the older painter's, though of course it embodies a different sensibility. In his later work the two sides of painterly landscape and imaginative fantasy come even closer, to produce sometimes a strange kind of local Expressionism, and though the arbitrary, decorative colours of the Fauves may represent a temptation for him, their emotional lightweightness is a trap into which he seldom if ever falls.

Jón Stefánsson is something like the exception that proves the rule in Icelandic art. It has often been noted that among these deep and sometimes tortured Romantics he is the cool and elegant Classicist. Not for nothing did he begin his career as an engineer, pursuing his engineering studies in Copenhagen and deciding to devote himself to art only in 1903. He was always a man of ideas and few words, so that at the beginning his work sometimes had a tumultuous pent-up emotion behind it. But he rapidly realised that all he needed was to master the technique of painting in order to express himself properly and completely in paint. The crucial moment in his development was late in 1908, when on the advice of a Norwegian pupil of Matisse he went to Paris. Here everything became clear. From Matisse's school he wrote in a letter home:

I feel completely absorbed when I see a well-ordered picture which may be taken in one view, where a dramatic struggle has at the same time been created and smoothed out, followed by omnipotent calm – all this conditioned alone by that which is passing within the picture. It is like having eternity in one's hands … The great Frenchmen have, like the old masters, this remarkable depth, richness and calm; like the ocean, the surface of which may become rippled, while the depths are always the same.

This lesson of luxe, calme and (within reason) volupté was what Stefánsson brought home with him, and so persuasive was it that a whole generation of Icelandic painters was heavily influenced by his teaching. And it is true that he personally practises what he preaches: a picture of horses prancing and curveting in the wild might in other hands carry a strong symbolic charge, but in Stefánsson it seems to be only what it is, an image of decorative calm, all passion spent. Except, naturally, the passion of applying paint in a meaningful way. A colourist of extraordinary luminosity (something that he found in Iceland and learned in France how to record), Stefánsson remains a major artist, but of a kind which seems curiously marginal to the main thrust of Icelandic art since 1900.

Jóhannes S Kjarval and Einar Jónsson are much more important and, it seems to me, more distinctively Icelandic phenomena. And both are undeniably fully-fledged Symbolists. Of the two Einar Jónsson is undoubtedly the more extraordinary and unaccountable, though not necessarily the more important artist. What is especially strange about him is that he was a large-scale monumental sculptor, the sort of artist who would be completely understandable in a country like France, where there is a generous and long-established tradition in major public commissions of sculpture for public sites. In other circumstances he might have been, say, a Vigeland, given full scope to make a whole sculpture park of his own. But however did he grow and flourish in the seemingly alien, and certainly unprepared, soil of Iceland?

And indeed, the background history is quite mystifying. According to the story, young Einar, born on a remote farm in south Iceland, decided that he wanted to be an artist, and specifically a sculptor, long before he had in fact seen any art. A prey to dreams and visions, he yet obviously had the inner toughness and determination to thrust aside all obstacles, going first to Reykjavík, then to Copenhagen, and managed to bludgeon his way into the workshop of the local sculptor Stephan Sinding, whence he went on to the Copenhagen Academy of Art. By 1901 he even won some success and notice with his large statue THE OUTLAW, which was shown by the Charlottenborg Exhibition Committee

and enthusiastically received. On the strength of this the Icelandic *Althing* voted him a grant to study in Rome, and two years later the Copenhagen Academy voted him its Grand Grant, which enabled him to travel to Budapest and elsewhere. From 1905 he settled back in Copenhagen, but never lost intimate contact with his homeland, and in 1909 he offered the nation all his works as a gift, on condition that it house them properly. The offer was accepted.

By the time of his return to Iceland in 1914, Einar Jónsson was virtually accepted as the national sculptor. This, of course, did not necessarily mean that he was prosperous or well-paid, since opportunities for his kind of work were few and far between in Iceland at that time. Indeed, he was able to afford to marry his fiancée of sixteen years only through obtaining an important commission in Philadelphia to make a statue of Thorfinnur Karlsefni, the first European settler in North America, for a new sculpture park there. He spent two years in America working on the project, and then returned to Iceland loaded with honours. For the rest of his long life (he died in 1954 at the age of eighty) he lived in increasing isolation in his home-cum-museum, keeping himself to himself artistically and socially and denouncing modern trends in art with as much enthusiasm as he had the official art policy of his youth.

As this outline of his life suggests, he was artistically self-centred, following his own private vision and his own ideas of what art could be and should be. At the beginning he was ahead of fashion, because he had no way of knowing (apart from that mysterious something in the wind) what fashion was. Then fashion caught up with him: his position in the scheme of things might be compared internationally with that of rather older Alfred Gilbert (1854-1934) and Émile Antoine Bourdelle (1861-1929), of an age to be brushed by Art Nouveau and more markedly influenced, especially in the case of Bourdelle and Jónsson, by the sleek stylisations of Art Deco. What Jónsson most prominently had in common with them both was a lack of interest in realism for its own sake. Like both of them, he believed that it was necessary to know how to sculpt with meticulous realism, but that that was only the beginning: sculpture was meant for something grander and rarer than mere reproduction.

Sculpture in Einar Jónsson's terms had to carry a weight of significance beyond the immediate and actual: it had to convey ideas; it had to capture and make concrete the hopes and dreams and aspirations of Man. In other words, he had to observe Symbolist criteria of meaning and value. Though he began with a kind of detailed realism, as may be observed in his much-praised group THE CAPTIVES, he does not rest long at that point. Already in the next two years, with such expansive concepts as THE WATCHER and TIME, he had moved into his own special world, where proportion is made entirely subservient to subjective importance (as in Ancient Egyptian art, though otherwise there is no connection). Thus the Watcher (God? Fate? Mankind?) looks over and after a sleeping, maybe a dead, form, while attendant guardians hardly higher than his knee flank him and his seat is supported by others of intermediate size; Time is represented by three fused figures, the largest, winged, holding a globe above his head, while the medium-sized one, overshadowed and protected by the first, holds a similar, smaller globe out, and the smallest, female, looks backward from under the dominating figure's wings.

Though quite possibly Einar Jónsson had his own detailed programmes for these and other, similar works, the works themselves are left to inhabit a web of dubious and possibly contradictory significances. Like all truly Symbolist works, they function not by precise allegorical correspondences, but by clothing themselves in a cloud of reference and implication, calling upon the spectator to search his own soul, or reach, as Jung would say, into the dark world of the collective unconscious to root out some archetypal image he will understand without ever having to be told. In the work of later decades, such as THE KING OF ATLANTIS (1919-1922), the MONUMENT TO DOCTOR CHARCOT AND HIS SHIP (1936), JOB (1940) or the MONUMENT TO A LOST AIRLINER (1952), the allusions become even more esoteric, the imagery even more complex and ambiguous. What meaning, for instance, did the pyramid have for Jónsson? It occurs in the King of Atlantis's headdress, it crops up again, doubled into a star, in JOB and it is frequently included in weird and wonderful paintings and drawings Jónsson did (or continued to tinker at) throughout his life.

Sometimes one suspects the presence of some clearly structured system of reference to which one just does not happen to have the key, such as the symbolism of Freemasonry. But it is doubtful if anything like that could completely explain Einar Jónsson's art, let alone explain it away. The question does arise, though: what, if anything, in it is necessarily Icelandic? Perhaps nothing if one is looking for some link with local folklore or more sophisticated culture. And yet, if Iceland's relative geographical isolation means anything or has any definable effect, that must all be somewhere

here. Einar Jónsson has obvious affinities in his graphic work with almost contemporary figures from other marginal or isolated cultures, such as the Hungarian Csontvary or the Lithuanian Ciurlionis, just as one finds the nearest affinity to Ásgrímur Jónsson's trolls and sprites in the similarly funny, similarly tormented drawings of the Finnish Hugo Simberg.

And it must be that in his sculpture, most of which (symbolically, perhaps) remained at the stage of a project modelled in plaster rather than in a fully realised bronze, a degree of external isolation which Einar Jónsson shared with his country accentuated the inner isolation which his combative yet unworldly character forced upon him. And all that went to produce a kind of art which is strangely out of time, anachronistic, but more than that, so fully inhabiting its own world that it takes determination and a complete lack of preconception to penetrate it. The artist seems to be living in his own private world, and yet it is a world that Icelanders instantly responded to, recognising his quality in the most practical way possible at a time when anyone else might have been content to wait and see. Even today, through all the vicissitudes of fashion which Einar Jónsson's sculpture has experienced before and since his death, the special feeling for a maker of national monuments who became himself a national monument remains surprisingly strong.

It is no doubt not entirely coincidental that Iceland's great Symbolist painter, Jóhannes S Kjarval, came from a background somewhat similar to Einar Jónsson's. He too was born on a remote farmstead, and there is a similar mystery about how and where he acquired the idea of being an artist. It is known that he was already drawing by the time he was fifteen, when he was working during the summers as a deck hand on fishing boats. His subjects were mainly nautical, and his talent already attracted attention when he moved to Reykjavík the following year, began formal schooling and took lessons for a while with Ásgrímur Jónsson, whose more fantastic works probably exercised some influence on him and his growing artistic involvement with the supernatural. Not lacking in confidence, he put on his first one-man show in Reykjavík in 1908, and even had some success with it. In 1911, avoiding the normal convention by which Icelanders went to study in Copenhagen, he travelled to London and tried (unsuccessfully) to get into the Royal Academy Schools.

It seems that the most important experience of his London visit was his encounter with the works of Turner, which showed him a way to combine landscape with intimations of immortality. Also around this time he met Einar Jónsson, whose works, particularly the drawings, showed him another way to use the literal as a metaphor for personal, and specifically Icelandic, experience. In 1913 Kjarval (he adopted the name himself because of its romantic and legendary overtones) bowed to the inevitable and moved to Copenhagen, where he studied for the next four years. But even there he seems to have sought out the company mainly of other Icelanders, and to have held himself aloof from the implications of current Danish art teaching. He apparently derived more spiritual sustenance from seeing the work of Matisse and the Nabis in Copenhagen galleries, which would have confirmed his own natural tendency towards certain kinds of pictorial formalisation and seeing through the outer shell of things to some veiled inner meaning.

He also had at that time a strong sense of what one might call national duty. He wrote in a letter: 'I realized that Iceland was without a past in painting, and felt the call of obligation ...', and again 'I feel endowed with the strength of a whole nation and believe all my beautiful dreams, and work towards their fulfilment.' Consonant with this, though he continued sporadically to travel – Norway and Sweden in 1919, Rome in 1920, Paris in 1928 – he lived mostly in Iceland and concentrated on local themes and on communicating with a local audience. (This is in contrast to various other major figures in Icelandic art who lived outside Iceland – most often in Denmark – for many years at a time.) And there is no doubting the almost mystical involvement he felt with the Icelandic scene and the fabric of Icelandic history and legend. Probably his childhood, like that of Einar Jónsson, fostered a sense of the half-hidden forces in nature, bolstered with a whole complex of legend, still current at the turn of the century, concerning the tutelary deities of the mountains and sea, capriciously friendly or hostile to human beings and in any case always requiring to be kept in mind whatever the staid, Christianised superficies of life might suggest to the contrary.

In many of Kjarval's works the 'hidden people' actually materialise out of rocks or waves or bare, mossy uplands. In others, such as the very late A GIRL NAMED SIGRÚN (1960) the reverse or complementary process seems to be in operation: the concrete human figure is dissolving into the landscape with which it is indissolubly linked, as though about to meet halfway the spirits of the hill and sky who loom over the skyline in the middle

distance. This identity between land and people is constantly stressed in Kjarval's painting, carrying the Icelandic synthesis a stage or two further than in Thorláksson, where direct evidence of humanity is often suppressed in favour of the elemental aspects of the landscape, or in Ásgrímur Jónsson, where the places and the people (natural or supernatural) tend to be kept apart and inhabit separate sectors of his art.

From the time of Kjarval's return to Iceland in 1922 a recurrent, almost an obsessive, theme in his work is the distinctive landscape. In 1929 he began to paint over and over different aspects of Thingvellir, which of course for any Icelander must be loaded, in addition to its physical grandeur, with a great weight of historical and symbolic association as the site of the original Icelandic national assembly, the *Althing*, in continuous use since the days of the Sagas. Even when these pictures appear to be close to literal renderings of light and shade and rock and vegetable formations on the spot, they are charged with a terrible intensity which brings them close in feeling to Munch or such German Expressionists as Nolde. And it is a unique quality of Kjarval that, even though he was very conscious of some kind of mission to create and uphold an unmistakably national Icelandic art, he remained throughout his life very open to influence from anything he saw and anyone with whom he came into contact. Moreover, his brand of artistic nationalism, though obviously serious, was never solemn: he was noted for his personal eccentricity and a playfully irreverent sense of fantasy, which sometimes got him into mild trouble with the staider elements of Icelandic society.

The key to how this outgoing, eclectic artist could at the same time be the most intensely Icelandic and the most deeply mystical no doubt resides in the quality everyone notes from earliest days: his quiet, unpushy but unshakable self-confidence. He seems always to have known what his art had to be about and where it was going, and to have been able to maintain this vision of his separate identity and his mission without resorting to the hermit-like tactics of Einar Jónsson. Equally, he had so little doubt about the strength of his art's central core that he could welcome influences from here, there, and everywhere, sure that whatever went into the formidable machine of his talent, it would all come out unmistakably stamped with his own style and personality.

Inevitably he was prey from time to time to doubts about his prospects of worldly success as an artist, and in the mid-1920s he suffered a period of particular disturbance and disorientation when his wife divorced him and his financial resources were at a very low ebb. However, even then he did not apparently doubt his artistic calling, and indeed used his art as a solace and a means of escape – or rather, perhaps, as a stage upon which the psychodrama of his middle years could be played out in terms of symbolic fantasy. First he went back to the land of Iceland, making camping journeys to the central mountains with his daughter and rigorously observing the farmers and fishermen of the east. Then he went in the opposite direction, by journeying to Paris for a year and throwing himself into the study of Cubism in its later manifestations. The result of this latter venture was a group of abstract or semi-abstract works he painted either in Paris or immediately on his return. Even here, at the farthest reach from his normal stylistic repertoire, the fingerprint is unmistakable, and when he returned to the Icelandic landscape and Icelandic legend in the early 1930s all the former elements of his work recurred, strengthened and defined by his adventures into the abstract.

It is surely on the art of this period that Kjarval's claim to be not only the most Icelandic but the greatest Icelandic painter stands or falls. Whether in the straightforward but somehow transfigured landscapes like SUMMER NIGHT AT THINGVELLIR (1931) or the strangely haunted glimpses into his own private world of imagery like ON THE SHORE OF DREAMS (c.1935) or DREAMS OF FLIGHT, which he worked on intermittently from 1935 to 1954, the Symbolist aura is unmistakable: even the most superficially realistic depiction of place is not merely what it seems, and in the fantasy pictures the borderlines between the seen and the felt are magisterially obliterated. In his later work this feeling for the interpenetration of the natural and the supernatural, present and past, what we assume to be real and what we suppose to be imagined, becomes inescapable, and is the basis of all his most memorable paintings, such as OLD MEMORIES of 1943 and IN THE SUN'S PATH of 1955. In feeling (though never in technique) these bring him very close to the Anglo-Welsh David Jones, and make him, for all that at the time he seemed to occupy a very solitary and isolated position in world art, unexpectedly timeless and relevant to the concerns of our own day.

In the end, after many years of discussion, the *Althing* finally decided to carry through the project of building a studio/home for Kjarval near Reykjavík, explicitly accepting him as a major ornament to the national art scene. The recognition came almost too late: he was able to live and work there for barely seven years

40 Ásmundur Sveinsson
Head Ransom, 1948
Listasafn Reykjavíkur,
Ásmundarsafn (cat.29)

Ásmundur Sveinsson's sculpture
HEAD RANSOM was inspired by a
poem of the same name (Höfuð-
lausn), composed by the greatest
poet of the first centuries of settle-
ment in Iceland, Egill Skallagrímsson
(*c.*AD 900-990). Skallagrímsson was
also a Viking warrior who earned
himself fame in battles in England.
When his ship was wrecked in the
mouth of the Humber, he narrowly
escaped death at the hand of King
Eric Bloodaxe in York. Imprisoned,
overnight he composed a *drápa* –
twenty staves – which he sang next
day in the King's praise, so impres-
sing his captor that he was freed.

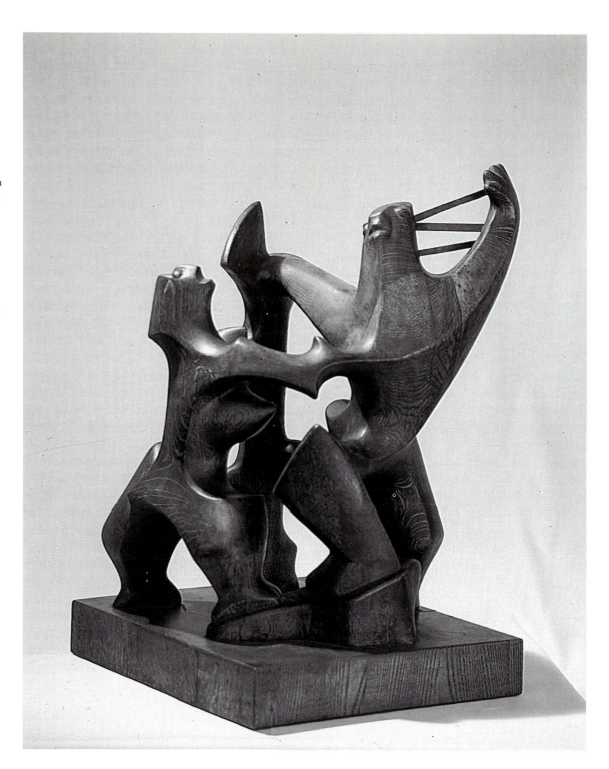

before his death, as against the nearly fifty Einar Jónsson spent in a similar situation. Still, it seems fitting that these should have been the two artists most notably singled out for that kind of national testimonial and support, since their shared acceptance of Iceland as symbol as well as reality, and their extreme individuality which remained nevertheless firmly rooted in the soil of Iceland, marked them out as uniquely fitted to become in their own way as much a symbol of Icelandic art as anything they themselves sculpted or painted.

In the careers of Einar Jónsson and Kjarval Icelandic art reached some kind of a peak, both in world quality and in the intensity of local vision. It is very difficult to make a neat picture of what happened immediately after in terms of artistic generations, because new waves and new attitudes followed one another with astonishing speed: hardly were the elders established when a group of others, only five or ten years younger, came up to challenge their supremacy. But whatever new attitudes might manifest themselves, and however strong the clear-cut, rational influence of Jón Stefánsson on his juniors might be, there seems to me always something wild and intense and secret, something not altogether reducible to reason, about the Icelandic artists who followed so rapidly on one another's heels.

No doubt the most naturally like-minded to Stefánsson in his quest for the still point at the centre of the storm, the elusive balance which keeps emotion under control and classically crystallised into art, were the sculptors Nína Sæmundsson (1892-1965) and Ásmundur Sveinsson (1893-1982). Both of them assumed in the 1920s a spare elegance and monumental repose in their work which linked them with, say, the work of Maillol in France. Curiously enough, while Sæmundsson continued to work in this line, Sveinsson, while actually in France, began to range more widely, dealing with traditional Icelandic subject-matter like SÆMUNDUR ON THE SEAL and following the Cubists in their pre-occupation with primitive sculpture in order to beat out his own individual way of doing it. Later still he went even further along the road to Expressionism, and after that went completely into a kind of free-form abstraction which we could almost categorise as Abstract Expressionism – the symbolic overtones of which do not need emphasising.

The painter of the next generation who most rapidly made a name for himself and established his own inviolate individuality was Finnur Jónsson (1892-1989). Finnur Jónsson has good claims to be regarded as Iceland's first thorough-going modernist. Though his early life follows very closely on the pattern established by Thorláksson and Kjarval – born on a remote farm, initial work as a seaman, apprenticeship in goldsmithing which takes him from Reykjavík to Copenhagen for specialised training, and discovery of a fine-art vocation in Europe – the fact that he was significantly younger than the other artists we have been discussing, not reaching maturity until the eve of the First World War, means that he belongs to a very different world of experience. He began painting and exhibiting around 1921, when he still had very little formal instruction, and his career as a painter really begins towards the end of that year, when he went to Berlin and was first open to the exhibitions of the modernist gallery Der Sturm, almost immediately followed, in Dresden, by a meeting with and advice from Kokoschka. Other influential figures he knew personally at this period were Kurt Schwitters, who taught him in Dresden, Kandinsky, whom he met in Berlin, and Herwarth Walden, impresario of Der Sturm, who proceeded to show eight of his works in 1925.

Not surprisingly, in an artist formed in this hotbed of advanced thinking, Finnur Jónsson's earliest surviving works clearly belong to the Middle-European mainstream, first mildly Expressionist, then Dada-ish abstraction. Back in Iceland in 1925 he had a show in Reykjavík consisting of a mixture of abstract and representational work. It caused something of a scandal and only the representational work sold. In the following years he returned to working in a much more traditional style, painting Icelandic landscapes and scenes from fishing life, as well as occasionally continuing to work as a goldsmith, an area in which he had had some success both at home and abroad. The professional formation as a goldsmith is in fact quite significant, much like Stefánsson's first ambitions as an engineer: it leads Finnur Jónsson frequently in the direction of the kind of flattened decorative formalisation regular in fine metalwork, as well as creating a particular sympathy for gold and silver as regular components of a painter's palette.

During the 1930s elements of Cubistic abstraction crept back into Finnur Jónsson's work, and during the war years his conventionalisation became bolder, even when applied to 'safe' legendary subjects like RAVEN-FLOKI (1946). Curiously enough, as Finnur Jónsson advanced into his late sixties, a stage in life when many artists have ceased to quest, he moved again towards abstraction, though this time more suggestive in colour and theme of the

paintings Kandinsky and his associates were doing on the brink of abstraction in the 1900s. The figurative themes which can be detected are mostly concerned with the heavens and the movements of heavenly bodies. As Frank Ponzi has pointed out, it is curious, to say the least, that Der Sturm's original Expressionist manifesto stated categorically: 'Sun and Moon are our pictures. There is no more I and you, only eternity and our way to the stars'. Finnur Jónsson says that he was unaware of this proclamation, but it could hardly be more exact in its application to his own later work – or more indicative of the psychological junction between Symbolism and Expressionism, where the one becomes philosophically indistinguishable from the other.

If Finnur Jónsson was more closely plugged in than any other Icelandic artist to what was going on in the revolutionary centres of European art during the early 1920s, it must also be said that his own extremely individual variations and adaptations of what he had learnt with Schwitters and Kandinsky come from his long physical and psychological isolation in Iceland after 1925, during which period he evolved entirely according to his own lights, with as far as we know very little contact with the course modern art on the mainland of Europe was taking. Thus he was free to go from abstraction to minute representation and then gradually to fuse the one with the other into his unclassifiable later style, which enables him to discard the superficial and go straight to the eternal. And is this fusion specifically Icelandic? Empirically one would have to grant that it must be so, for where else could it have come from? But also the close coincidence of theme and tone between much of Finnur Jónsson's work and that of such elders as Kjarval, not to mention numerous juniors who might have been influenced by him, encourages us to think that we are confronted with a distinctly Icelandic art, in which the literal and the metaphoric coexist without difficulty in a new, indigenous form of Symbolism.

And this has continued to be a sort of guiding light for Icelandic art right up to the present. A painter like Gunnlaugur Scheving (1904-1972) may have studied in Paris with Lhote and imbibed a modified species of Cubist formalism from that impeccable source, but taken back to Iceland and developed in the very special conditions which obtained there, it gave rise to the unpretentious monumentalism of SEAMEN IN A BOAT (1947), where we seem to see something more closely akin to Flemish Expressionism, or the decorative simplifications of SUMMER NIGHT (1959). In this latter canvas, and many more, Scheving indicates another special charac-

teristic of Icelandic painting which is not without its symbolic resonance: the frequent intensity in the use of colour.

As with the long-lived school of Scottish Colourists, Icelandic colourists often maintain that there is nothing unrealistic about their colours, and it is just the ignorance of outsiders to suppose that the Icelandic scene is grim and uniformly dark-toned. There is of course a lot to that, but all the same, it is difficult not to conclude that the Icelanders' penchant for brilliant colour-schemes is also partially a compensation and partially a symbolic device for imbuing what they see in front of them with the feeling they experience while seeing it – the light that never was on land or sea, indeed. This dazzling chromaticism is carried over to much more 'modern' painters, such as the slightly younger Svavar Guðnason (1909-1988) and Jón Engilberts (1908-1972), who were early involved in the Danish part of the COBRA movement, or at least touched by its matter and manner to achieve their own kind of violent expressivity.

Even right up to date, through all the alarums and excursions of Kinetics and Op Art, Pop Art, Minimal and Conceptual, the tradition of brilliant colour in Icelandic art has remained intact, however various the ends it has been applied to. And the references to Icelandic landscape, however transformed and transfigured, as the inescapable basis of so much Icelandic art, still remain glimmering there through the complex web of free-form abstraction or the apparently casual collocation of found and made objects in a 1970s installation. The artists are shaped willy-nilly by the land, and in their turn shape the land according to their own special consciouness of it.

Perhaps it took the unguardedness of earlier generations to admit to an identification with the sometimes malign spirits of nature, as Ásgrímur Jónsson did, or to build art on the almost palpable presence of the 'hidden ones' bringing life and sentience to even the most apparently inorganic of natural phenomena, as Kjarval did. But even today – perhaps more than ever today – a kind of natural magic persists, inseparable from the rocks of Thingvellir, a sense of oneness with threatened, polluted nature which gives Icelandic art its own peculiar force and power. Icelandic artists are practised in seeing things as they are and as they might be, as common sense tells us they are and as deeper intuitions tell us they must be. Pictorial symbols, like a cloud of witnesses, gather round the most unassuming Icelandic work of art, hooking it in incontrovertibly with the whole Northern Romantic

tradition, of which it is an up-to-now little-noticed outrider, but by no means the least interesting or enlightened part. With a universal raising of consciousness in the matter of symbolic discourse in art, it is important to discover that the lost tradition is alive and well and still living happily in Iceland.

JOHN RUSSELL TAYLOR (*b.1935*) is the Art Critic of *The Times*. He was educated at Cambridge and the Courtauld Institute of Art, London, was Film Critic of *The Times* for ten years and a Professor in the Cinema Division of the University of Southern California, Los Angeles, for six years. His forty-odd books include *The Art Nouveau Book in Britain, The Art Dealers, Impressionism* and *Edward Wolfe,* as well as *Strangers in Paradise: The Hollywood Emigrés 1933-1950* and *Hitch,* the authorised biography of Alfred Hitchcock.

Michael Tucker

Not the Land, but an Idea of a Land

Landscape, suggests the contemporary Icelandic poet Jóhann Hjálmarsson

> is not the land,
> but an idea of a land
> waiting to be settled
> by an alien dream.[1]

The poem serves to remind one of the many implications of Bo Jeffares' observation that 'Landscape painting provides the perfect vehicle for personal interpretations of heaven and hell.'[2] For some, the twentieth century has tipped the balance firmly away from heaven to hell. In the Epilogue to his 1949 study *Landscape Into Art*, the late Sir Kenneth Clark revealed his post-atomic fears that 'in the last few years nature has not only seemed too large and too small for imagination: it has also seemed lacking in unity ... we have even lost faith in the stability of what we used hopefully to call "the natural order"; and, what is worse, we know that we have ourselves acquired the means of bringing that order to an end.'[3]

Forty years later, landscape is still very much the focus of Western reflections upon the artistic mediation of experience and imagination, in a world seemingly unleashed from the restraints of any commanding symbolic order. Clark's hope that we might be able to revivify the pathetic fallacy and once again 'use ... landscape as the focus of our emotions'[4] has survived avant-garde dismissals of the 1960s and 1970s, to reappear most forcefully in Peter Fuller's current, psychoanalytically-based defence of the romantic English landscape tradition. Fuller calls this a '"higher" landscape painting which could offer an illusion of hope, healing and reconciliation (like a cathedral) through an image of the world transfigured',[5] and believes that the roots of indigenous tradition can and should inform that 'new imaginative engagement with nature which man must develop if he is to save himself'.[6]

Fuller sets his reflections within the context of present ecological concern, disillusionment with the joys of endlessly increasing production, and 'the evident failure of Modernism's quest for a machine-based aesthetic'.[7] Given this, it is surprising that he has made little reference to Nordic art and culture in his various attempts to root contemporary aesthetic sensibility within a symbolically charged, compassionate relationship to 'Mother Nature'.[8] For it is precisely within the Nordic countries that internationalist and modernist currents have been most fruitfully tempered by the specificities of place and history. In architecture and design the achievements of Erik Gunnar Asplund and Alvar Aalto come most immediately to mind: they exemplify a peculiarly Nordic ability to synthesise pagan and Christian, and historic and contemporary resonances, in a way which should give any inhabitant of our post-Corbusian Wasteland pause for thought.[9]

The present exhibition of eighty years of magnificent Icelandic landscape art offers much that should gladden not only Peter Fuller's heart but that of anyone who relishes evidence of the fact that art produced at the geographical margins of existence may be anything but marginal in both its intrinsic qualities and psychological import. The landscape tradition in Iceland is of comparatively recent vintage, and there is a noticeable and welcome freshness and vigour in much of the work. There is also that deep, dream-like quality in the predominant and wide-ranging spectrum of blue that is so much a part of both the natural light and psychological mood that one meets in painting from all the Nordic countries. To say that much Icelandic art seems healthy, wholesome even, is not to damn it with faint praise. On the contrary: Nordic art has much to teach us about our 'night side', but Edvard Munch was the painter of the huge, affirmative mural THE SUN as well as THE SCREAM. *Pace* Wilhelm Worringer's influential notion, in his 1908 *Abstraction and Empathy*, that Nordic culture is dominated by a sense of alienation from nature at its most fierce, Nordic art often reveals a deep-seated empathy with a world of wind and rain, fog, snow and ice, besides hymning summer's white nights or autumn's brief mountain carpets of russet and gold. More than most, it is an art which embodies the yea-saying spirit of Nietzsche's Zarathustra – 'Truly, the earth shall yet become a house of healing!'[10]

The range of poetically charged Icelandic response to a landscape of awesome, magnetic power and pastoral charm can do much to help us replenish our sense of a meaningful participation in the world – meaningful in the sense that the French philosopher Gaston Bachelard intended in his celebration of imagination and reverie as the deepest links between ourselves and the world experienced as integrated cosmos. In fact, the following insights of Bachelard's seem particularly appropriate to much of this landscape art from the island of ice and fire: 'Psychically, we are created by our reverie – created and limited by our reverie – for it is the reverie which delineates the furthest limits of the mind. Imagination works at the summit of the mind like a flame ... One has never seen the world well if he has not dreamed what he was seeing ... Space, vast space, is the friend of being.'[11]

Shamanic thought emphasises that the way to such psychic health must often pass through initiatory terrors of desolation and loneliness, with an actual or symbolic wilderness providing the crucial terrain wherein psychic abstraction is eventually transmuted to empathetic solitude, a necessary prelude to worthwhile social interaction.[12] In a variety of ways, this is a predominant theme in much Nordic thought – take, for example, much of the tenor of Kierkegaard's reflections, the early novels of Hamsun or the later work of Gunnar Ekelöf, Rolf Jacobsen and Tarjei Vesaas. There is no more compelling embodiment of the physical and symbolic dimensions of this theme than Iceland, with its population hugging the coast and cultivated valleys while the immense, unpopulated interior reigns over silence and lava-riven space. Indeed, the Norwegian Vesaas' 1953 collection of lyric poetry *Land of Hidden Fires* might well have been titled and written with Iceland in mind, with its celebration of

> molten avalanches
> rumbling in the mountain's heart
>
> Man drawn to man
> across a thousand miles
> as if thirsting for a single flame[13]

Icelandic landscape art thus merits its own distinctive place within the recent, important series of American and European re-evaluations of the relation of Nordic art to modernism. Kirk Varnedoe has emphasised Robert Rosenblum's 1975 *Modern Painting and the Northern Romantic Tradition* as being the key,

innovatory text here.[14] However, for all its welcome attention to the work of J C Dahl and Christian Købke, and its underlining of the strength of Munch's work up to the 1909-1911 mural THE SUN, Rosenblum's bold fashioning of the conceptual link of a romantic, transfigured Northern landscape tradition, stretching between Caspar David Friedrich and Mark Rothko, actually concealed much more than it revealed about the Northern landscape tradition as it developed in the Nordic countries. An American-oriented modernism was still present within Rosenblum's ostensible revisionism, with Abstract Expressionism's 'dark, compelling presences' offering a cul-de-sac conclusion to the spiritual odyssey set in motion a century and a half previously by Friedrich's MONK BY THE SEA.

Nearly a decade after Rosenblum's book, the Van Abbemuseum in Eindhoven mounted an important exhibition entitled *Uit het Noorden*, which in contrast to Rosenblum concentrated on Munch's post-breakdown work, up to his death in 1944, setting it in the context of the subsequent variety of Nordic landscape imagery in Asger Jorn and Per Kirkeby. In his catalogue essay R H Fuchs commented that 'We are now rediscovering Europe, not for the purpose of rewriting the history of the past thirty years of art, to which also America has made such a real contribution, but to enrich it with things that escaped our notice before because our attention was focused elsewhere.'[15] The major British exhibitions of Jorn (1983), Kirkeby (1985) and Frans Widerberg (1986-1987) confirmed the fruits of such an approach,[16] highlighting the complementary contrasts of what Kirkeby has described as 'the Nordic dimension ... the subterranean influence ... something one could call the depth of the motif ... [and] ... The succession through Runge, Turner, Jorn. A Nordic discovery, the primacy of light.'[17] One should also underline the expressive role of texture in much of this art, a Nordic element notoriously introduced by Munch in his scraping and gouging of the layers of paint which lay at the heart of the 1885-1886 THE SICK CHILD; celebrated in COBRA's impastoed inventiveness, and crucial to the haunting impact of much of Widerberg's graphic work. All three factors – poetic depth, blazing light and textural interest – combine in the work of Jóhannes S Kjarval, whom the art historian Aðalsteinn Ingólfsson rightly considers to be 'more or less the Icelandic equivalent of Edvard Munch ...'[18]

What attention, then, has Iceland received within this revisionary process – Iceland, the country whose rich mythology and

41 Jón Reykdal (*b.*1945)
In the Wilderness, 1987
Linocut
Collection M Tucker

Sagas inspired so much of the late eighteenth century Nordic Renaissance, before it was to shape its own a century later; the country to which Friedrich apparently dreamed so much of travelling?[19]

The historical framework of both the 1982 *Northern Light: Realism and Symbolism in Scandinavian Painting 1880-1910* and the 1986 *Dreams of a Summer Night* exhibitions confined exposure of Icelandic work to that of the two early and distinctive pioneers Thórarinn B Thorláksson and Ásgrímur Jónsson. In contrast, the particular contemporary emphasis of the 1982 *Sleeping Beauty – Art Now: Scandinavia Today* show lent some credence to Neil Kent's recently expressed belief that '… after 1945 Nordic artists produced works more closely integrated with continental and especially American styles, and they completely adopted modernist conventions.'[20] The recent attention given to COBRA artists in a variety of important exhibitions and publications suggests that this assertion requires considerable qualification, at least with regard to the distinctive Icelandic COBRA participant, Svavar Guðnason,[21] and such major Danish painters as Asger Jorn, Egill Jacobsen and Mogens Balle.

Pontus Hulten's comment on early to mid-twentieth century Icelandic art, expressed at the time of the *Sleeping Beauty* show, requires similar qualification: 'We hear all about Kjarval, but I don't think he was, at that time, anything more than the local genius. There was no earth to grow for younger artists … [Nína] Tryggvadóttir was an interesting abstract artist, for example, working in Paris.'[22] Apart from its slighting of Kjarval, who by 1940 could already lay claim to a unique range of achievement in both emblematically monumentalised and symbolically intriguing landscapes, executed with an enviable variety of expressive means, Hulten's comment excludes any historical consideration of both the work and teaching roles of such important Icelandic painters as Finnur Jónsson and Jóhann Briem, with whom Tryggvadóttir studied in Reykjavík in the early 1930s.[23] They are two of the very best examples of the way in which Icelandic art has been able to combine such modernist notions as the independent role of colour and the flatness of the picture plane with a striking sensitivity to the local power of light and legend.

The present exhibition may, therefore, function not only to celebrate a range of landscape achievement unique to the island which W H Auden thought had the most magical light of anywhere on earth,[24] but also to correct certain modernist misconceptions about the development and worth of Icelandic art. Consider, for example, the response of Alfred Barr Jr to the work of the Matisse-trained Jón Stefánsson. Halldór Laxness tells of a visit the arch-modernist once made to Reykjavík to assess Stefánsson's work. Barr was shown 'some pictures of overworked cliffs and glaciers, shaggy horses and seascapes with breakers as thick as oatmeal [and] hurried to look away without a word'.[25] As the art historian Halldór Björn Runólfsson has emphasised, Stefánsson's Apollonian temperament ensured that 'Cézannism' took root in Icelandic art. Despite Auden's belief that 'Cézanne has done them [Icelandic painters] no good',[26] an unforced, personal development of the mysteries which Clive Bell addressed through the concept of 'significant form'[27] lies behind the ennobling strength of much Icelandic art. Apart from his general importance for the development of a Post-Impressionist sense of structure in Icelandic art, Stefánsson also painted such hallowed images of Nordic mood as the 1929 SUMMER NIGHT, where the spirit of Cézanne seems to sit quite happily with that of Richard Bergh, Bruno Liljefors and Ferdinand Hodler.[28]

The particular idea – or 'alien dream' – of Icelandic landscape art which lies behind the shape of this exhibition is offered neither as a definitive key to the whole Icelandic landscape tradition, nor as an outline of all the main trends in Icelandic art this century. It is also not intended to conjure any limiting notion of Iceland as 'the hermit in the west'.[29] The island's medieval contact with various European centres of learning has been documented by Björn Th Björnsson, who has also traced the range of European Romanesque and Gothic influence which underpins the fertile variety of achievement in the Icelandic illuminated manuscripts. Björnsson considers that keen attentiveness to developments abroad 'governed the evolution of Icelandic art right from the outset, and is still one of its chief characteristics today'.[30] One thinks of the impact of Van Gogh and Cézanne on Ásgrímur Jónsson and Jón Stefánsson, or Kjarval's 1911, saga-like journey on a trawler to London, where he came under the spell of Turner. The first ever showing of abstract art in Reykjavík in Finnur Jónsson's 1925 exhibition – which caused considerable uproar in the local press – followed six years of study by the artist in Dresden and Berlin.[31]

Subsequent impulses from abroad in the field of abstraction (the geometric versions of which, Nordic practitioners prefer to call 'concrete art', on the basis that there is nothing abstract about the materialisation of their ideas in the physicality of canvas and paint)

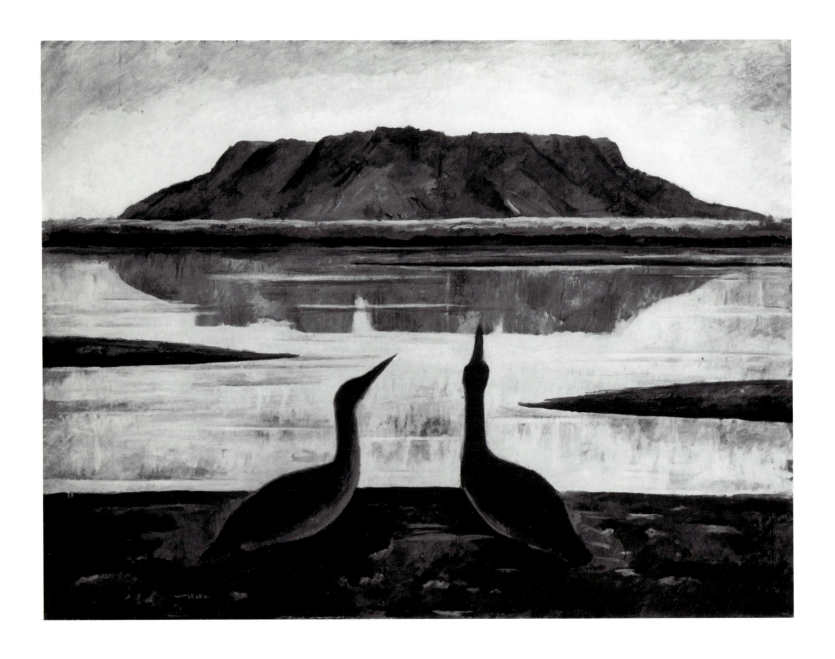

42 Jón Stefánsson
Summer Night, 1929
Oil
Listasafn Íslands

have several times led to Icelandic avant-garde protest against what has been seen as the constraining notion of a dominant, indigenous landscape tradition. A leading Icelandic 'concrete' painter, Valtýr Pétursson, recently underlined how the September 1947 Reykjavík exhibition of many kinds of semi-abstract art was 'among other things, an attack on the Icelandic landscape tradition … We needed an uncompromising and puritan movement like geometric abstraction in order to establish modernism once and for all in Iceland.'[32] Twenty years later, a mixture of Duchamp, Pop and conceptual practice lay behind the determination of the súm group to move Icelandic art away from such achievements towards a surrealistically-tinged, sociologically-inclined art. Joseph Beuys' ideas of art as social sculpture clearly informed much of this work.[33]

Nevertheless, to most outside observers, the landscape tradition remains the single most striking feature of Iceland's diversified artistic history this century. Donald Horne has recently analysed nineteenth century landscape art in Britain and Scandinavia in terms of nationalist impulses, and much the same sociological points could be made about the dominance of the landscape tradition in Iceland up to and beyond its full independence from Denmark on the attainment of Republican status in 1944.[34] From an aesthetic point of view, it is the sheer variety of conception and mixture of international and localised factors that so impresses within the overall quality of this particular tradition, and it is both this quality and variety which the present selection of work is intended to reveal. One may wonder to what extent Icelandic artists have been familiar with such other Nordic images of dream-charged landscape as the Swede, Prince Eugen's THE LAKE of 1891 or the Norwegian Harald Sohlberg's WINTER NIGHT IN RONDANE from 1914.[35] Such works epitomise the subtle blend of atmospheric naturalism and symbolism in much Nordic art. They also make an interesting contrast to the subsequent range of composition and handling in Icelandic art, where a freshly focused perspective may be brought to bear upon the landscape's rudest terrain and livid storm light, no less than to the sweep of its pastoral slopes or the sublimity of its mountain vistas, raked by light of astonishing clarity.

One is reminded of the Norwegian Christian Krohg's belief that 'All national art is bad, all good art is national.' A strong receptivity to currents from abroad often combines with the sort of emotional response which Nína Tryggvadóttir revealed shortly before painting the superb 1956 ABSTRACT, where the lyricism which had always tempered her geometrically inclined work is finally triumphant. Discussing the canvases which she had brought back from a lengthy stay in Paris, Tryggvadóttir commented that 'The pictures are supposed to show how Icelandic nature has crystallised in my consciousness during those years, how its mountains and colours have affected me and settled in my mind.'[36] Another essentially lyrical painter, Ragnheiður Jónsdóttir Ream, developed this theme in her 1962 statement that 'My paintings are not truly abstract since they are always based directly on nature. The inspiration of my work is the scenery of my early youth, the vast expansive landscape of Iceland with its great open spaces and clear northern light. Always I strive for this "Open Feeling" in my canvases.'[37]

The current strength of the Icelandic landscape tradition is attested to by the recent work of such diverse painters as Einar Hákonarson – in whom the impact of Bacon and Hockney has been mediated by a sensitivity to both modernist selfconsciousness and folk legends – and Gunnar Örn Gunnarsson and Georg Guðni Hauksson. In Gunnarsson's packed imagination the presence of Bacon is again felt, mixed with the influence of Icelandic manuscript illumination, while the distilled poetry of Haukssons's subtly modulated tones recalls the idealist spirit in Friedrich's metaphysical longings. The work of tapestry artists Hildur Hákonardóttir and Ása Ólafsdóttir also testifies to the current health of the landscape impulse, in pieces where decorative design combines with a contemplative grandeur of colour and motif, building upon the earlier, pioneering achievements of Ásgerður Búadóttir. Búadóttir's ability to 'tell us something about different moods, about the rugged Icelandic landscape, about man's struggle with the elements – and about elementary beauty'[38] is one of the most compelling examples of Nordic art's ability to fructify modernism's desire to say more with less.[39]

Students of the sociology of religion sometimes have their agnostic pride tempered by the thought that a stained glass window can only be 'read' from the inside of a church. Bearing this in mind, I would nevertheless now like to consider Icelandic landscape art from a particular, outside perspective. This is a perspective coloured by Romanticism's insistence that every art must always return afresh to the world's 'primordial energy', as Schelling so memorably expressed the problematic relationship of

culture and nature.[40] While fully respecting the art of this exhibition as a product of factors particular to Icelandic culture, experiencing such a variety of Icelandic landscape imagery in Britain not unnaturally leads one to consider its resonance within the context of the Romantic British and European landscape traditions, and the fascination with the idea of the North which the British tradition in particular suggests.

For Baudelaire, Romanticism was a child of the North: colouristic, and inspired by dreams and fairy tales. As such, it has played a crucial role in that quest for the replenishment of the power of origins which Baudelaire summarised in his famous remark that genius is childhood recaptured at will. This quest has seen innumerable attempts to develop the implications of Runge's belief that the painter's function is to create 'symbols of our conceptions of the great forces of the world', realised through colour, 'the greatest art'.[41] When one considers the awesome dimensions of Iceland's landscape, its striking embodiment of 'the great forces of the world', it seems natural to regard it as the Ultima Thule of Northern Romanticism. On the edge of the primal, lunar-like interior, beneath cliffs of twisted lava, Thingvellir's massive plain and lake are surely the essence of that genius loci coveted by romantics and primitivists alike over the past two centuries.[42] Lord Dufferin's description of the view from the lake and lava plain has never been surpassed:

A walk of about twenty minutes brought us to the borders of the lake – a glorious expanse of water, fifteen miles long, by eight miles broad … A lovelier scene I have seldom witnessed. In the foreground lay huge masses of rock and lava, tossed about like the ruins of the world, and washed by waters as bright and green as polished malachite. Beyond, a bevy of distant mountains, robed by the transparent atmosphere in tints unknown to Europe, peeped over each other's shoulders into the silver mirror at their feet, while here and there from among their purple ridges columns of white vapour rose like altar smoke towards the tranquil heaven.[43]

In his *The Search for the Picturesque: Landscape Aesthetics and Tourism in Britain, 1760-1800* Malcolm Andrews has charted the northward drift of poetic and painterly sensibilities in British art, in a period when the search for the picturesque was inextricably bound up with shifting notions of the beautiful and the sublime. Quoting the agricultural writer William Marshall's 1785 observation that 'Nature scarcely knows the thing mankind call a *landscape*',[44] Andrews then details the cultural complexities of a post-Burkean

pursuit of sublime wilderness. Such a wilderness had been courted as early as 1709 in the Earl of Shaftesbury's *The Moralists*:

I shall no longer resist the passion growing in me for things of a more natural kind, where neither art nor the conceit or caprice of man has spoiled their genuine order by breaking in upon that primitive state. Even the rude rocks, the mossy caverns, the irregular unwrought grottos and broken fall of waters, with all the horrid graces of the wilderness itself, as representing Nature more, will be the more engaging, and appear with a magnificence beyond the formal mockery of princely gardens.[45]

The subsequent pursuit of such qualities led those in search of something more uplifting than Gilpin's 'correctly picturesque' landscape[46] to first South and then North Wales, before the search for sublimity moved inexorably northwards into the Lake District and the Scottish Highlands. In the latter, as James Beattie pointed out in his 1762 essay *On Poetry and Music, as they affect the mind*, the picturesque was shot through with the sublime melancholy of 'Long tracts of mountainous desert, covered with dark heath, and often obscured by misty weather; narrow vallies, thinly inhabited, and bounded by precipices resounding with the fall of torrent; a soil so rugged, and a climate so dreary …'[47] Such scenes of melancholic grandeur found no more popular expression than in the *Ossian* poems of James Macpherson, published in the 1760s and celebrating 'A Tale of the times of old! The deeds of days of other years! … The murmur of thy streams, O Lora, brings back the memory of the past …'[48]

'The deeds of days of other years!' might have been the subtitle of the *Icelandic Journals* of William Morris, written over a century after the *Ossian* poems and celebrating not Nordic poetic fantasy but rather the integration of Icelandic Saga history with a landscape which Morris found ever compelling – now sublime in its vastness, now charming in its pastoral intimacy.[49] Magnus Magnusson has calculated that of the five hundred or so travel books about Iceland which have been published to date, some one hundred and fifty have been written by British travellers.[50] We can see such a statistic as part of a general movement northwards, over the past two hundred years, by a British imagination conditioned by the sort of burgeoning, primitivising expectations which can be discerned in Andrews' documentation. One senses that Morris felt in Iceland as W A Ross had done some twenty-five years earlier in Norway: 'truly spiritualised by the grandeur of the scenery … [and] … the honest frankness and simplicity of its people'.[51] In 1899 W G Collingwood and Jón Stefánsson pub-

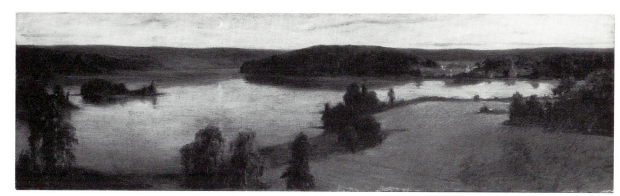

TOP
43 Prins Eugen (1865 - 1948)
The Lake, 1891
Oil
Nasjonalgalleriet, Oslo

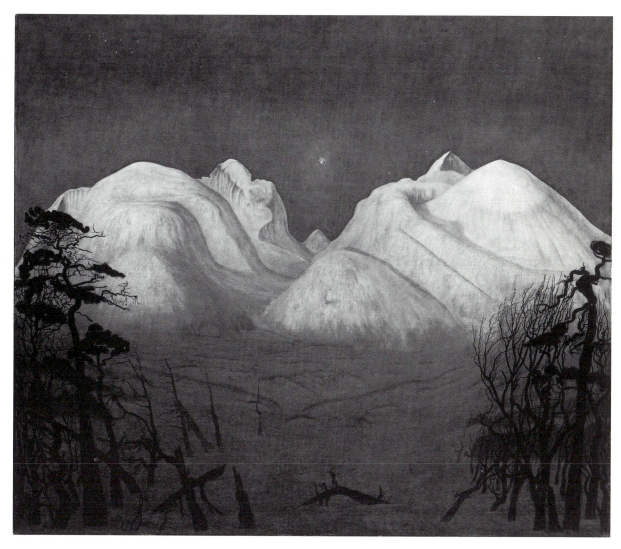

BOTTOM
44 Harald Sohlberg
(1869 - 1935)
Winter Night in Rondane, 1914
Oil
Nasjonalgalleriet, Oslo

lished their homage to what they saw as 'every touch of human interest in the sagas – pastoral, romantic and sublime –' recording much of the topography of Saga narrative in watercolour. Commenting that their eyes were 'opened at last, to the glory of the North', they intimated much of the development of Icelandic art in the twentieth century in their remark that 'There is quite a new world for the painter in Iceland – in sensational landscape and in pastoral subjects ...'. They also summarised the main problem of any latter-day seeker of the sublime in their comment that 'One realised what folk meant once when they talked of the horror of the hills – the words we often smile at nowadays, with our engineered highway and hotel in the foreground. Here we saw travelling as it used to be ...'[52]

When Auden revisited Iceland in 1964, three decades after the visit with Louis MacNeice which had resulted in *Letters from Iceland*, he noted that there were 'no autobahns, thank God'. However, much of his earlier text had already revealed a touristic diminution of any sublime response to landscape. Acknowledging his sympathy with Byron's dislike of Wordsworth and 'that kind of approach to nature', Auden described Thingvellir, which had so impressed Lord Dufferin, Morris and Collingwood, as 'the stock beauty spot'. In the section 'Hetty to Nancy', a parody of touristic response which one suspects is in places not all that far removed from Auden's own feelings, we learn that the landscape looks 'rather nice from our bus' and that 'In the centre of Iceland there are only three kinds of scenery – Stones, More Stones and All Stones'.[53]

One wonders if the full, unnerving impact of the interior of Iceland came back to Auden while he was translating the Swedish author Pär Lagerkvist in the early 1970s. Certainly I have never been in any other landscape which has so echoed the startling note of desolation which Lagerkvist struck in passages such as the following, from his 1953 collection *Evening Land*:

Shadows glide through my lands,
quenched shapes of light.

The mountains raise their desolate summits.
There are ashes upon them, following fires.

Birdless deserted regions. Who once lived here?

Extinguished torches are born through valleys,
empty valleys.

Torches whose flames have been quenched in the emptiness of space,

a space without morning or evening.[54]

Does one welcome or bemoan Auden's retreat from the Nordic sublime in *Letters from Iceland*? How necessary – or fruitful – is any myth of the North's special qualities, as developed in the picturesque British landscape tradition and beyond, today? And how might we experience that myth? Recent Nordic exhibitions such as the 1987 *Borealis 3: Painting and the Metaphysical Landscape* – in which Georg Guðni Hauksson participated – suggest that such questions are very much alive in the North now. And it is interesting to note how the pursuit of an ambiguous, timeless quality in the work of the contemporary Norwegian painter Odd Nerdrum has recently been stimulated by Iceland's rugged interior, giving provocative currency to the idea of the sublime in an image like the 1986 SLEEPING COURIER.[55]

A different perception of the possibility of sublime landscape today is argued by Bo Nilsson in his catalogue essay for *The Metaphysical Landscape* exhibition. Having reviewed the development of picturesque attitudes, Nilsson concludes that 'The authentic experience of the landscape is in modern informative society an obsolete experience. The contemporary experience of the landscape is superimposed with everything from historic ideas and models to the entire pictorial supply of the mass media industry of experiences which the artist can hardly disregard in the artistic representation.'[56] This is surely question-begging. Like life, art develops on the basis of choices, some more conscious than others. A passage in St Augustine's *Confessions* precipitated Petrarch's famous descent from a mountain seven centuries ago: in today's polluted world there seems ample reason for Nietzsche's late nineteenth century invocations in *Thus Spake Zarathustra* still to compel our attention upwards to distant peaks and plateaux. A large part of the regenerative myth of the North that has been developed over the past two hundred years is that experience of these high latitudes is in some way ennobling, whether that experience be based on physical effort and achievement, or aesthetic participation in the oneiric world of 'deep water ... and ... lovely fire' which we meet in much Nordic art.[57] As already noted, there are often echoes here of the ancient shamanic theme of walking into the wilderness, dispensing with the distracting clutter of everyday life in order to attain an inner level of transcendent energy and affirmation. If this is 'nothing but' a myth, it may yet

45 Odd Nerdrum (*b.*1944)
Sleeping Courier, 1986
Oil
Collection Karen Johnson Boyd, USA

46 Jens Ferdinand Willumsen (1863 - 1958)
Jotunheim, 1892 - 93
Oil; frame: wood, painted zinc on copper
J F Willumsen Museum, Frederikssund

prove to be an essential one in our consumer-crazy, 'mega-visual' world of limitless, yet utterly limiting material ambition.[58]

Of course, such a myth runs the risk of misleading onesided-ness. Ruskin once drew a memorable portrait of the 'savage North'. Encouraging us to cultivate 'that broad glance and grasp which would enable us to feel them [the differences between Northern and Southern countries] in their fullness', he contrasted the terraced gardens of the South with 'irregular and grisly islands amidst the northern seas, beaten by storm, and chilled by ... the hunger of the north wind ...'[59] A century later, a similar mythic perspective propelled Larkin's *The North Ship*

> Into an unforgiving sea
> Under a fire-spilling star.[60]

It also helped to consummate Borges' lifelong love affair with the literature of medieval Iceland. In *Elegy* this most cultured of poets lovingly recalled

> the North, with its unfeeling temper,
> savage both at sunrise and at sunset ...[61]

As persistent as it is poetic, the savage flavour of the Nordic myth has to be taken with at least a pinch of storm-tossed salt. With moving economy, one of the most memorable passages in the Sagas reminds us of the pastoral quality in Nordic life. In *Njal's Saga*, Gunnar Hámundarson has been outlawed and is on his way to an exile which, if not respected, carries the death penalty:

They rode down towards Markar River. Just then Gunnar's horse stumbled, and he had to leap from the saddle. He happened to glance up towards his home and the slopes of Hlidarend.

'How lovely the slopes are,' he said, 'more lovely than they have ever seemed to me before, golden cornfields and new-mown hay. I am going back home, and I will not go away.'[62]

The sculptor Ásmundur Sveinsson once commented that 'Iceland ... is no less beautiful in severity than in sweetness. People like Kjarval and Gunnlaugur Scheving know that. Kjarval knows how to treat the wilderness, Scheving the sea. They've got their diplomas in winter shepherding.'[63] As have Louisa Matthíasdóttir and Nína Tryggvadóttir in summer shepherding, one might add. The range of landscape mood in Icelandic art reveals how much of a savage stereotype it is which conditions the allegorical frame-work of the extraordinary, moralising JOTUNHEIM, painted by the Dane Jens Ferdinand Willumsen in 1892-1893 in response to the

wildest range of mountains in Norway. There *is* a moral dimension within the Icelandic landscape tradition, but it differs somewhat from Willumsen's dramatically cast dualisms.[64] Parallel to its shamanic dimensions, it seems to be closely related to those parti-cipatory, Taoist-like feelings of reverie which Thoreau celebrated in *Walden*, as a means of healing the mid-nineteenth century wounds of an already overdriven American culture. In this subtle hymn to simplicity, we learn of the 'tonic of wildness' afforded by 'peaks of the still bluer and more distant mountain ranges in the northwest, those true-blue coins from heaven's own mint'. We also meet a lake that is 'the landscape's most beautiful and expres-sive feature. It is earth's eye; looking into which the beholder measures the depth of his own nature.'[65] Such animistic reflections bring Kjarval's THE LAKE AT THINGVELLIR immediately to mind: the American who advised us to explore '[our] own higher lati-tudes' would surely have felt a strong affinity with the landscapes of Kjarval, who was also to show that 'It's necessary to know that the landscape has a thing or two to tell.'[66]

The fears that Clark expressed in his Epilogue to *Landscape Into Art* were felt long ago: Lao Tsu's *Tao Te Ching* warns us that 'when men lack a sense of awe, there will be disaster'.[67] It was surely not by chance that in the late Andrei Tarkovsky's 1986 film *The Sacrifice*, a magisterial study of contemporary despair and spiritual longing set on a coast bathed in Nordic summer light, the healing figure of Maria (played by Guðrún S Gísladóttir) is cast as an Icelander of strange, shamanic powers.[68] A century has passed since Europeans were so captivated by the lyricism and emotional intensity of the North, as embodied in the Icelandic landscape and the work of such creative giants as Ibsen and Munch, Hamsun and Strindberg, Jens Peter Jacobsen and Akseli Gallen-Kallela. We are still struggling along their difficult yet exalting road back to the sources of inner life. What is that road but a dream, the 'alien dream', that one day culture and nature will flow effortlessly into one another? Such a dream, as necessary for life as food or air, can only be strengthened by the poetic depths which fire so much Icelandic landscape art. A young and vibrant art, it has much to tell us of ancient and essential things.

1 Jóhann Hjálmarsson (b.1939): 'On Landscape', in Sigurður A Magnússon (ed): *The Post War Poetry of Iceland*, University of Iowa Press 1982 p.197

2 Bo Jeffares: *Landscape Painting*, Phaidon Press, Oxford 1979 p.78

3 Kenneth Clark: *Landscape Into Art*, John Murray, London 1976 p.239

4 *ibid* p.241 Clark speaks of the need to 'extend the pathetic fallacy'

5 Peter Fuller: *Images of God: The Consolations of Lost Illusions*, Chatto & Windus/The Hogarth Press, London 1985 p.78

6 *ibid* p.91

7 *ibid* p.82

8 The title of Chapter 9 of *Images of God*. Reviewing an Arts Council exhibition of *Landscape in Britain 1850-1950* Fuller used psychoanalyst Donald Winnicott's concept of the 'potential space', in which, after the child gradually intuits the separateness of itself, mother and world, 'through play, toys and so on, the fantasised and the real are mingled through imagination in consoling and creative ways' [Fuller *ibid* p.79]. Fuller believes that industrial culture has more and more invaded and ruined this space, so to speak, forcing it out of the bonds of creative work and religious and artistic pursuits into 'those imaginary worlds which painters created behind the picture plane. This is not, of course, a matter of regressing to the lost paradise of early infancy. Rather, the painter sought to create an *adult* equivalent which drew upon developed sentiment, acquired skills and mature perceptions of the external world' [*ibid* p.79]. Under increasing pressure from industrialisation, the aesthetic response retreats 'via the negative sublime into the world of fully abstract painting' [*ibid* p.81]. The present task is then, for Fuller, a rebirth of landscape and the 'potential space' of healing aesthetic engagement, without relapse into sentimentality

9 I am thinking in particular of Asplund's 1935-1940 Woodland Crematorium, Stockholm and Aalto's 1938-1939 Villa Mairea, Noormarkku. See S Wrede: *The Architecture of Erik Gunnar Asplund*, MIT Press, Massachusetts & London 1980 and The Museum of Finnish Architecture *Alvar Aalto 1898-1976*, Museum of Finnish Architecture, Helsinki 1978

10 F Nietzsche: *Thus Spake Zarathustra* Penguin, Harmondsworth 1967 p.103. Worringer's emphasis on 'das unheimliche Pathos' of the North, as developed in his *Abstraction And Empathy: A Contribution to the Psychology of Style* Munich 1908, repr. 1963, does illumine much of the angst-ridden expressionist tradition in Nordic art. However, its emphasis needs to be strongly qualified by *eg* the sort of documentation of the influence of a Matisse-oriented Expressionism in Nordic art which Marit Werenskiold offers in *The Concept of Expressionism: Origins and Metamorphoses*, Universitetsforlaget, Oslo 1984

11 Gaston Bachelard: *The Psychoanalysis of Fire*, Beacon Press, Boston, Massachusetts 1968 p.110; *The Poetics of Reverie: Childhood, Language and the Cosmos*, Beacon Press, Boston, Massachusetts 1971 p.173; *The Poetics of Space*, Beacon Press, Boston, Massachusetts 1969 p.208. Such observations inevitably bring to mind the transcendentalist reflections of Ralph Waldo Emerson, as developed a century before in such essays as 'Circles' and 'The Poet'. See *Emerson's Essays*, Introduction by Sherman Paul, Everyman's Library, J M Dent & Sons, London 1980

12 See *eg* Mircea Eliade: *Shamanism: Archaic Techniques of Ecstasy*, Bollingen Series, Princeton University Press 1972; Stephen Larsen: *The Shaman's Doorway: Opening the Mythic Imagination to Contemporary Consciousness*, Harper Colophon Books, New York 1977; Joan Halifax: *Shamanic Voices: The Shaman as Seer, Poet and Healer*, Pelican Books, Penguin, Harmondsworth 1980

13 Tarjei Vesaas: *Land of Hidden Fires*. Translated by Fritz Konig & Jerry Crisp, Wayne State University Press 1973 p.7

14 Kirk Varnedoe: *Northern Light*, Yale University Press 1988 p.278 footnote 20

15 Van Abbemuseum, Eindhoven *Uit het Noorden* 1984 p.61

16 See The Solomon R Guggenheim Museum, New York 1982, *Asger Jorn*; Whitechapel Art Gallery, London 1985, *Per Kirkeby*; The Polytechnic Gallery, Newcastle upon Tyne 1986, *Frans Widerberg*

17 Per Kirkeby: *Bravura*, Van Abbemuseum, Eindhoven 1982 pp.50 & 92. Translated by Peter Shields

18 Aðalsteinn Ingólfsson & Matthías Johannessen: *Kjarval: A Painter of Iceland*, Iceland Review, Reykjavík 1981 p.3

19 On the Nordic Renaissance see D M Wilson (ed): *The Northern World: The History and Heritage of Northern Europe*, Thames & Hudson, London 1980, Chapter 8 'Romanticism and Revival' by Joran Mjöberg
 Jens Christian Jensen offers a qualification of the conventional notion of Friedrich's planning of an Icelandic trip in 1811, by suggesting that Friedrich was being ironic while discussing the idea with Karl Ludwig von Knebel. See *Caspar David Friedrich*, Barron's Educational series, Woodbury, New York & London 1981 p.137

20 Neil Kent: *The Triumph of Light and Nature: Nordic Art 1740-1940*, Thames & Hudson, London 1987 p.216

21 See *eg* Jean-Clarence Lambert: *COBRA*, Sotheby Publications, London 1983; Willemijn Stokvis: *COBRA*, Rizzoli, New York 1987. In a recent article 'The Last Great Modernist in Icelandic Art' Aðalsteinn Ingólfsson comments on Guðnason that '… while artists like Jorn, Pedersen and others sought to consolidate this international alliance [COBRA], Guðnason was more interested in being an Icelandic artist. In 1945 he had a one man show in Reykjavík which was a revelation to those who attended it … in 1951 Guðnason decided to return to Iceland for good … His paintings became more expansive and explosive, his forms and colours coalesced into grand symphonies which foreign critics likened to the rugged Icelandic landscape, but probably had more to do with Guðnason's temperament.' 'The Arts in Iceland 1', *Iceland Review*, Reykjavík 1988 p.51

22 *Studio International*, Vol.185, No.997, 1982 p.8

23 See Halldór Laxness & Hrafnhildur Schram: *N Tryggvadóttir: Serenity and Power*, Iceland Review, Reykjavík 1982 pp.9–10

24 W H Auden & L MacNeice: *Letters From Iceland*, Faber & Faber, London 1967 p.8

25 Quoted in Øystein Hjort: 'Making Art. Making a Living. The artist's role in Scandinavia', in *Sleeping Beauty – Art Now*, The Solomon R Guggenheim Museum, New York 1982 p.30

26 W H Auden & L MacNeice: *op cit* p.112

27 See Clive Bell: *Art*, Perigee Books, New York 1981 and Roger Fry: *Vision and Design*, Oxford University Press, London 1981

28 It is interesting to think of Stefánsson's SUMMER NIGHT as a primitivising development of Richard Bergh's already primitivist NORDIC SUMMER EVENING of 1899-1900 [Göteborgs Konstmuseum, Göteborg], with the art of Bruno Liljefors as perhaps an intermediary reference. I do not know how much – if at all – Stefánsson was aware of any of the work of the three artists cited here. In a conversation of April 1989, Hrafnhildur Schram, a leading Icelandic art historian, suggested to me that

the possibility of Stefánsson being influenced by Ferdinand Hodler was very small. Coincidental as they may be, the parallels of SUMMER NIGHT with an image like Hodler's 1909 LAKE THUN [Musée d'art et d'histoire, Geneva] are nevertheless striking

For Runólfsson's discussion of Stefánsson's importance for the introduction of 'Cézannism' into Icelandic art see his 'Reflections On Icelandic Art', in *Aldarspegill: Íslensk myndlist í eigu safnsins 1900-1987*, Listasafn Íslands, Reykjavík 1988 pp.176. I am unaware to what extent, if any, Icelandic 'Cézannism' rested on conscious absorption of the aesthetic theories of either Clive Bell or Roger Fry

29 Gunnar Broberg: 'Scandinavia at the Turn of the Century', in Arts Council of Great Britain, *Dreams of a Summer Night*, ACGB, London 1986 p.55

30 'Pictorial Art in the Icelandic Manuscripts', in *Icelandic Sagas, Eddas and Art*, The Pierpont Morgan Library, New York 1982 p.34

31 See Frank Ponzi: 'Artist Before his Time', in *Finnur Jónsson*, Almenna bókafélagið, Reykjavík 1983

32 Bera Nordal: 'Interview with Valtýr Pétursson', in *Nordic Concrete Art 1907-1960*, Nordic Arts Centre, Helsinki 1988 p.176. I am grateful to Bera Nordal, Director of The National Gallery of Iceland, for her clarification to me of both this period of Icelandic art history and the later súm developments, in a written response to an early draft of the present text

33 See Torsten Bløndal (ed): *Northern Poles: Breakaways and Breakthroughs in Nordic Painting and Sculpture of the 1970s and 1980s*, Bløndal, Copenhagen 1986 pp.48–118, Chapter on Iceland by Aðalsteinn Ingólfsson

34 See Donald Horne: *The Great Museum: The Representation of History*, Pluto Press, London & Sydney 1984 pp.165–172

35 See Roald Nasgaard: *The Mystic North: Symbolist Landscape Painting in Northern Europe and North America 1880-1940*, University of Toronto 1984 pp.109–12 for discussion of Sohlberg's Rondane winter pictures. Prince Eugen drew the motifs of several of his landscapes from Norway; in particular, the Valdres area. See Nasjonalgalleriet, Oslo 1988, *Prins Eugen (1865-1947)* pp.50–62

36 Laxness & Schram: *op cit* p.34

37 Ream exhibition *Yfirlitssýning*, 20 March–4 April 1982; catalogue, Kjarvalsstaðir, Reykjavík 1982 p.2

38 Aðalsteinn Ingólfsson: *The Woven Art of Ásgerður Búadóttir*; catalogue essay for 1984 Kjarvalsstaðir exhibition, Reykjavík, November 1984 (no pagination)

39 See Björn Th Björnsson: 'The Icelandic Textile Artist Ásgerður Búadóttir', in *Ásgerður Búadóttir: Woven Tapestry*, Listasafn ASÍ (IFL's Art Gallery) Reykjavík 1984

40 August Wiedmann: *Romantic Roots in Modern Art*, Gresham Books, Old Woking, Surrey 1979 p.13

41 *ibid* p.67

42 It is difficult to see why Thingvellir is not once mentioned in Christian Norberg-Schulz's otherwise excellent *Genius Loci: Towards a Phenomenology of Architecture*, Academy Editions, London 1980, a book concerned with Nordic, 'desert' and classical landscapes and those factors of 'place' and 'gathering' so evident at Thingvellir

The question of how to interpret a term like 'primitivist' is no easier today than it was when Robert Goldwater first published his landmark study, *Primitivism In*

Modern Art, in 1938 – currently available in a revised, expanded edition from The Belknap Press of Harvard University Press, Cambridge, Massachusetts & London 1986. Robert Harbison charts what he sees as the inevitable dangers of any so-called regenerative search for simplicity in his *Deliberate Regression*, Andre Deutsch, London 1980. For Harbison 'Nineteenth century subjectivism leads through personality to a depersonalised end' (p.xv). But the connections between romanticism, expressionism, primitivism and Fascism, however subtly argued, have to skirt the enormous differences between these phenomena which the 1937 Nazi *Degenerate Art* exhibition, at the very least, suggests. Similarly the anonymous Nazi remark which Auden and MacNeice quote in *Letters from Iceland* – 'Für uns Island ist das Land' – can scarcely count as definitive evidence in any argument against those aspects of the myth of the North being traced here

43 Lord Dufferin: *Letters from High Latitudes* J M Dent & Sons, London 1925 pp.67–68. Dufferin travelled to Iceland in 1856

44 Malcolm Andrews: *The Search for the Picturesque*, Scolar Press, Aldershot 1989 p.34

45 *ibid* p.44. Edmund Burke's *Philosophical Enquiry into the Origin of our Ideas of the Sublime and Beautiful* appeared in 1757. See Andrew Wilton: *Turner and the Sublime*, British Museum Publications, London 1980 pp.28–30 for discussion of Burke's concepts in terms of their relation to Hume's earlier discussion of beauty and deformity in his *Treatise of Human Nature*, and what Wilton calls Kant's later clarification of Burke's equation of the sublime and terror, through the suggestion that 'the sublime was characterised primarily by boundlessness while the beautiful, dependent on form, naturally resulted from the presence of boundaries.' Wilton: *op cit* p.29. Andrew Wawn: 'The Enlightenment traveller and the idea of Iceland: the Stanley expedition of 1789 reconsidered' is an interesting study of the 'shock waves resulting from the collision between romantic primitivist illusion and elemental Icelandic reality', with regard to the 1789 Icelandic expedition of the young British scientist John Thomas Stanley. Both Enlightenment scientific enquiry and romantic veneration of place came into troubled relation with the realities of the 'sublime' Icelandic landscape, as experienced by Stanley in an ascent of Mount Hekla. See *Scandinavica* Vol.28, No.1, May 1989 pp.5–16

46 Andrews: *op cit* p.90

47 *ibid* p.202

48 *ibid* pp.203–04. Horne: *op cit*, points out the grim irony of such passages when read in the light of the later, brutal Highland Clearances

49 William Morris: *Icelandic Journals*, Centaur Press, Fontwell, Sussex 1969. Morris travelled to Iceland in 1871 and 1873

50 Magnus Magnusson: *Iceland Saga*, The Bodley Head, London 1987 p.146

51 *Travellers Discovering Norway in the Last Century*, Dreyers Forlag, Oslo 1968 p.5

52 W G Collingwood & Jón Stefánsson: *A Pilgrimage to the Saga-Steads of Iceland*, W Holmes, Ulverston 1899 p.148. They drew attention to the colouristic possibilities in the landscape in a remarkably prophetic way – 'It [Iceland] is not the dismal world of brown and grey we have been told about. It is a land of brilliant colour when the sun shines, and that is not seldom' p.13. *Fegurð Íslands …*, a 1988 Icelandic edition of Collingwood's letters and watercolours from this trip, acknowledges the topographical and historic importance of the 1897 trip for Icelanders. See *Fegurð Íslands og fornir sögustaðir: Svipmyndir og sendibréf úr Íslandsför W G Collingwoods 1897*, Bókaútgáfan Örn og Örlygur hf. 1988; pp.142–44 for English summary

53 W H Auden & L MacNeice: *op cit* pp. 154–97. One should remember Auden's comment in his 1965 preface to the new edition of these *Letters* that the three months in Iceland upon which they were based were among the happiest of his life (*ibid* p.9)

54 Pär Lagerkvist: *Evening Land*. Translated by W H Auden & Leif Sjöberg, Condor/Souvenir Press (E & A), London 1977 p.57. A distilled sense of the shaping power of the Icelandic landscape informs much of the excellent volume of post-war Icelandic modernist poetry edited by Sigurður A Magnússon, where feelings and the landscape are often blended with telling economy *eg* the 'Lost footprints/under the evening snow/of doubt' and 'The blue rain/of wing-cooled days', in Steinn Steinarr's magnificent 'Time And The Water.' Magnússon: *op cit* pp.26 & 28

55 See Jan Åke Pettersson: *Odd Nerdrum*, Dreyers Forlag, Oslo 1988, and '"The Aspect of Eternity": Odd Nerdrum talks about his landscapes with Jan Åke Pettersson' in *Siksi: The Nordic Art Review* No.1/87, pp.13–18, The Nordic Arts Centre, Helsinki

56 Malmö Konsthall/Nordic Arts Centre: *Borealis 3*, Malmö Konsthall 1987 p.43

57 Emmanuel Swedenborg: *Journal of Dreams 1743-1744*, ed. William Ross Woofenden, Swedenborg Foundation, New York 1977 p.90

58 The term 'mega-visual' is used by Peter Fuller in his various discussions of the impact of the advertising industry upon aesthetic taste and practice over the past thirty years

59 John Ruskin: 'The Nature of Gothic' in *The Genius of John Ruskin, Selections from his writings*, ed. by John D Rosenberg, Routledge & Kegan Paul, London 1979 p.173. It is interesting to recall that W G Collingwood had got to know Ruskin while studying at Oxford, establishing the bonds of a lifelong friendship; Collingwood was Ruskin's private secretary and collaborator. See *Fegurð Íslands* ... p.142

60 Philip Larkin: *The North Ship*, Faber & Faber, London 1987 p.44

61 Jorge Luis Borges: *The Book of Sand*, Penguin, Harmondsworth 1979 p.173. Five of Borges' *Seis poemas escandinavos* from the privately printed 1966 Buenos Aires edition – including 'Snorri Sturluson' and together with Borges' Foreword outlining the reasons for his 'love of all things Scandinavian' – are published in various English translations in *Jorge Luis Borges Selected Poems 1923-1967*, ed. Norman Thomas di Giovanni, Penguin Modern Classics, Penguin, Harmondsworth 1985

In his 1975 *North* Seamus Heaney drew upon the historical dimensions of the myth of the savage North, to help fashion a complex series of reflections upon Irish history, past and present. On a 'long strand/the hammered shod of a bay' the poet suddenly hears 'ocean-deafened voices/warning me, lifted again/in violence and epiphany.' See S Heaney: *North*, Faber & Faber, London 1981 p.19

62 *Njal's Saga*. Translated by Magnus Magnusson & Hermann Pálsson, Penguin Classics, Penguin, Harmondsworth 1986 p.166

63 Matthías Johannessen: *Sculptor Ásmundur Sveinsson: An Edda in Shapes and Symbols*, Iceland Review, Reykjavík 1974 p.31

64 Nasgaard: *op cit* pp.15–28 discusses these dualisms and Willumsen's relation to Gauguin and the 1890s idea of a 'wilderness paradise'. What Nasgaard calls Willumsen's 'intellectualized stylization' distances JOTUNHEIM from the full 'affective transformation' of shamanic imagery and experience

65 Henry David Thoreau: *Walden, or, Life in the Woods*, New American Library, New York 1960 p.128. A Taoist spirit flows through Halldór Laxness's superb, lyrical novel of life in Reykjavík at the beginning of our century, *The Fish Can Sing*. Translated by Magnus Magnusson, Methuen, London 1966. Within the general theme of the importance of nature for so much Nordic creativity, it is not so much the European sublime that one meets in such various major artists as Laxness (*b.*1902), Swedish poets Gunnar Ekelöf (1907-1968) and Tomas Tranströmer (*b.*1931) and Norwegian saxophonist and composer Jan Garbarek (*b.*1947), as echoes of this ancient Chinese sensitivity to the mysteries that bind the inner and outer aspects of humanity and nature

66 Aðalsteinn Ingólfsson & Matthías Johannessen: *op cit* p.20

67 Lao Tsu: *Tao Te Ching*. Translated by Gia-Fu Feng & Jane English, Vintage Books/Random House, New York 1972 (no pagination)

68 Gísladóttir discusses working with Tarkovsky on the film in Sólveig K Jónsdóttir 'Bewitched by Theatre', *Iceland Review*, Reykjavík 1988 *op cit* pp.84–88. Tarkovsky's own *Sculpting in Time: Reflections on the Cinema*, translated by Kitty Hunter-Blair, The Bodley Head, London 1986 reveals a deep feeling for both Taoist values and the spiritual and cinematic values of that quintessentially Nordic artist Ingmar Bergman

MICHAEL TUCKER (*b.*1948) is a Principal Lecturer in the Department of Art and Design History, Faculty of Art, Design and Humanities, Brighton Polytechnic, where he lectures in Scandinavian Studies. He wrote the catalogue essay 'Dreamer in a Landscape' for the 1986-1987 British retrospective exhibition of the Norwegian painter Frans Widerberg, an exhibition which he selected together with Julian Freeman, Exhibition Officer at Brighton Polytechnic. A reviewer for *Jazz Journal International*, he has written widely on Scandinavian jazz, contributing the programme notes for the 1987 Arts Council of Great Britain Contemporary Music Tour by the Norwegian saxophonist and composer Jan Garbarek.

Biographies and List of Works

Artists' biographies are listed in chronological order
Dimensions of works are given in centimetres, height before width

Thórarinn B Thorláksson
1867-1924

Thórarinn B Thorláksson was born on a farm in northern Iceland. He moved to Reykjavík in 1885 and began studying bookbinding. After working as head of a bookbinding factory for ten years, Thorláksson went to Copenhagen in 1895 to study art.

Although professional painters were unknown in Iceland at that time, he nevertheless attended drawing classes in Reykjavík before travelling to Copenhagen. There he studied at the Royal Academy of Fine Arts from 1896-99 and from 1899-1902 at the private school of the Danish painter Harald Foss, a conservative landscapist of the older generation.

Thorláksson was the first Icelandic painter to interpret Icelandic nature by standing with his canvas in front of it. He visited Iceland in 1900 and held his debut show in Reykjavík, the first exhibition ever held by an Icelandic artist in Iceland. Thorláksson is therefore a pioneer of Icelandic art, although as a painter he was very traditional, following an academic Naturalism. Icelandic landscape was his main subject but he also painted portraits and interiors.

Thorláksson has been represented at important Icelandic art exhibitions given abroad, including the exhibition *Northern Light, Scandinavia Today*, held in the USA in 1982 and *Dreams of a Summer Night*, which travelled to three cities in Europe in 1986.

During his lifetime Thorláksson taught drawing and was Headmaster of the newly founded Technical School in Reykjavík, as well as running his own book and stationery shop. He was also very active in promoting the new Icelandic art both at home and abroad.

1 Hekla seen from Laugarvatn, 1917
(Hekla séð frá Laugarvatni)
Oil, 44 × 92
Listasafn Íslands Lí 99
PLATE 1

Ásgrímur Jónsson
1876-1958

Ásgrímur Jónsson was, together with Thorláksson, a pioneer of modern Icelandic painting. Jónsson was born on a farm in southern Iceland. He left his country for Copenhagen in 1897 to study art. He first attended drawing classes at the school of Gustav and Sophus Vermehren and then studied at the Royal Academy of Fine Arts from 1900-03. He stayed in Copenhagen until 1907.

Jónsson held his first private exhibition in Reykjavík in 1903 where he displayed only landscapes painted in Iceland. In 1904 he participated in the Charlottenborg Exhibition in Copenhagen where he exhibited regularly until 1912. In 1908-09 Jónsson went on a study trip to Germany and Italy where he stayed during the winter. In Germany (Berlin) he saw some works of the Impressionists, an event which had a decisive impact on his art. When Jónsson settled down in Iceland in 1909, he returned to the Icelandic landscape, which thereafter became his main subject. His attitude was still Romantic, but his palette was becoming lighter. In 1904 Jónsson started painting with watercolours, which he continued during his long career. He expressed with watercolours his refined sense for the nuances of light and colour of the natural world and for a while that technique even influenced his oil painting. His revived acquaintance with Van Gogh's painting, when he revisited Germany in the late 1930s, had a lasting influence on his development towards greater Expressionism.

Jónsson held annual exhibitions in Reykjavík for many years. Many retrospective exhibitions of his works have also been held, the last one on his centenary in 1976. His works have also been exhibited abroad *eg* in Copenhagen in 1966 and the exhibition *Northern Light, Scandinavia Today*, held in the USA in 1982.

The artist bequeathed all his works to the Icelandic nation and in 1960 a gallery with his name opened in his former home in Reykjavík. In 1988 the Ásgrímur Jónsson Collection became, according to his Will, part of the National Gallery of Iceland when it moved into its new premises.

2 Moonlight, 1909
(Tunglsljós, vesturbærinn í Reykjavík)
Watercolour, 31 × 48
Listasafn Íslands
Ásgrímur Jónsson Collection Lí ÁJ 19 (vl)

3 Esja from Vinaminni in Reykjavík, 1910
(Esja úr Vinaminni)
Oil, 92 × 142
Listasafn Íslands Lí 240

4 Evening in Reykjavík, 1916
(Kvöld í Reykjavík)
Oil, 60 × 77
Listasafn Íslands Lí 227

5 Hot Spring in Krýsuvík, 1948
(Hver í Krýsuvík)
Watercolour, 70 × 100
Listasafn Íslands
Ásgrímur Jónsson Collection Lí ÁJ 90 (vl)
PLATE 38

6 Winter Sun in Hafnarfjörður, 1929–30
(Skammdegissól yfir Hafnarfirði)
Oil, 65.5 × 80
Listasafn Íslands
Ásgrímur Jónsson Collection Lí ÁJ 75 (ol)
COLOUR PLATE ON FRONT COVER

7 Kiðárbotnar (Húsafell), 1948
Watercolour, 68.5 × 98.5
Listasafn Íslands
Ásgrímur Jónsson Collection Lí ÁJ 93 (vl)
PLATE 2

8 Skíðadalur, 1951
Watercolour, 57 × 79
Listasafn Íslands
Ásgrímur Jónsson Collection Lí ÁJ 64 (vl)
COLOUR PLATE I

Thórdís Egilsdóttir
1878 - 1961

Thórdís Egilsdóttir was born on a farm in southern Iceland, but lived mostly in Ísafjörður, a town in north-west Iceland.

Egilsdóttir was well-known for her embroideries and she held two exhibitions, in 1930 and 1937. Two of her embroideries were displayed at the World Fair in New York in 1939.

The embroidered picture shows scenery from Thingvellir, the place of the old Icelandic national assembly, *Althing*, and is prob-

ably made from a painting. It is executed in Icelandic wool, which was carded, spun and dyed, mostly with vegetable dyes, by the embroideress herself.

9 Thingvellir, 1949
Embroidery, Icelandic wool, 44.5 × 66
The Parliament of Iceland
PLATE 3

Jón Stefánsson
1881 - 1962

Jón Stefánsson was born in a village in northern Iceland. In 1900 he went to Copenhagen intending to study engineering, but three years later he changed his mind and started at a preparatory drawing class at the Technical College in Copenhagen. From 1905-08 he studied at the private school of the Danish painter Kristian Zahrtmann. From Copenhagen he went to Paris in 1908, where he studied at the private school of Henri Matisse for the next three years. He then returned to Copenhagen, where he lived until 1924, visiting Iceland every summer to paint.

Stefánsson exhibited for the first time at the Artists' Autumn Exhibition in Copenhagen in 1919. Nothing is known about his art before 1916 as he is said to have destroyed his earliest works, considering them not good enough. His surviving early works show little influence from his master Matisse. Instead he was very taken with Cézanne's stylistic criteria, which later found their way into his own interpretation of the Icelandic landscape. Stefánsson's art thus became a conduit of Cézanne's ideas into Icelandic art.

In 1919 he visited Iceland and painted his first publicly known landscapes. In the 1920s, when he visited Iceland regularly, he laid the foundation for his landscape paintings, which are characteristic of his works from that time. He was devoted to pure formal values, and was much attracted to the wild landscapes of the Icelandic highlands with their grand desolate views. He always used a classical composition, strengthening the horizontal lines, and the landscape is presented through a combination of simple but massive forms.

Stefánsson lived in both Iceland and Denmark and was active in the artistic life of both countries. He exhibited several times at the Charlottenborg Exhibition and was active in the Danish group 'Groenningen'.

10 Hallmundarhraun, *c.1930*
Oil, 80 × 110
Listasafn ASÍ
COLOUR PLATE II

11 Tindafjallajökull, *1936*
Oil, 90.5 × 125.5
Listasafn Íslands LÍ 589
PLATE 39

12 Ölfusá, *c.1935*
Oil, 99.5 × 138.5
Listasafn Íslands LÍ 588

Jóhannes S Kjarval
1885 - 1972

Jóhannes S Kjarval was born on a farm in south-east Iceland. While working as a sailor at the beginning of the century, he came to Reykjavík, where he became acquainted with two pioneers of Icelandic painting, Thorláksson and Jónsson, and made his exhibition debut as early as 1908, at the age of twenty-three. Kjarval stayed in London during the winter of 1911-12, visiting museums and studying art on his own. He then went to Copenhagen and studied art, first at the Technical College and then at the Royal Academy of Fine Arts in 1913-17. He stayed in Denmark until 1922 and exhibited there for the first time in 1919. He visited Rome in 1920 and Paris in 1928. During the first phase of his career Kjarval seems to have been absorbing different artistic movements which were current at the turn of the century — Symbolism as well as Impressionism and even Cubism, which deeply influenced him, and later he was to make an original use of this eclectic combination.

Kjarval began painting Thingvellir, the former place of the national assembly, *Althing*, just before 1930, and soon he became famous for his original interpretation of this particular scene and Icelandic nature. First seeking his motifs in the vast scenery, he gradually concentrated on close-ups, breaking the landscape down into its minutest particles. Around 1940 his paintings are characterised by a certain tactility, due not only to the nearness of his subject, but also to the use of earth colours and vivid brush-strokes. Later Kjarval interpreted the nature of the country in a more expressive style and he gave his landscape an imaginary dimension by weaving fantastic figures into it as some kind of per-

sonifications alluding to Icelandic folklore. Being an excellent draughtsman he drew these fantastic figures with the brush on the canvas, making them transparent and immaterial. In these paintings Kjarval's symbolism is very complex, consisting of personal symbols and allegories. In a way he is true to the literary nineteenth-century Symbolism, which appealed to his poetic mind, but his free expression is completely modern.

During his career Kjarval exhibited many times and took part in Icelandic exhibitions abroad. Many retrospectives of his works have been held, the last one at his centenary in 1985. Kjarval has also been represented at some international exhibitions such as the World Fair in New York in 1939 and the Biennial of Venice in 1960.

Kjarval died in 1972 and, in his Will, donated all his works to the city of Reykjavík.

13 Summer Night at Thingvellir, *1931*
(Sumarnótt á Thingvöllum)
Oil, 100 × 150
Listasafn Íslands LÍ 418
PLATE 4

14 From Thingvellir, A Hot Day, *1932*
(Frá Thingvöllum, heitur dagur)
Oil, 115 × 160
Listasafn Íslands LÍ 1370

15 Esjan and Úlfarsá, *1934*
(Esjan og Úlfarsá)
Oil, 67 × 142
Collection Thorvaldur Guðmundsson/Háholt
PLATE 5

16 The Lake at Thingvellir, *c.1936*
(Thingvallavatn)
Oil, 63 × 149
Thorvaldur Guðmundsson/Háholt
COLOUR PLATE III

17 Lava, *1949*
(Hraun)
Oil, 121 × 120
Listasafn Íslands LÍ 1209
PLATE 6

18 Bláskógaheiði, *1953*
Oil, 103.5 × 128
Listasafn Reykjavíkur, Kjarvalsstaðir LR K-7
COLOUR PLATE IV

19 Esjan in February, 1959
(Esjan í febrúar, 1959)
Oil, 103 × 120
Listasafn Reykjavíkur, Kjarvalsstaðir LR K-41
COLOUR PLATE V

20 First Snow, 1953
(Fyrstu snjóar)
Oil, 126 × 95
Listasafn Reykjavíkur, Kjarvalsstaðir LR K-19
PLATE 37

Júlíana Sveinsdóttir
1889 - 1966

Júlíana Sveinsdóttir was born in the Westman Islands, off the south coast of Iceland. In 1909 she went to Copenhagen, where she attended courses at private art schools. In 1912 - 17 she studied at the Royal Academy of Fine Arts and a year later, in 1918, she exhibited for the first time at the Artists' Autumn Exhibition at Charlottenborg in Copenhagen. Sveinsdóttir lived in Denmark for the next few years, but visited Iceland regularly, where she painted in the countryside. She lived in Iceland from 1928 until 1931, when she settled permanently in Copenhagen.

Although living in Denmark she kept in close contact with Iceland, where she sought her inspiration. Besides painting she worked with weaving and was during her lifetime a highly esteemed weaver. Her weaving seems to have influenced her painting towards abstraction. Without leaving figuration, she liberated herself from the representational and concentrated on pictorial, colouristic values.

As a resident of Copenhagen Sveinsdóttir participated regularly at the Charlottenborg Exhibitions, where she had a seat on the jury for many years.

21 From the Westman Islands, 1946
(Frá Vestmannaeyjum, Elliðaey)
Oil, 82 × 90
Listasafn Íslands LÍ 778
COLOUR PLATE VI

22 From the Westman Islands, 1956
(Frá Vestmannaeyjum)
Oil, 68 × 93
Leifur Sveinsson
PLATE 8

Finnur Jónsson
1892 - 1989

Finnur Jónsson was born on a farm in eastern Iceland. He received a diploma as a goldsmith in Reykjavík in 1919 and later went to Copenhagen to study art. After staying there for two years, attending classes at private art schools, *eg* with the Danish painter Olof Rude, he returned to Iceland in 1921, where he had his first private exhibition. The same year he left for Berlin, where he attended the private art school of Carl Hofer. From Berlin he went to Dresden in 1922, where he stayed until 1925. At first he studied at the Academy of Fine Arts with Oskar Kokoschka, and later at the art school, Der Weg, Schule für Neue Kunst, run by the painter Edmond Kesting. In Germany Jónsson became influenced by German Expressionism, which characterised his painting ever since. He also became acquainted with modern movements, such as Cubism and Constructivism, and experimented in their manner. In 1925 some of these experimental works were selected for the May exhibition in the Der Sturm Gallery in Berlin. The same year Jónsson returned to Iceland, where he held an exhibition showing his modernist works, some of which were non-objective. These works met an uncomprehending reception and Jónsson responded by reverting to more traditional painting, seeking his themes from the fishermen's life and the wilderness of the country.

Jónsson was represented by his modernist paintings from the 1920s at the exhibition *Europe 1925,* held under the auspices of the Council of Europe in Strasbourg in 1970.

23 Stjarna's Bones, 1934
(Beinin hennar Stjörnu)
Oil, 90 × 106
Listasafn Íslands LÍ 594
COLOUR PLATE VII

24 The Lava at Thingvellir, 1953
(Úr Thingvallahrauni)
Oil, 87 × 109
Listasafn Íslands LÍ 4444
PLATE 16

25 Three Suns, 1966
(Thrjár sólir)
Oil, 125 × 105
Listasafn Íslands LÍ 4461
COLOUR PLATE VIII

Ásmundur Sveinsson
1893 - 1982

Ásmundur Sveinsson was born on a farm in western Iceland. After studying wood-carving in Reykjavík in 1915 - 16, he went to Copenhagen, where he attended drawing classes at the private school of the Danish painter Viggo Brandt in 1919 - 20. In 1920 he went to Stockholm where he studied at the Royal Academy with the Swedish sculptor Carl Milles until 1926. In 1926 he went to Paris, where he lived for the next three years, including a period of study with the sculptor Charles Despiau. In 1929 he returned to Iceland, where he had his first private exhibition in 1930.

Sveinsson was at first influenced by the archaism of Milles, but during his Parisian years he became acquainted with Cubism. In the beginning of the 1930s he still worked with Cubist forms, as if to satisfy his need for concrete and immediate expression; then began to work with curved forms and his sculptures became more massive. During a stay in Copenhagen in 1935 - 37 he modelled several monumental sculptures of working people, which are characterised by massive and clumsy forms and are free from all sentimental heroism. In the 1940s Sveinsson began to work in wood and his sculptures, showing an influence from Henry Moore and others, came to be characterised by organic forms. While remaining figurative they became more abstract, often with literary or folkloric themes. Later he began to work with metal, often combined with wood; his sculptures became more constructive and the themes more abstract.

For many years Sveinsson taught at an art school in Reykjavík, where he instructed many of the most important Icelandic sculptors of the following generation. He has been represented at some international exhibitions such as the World Fair in New York in 1939 and the Biennial of Venice in 1960.

In 1941 he started building a house and studio, more a sculpture than a piece of architecture, which has now become his museum. The artist donated all his works to the city of Reykjavík.

26 Giantess, 1948
(Tröllkona)
Concrete and obsidian glass, h.58
Listasafn Reykjavíkur, Ásmundarsafn LR ÁS H-49

27 Black Clouds, 1947 - 48
(Svört ský)
Concrete and obsidian glass, h.90
Listasafn Reykjavíkur, Ásmundarsafn LR ÁS H-44
PLATE 11

28 A Magician, 1946
(Galdramaður)
Bronze, h.69
Listasafn Reykjavíkur, Ásmundarsafn LR ÁS H-42

29 Head Ransom, 1948
(Höfuðlausn)
Oak, h.66
Listasafn Reykjavíkur, Ásmundarsafn LR ÁS H-50
PLATE 40

30 Lament, 1948
(Sonatorrek)
Concrete and obsidian glass, h.69
Listasafn Reykjavíkur, Ásmundarsafn LR ÁS H-47
PLATE 12

31 Ripples, 1952
(Öldugjálfur)
Bronze, h.36
Listasafn Reykjavíkur, Ásmundarsafn LR ÁS H-70

Gunnlaugur Scheving
1904 - 1972

Gunnlaugur Scheving was born in Reykjavík, but brought up in a village on the east coast of Iceland. After a one-year stay in Reykjavík where he attended drawing classes, he left for Copenhagen in 1923. At first he attended drawing classes at a private art school, but he studied later at the Royal Academy of Fine Arts in 1926 - 29. He exhibited for the first time at the Charlottenborg Exhibition in 1929 and a year later in Iceland.

Scheving represents those artists who made their debuts in the 1930s and sought their motifs in the surroundings of ordinary people's daily life. He selected his motifs from the fishermen's work, especially on the boats. In his stylised paintings from the sea, the man is always central, the boat is like a world in itself. With his formalist interpretation of the realist motif Scheving avoids all sentimental heroism. While these paintings, characterised by diagonals, suggest a realist presence, his landscape paintings are laden with folkloristic and religious references. Their composition is horizontal instead of diagonal, expressing the harmony between man and nature.

Scheving participated in the September Exhibitions in Reykjavík in 1947 - 52, together with a group of younger radical artists.

Although many of his colleagues later turned towards abstract painting, Scheving never renounced figuration. In spite of his formalism he above all respected his motifs, which he sought in Icelandic reality and culture.

32 Fishing Boat, 1958
(Fiskibátur)
Oil, 160 × 209
Listasafn Íslands Lí 1076
PLATE 18

33 Fishermen Hauling in a Shark, c.1950s
(Sjómenn að taka inn hákarl)
Watercolour, 20 × 30
Listasafn Íslands Lí 1716
PLATE 17

34 Fisherman in a Boat, c.1950s
(Sjómaður á báti)
Watercolour, 28.5 × 36
Listasafn Íslands Lí 1716
PLATE 20

35 Two Fishermen in a Boat, c.1950s
(Tveir sjómenn á báti)
Watercolour, 27 × 31.5
Listasafn Íslands Lí 1746
PLATE 19

Jóhann Briem
b.1907

Jóhann Briem was born in southern Iceland. Having attended drawing classes in Reykjavík he went to Dresden, where he studied at the Akademie Simonson-Castelli in 1929-31 and at the Staatliche Kunstakademie in 1931-34. In 1934 he returned to Iceland and in the same year he had his debut show. Together with the painter Finnur Jónsson he gave private classes in drawing and painting in 1934-40.

In Dresden Briem became acquainted with German Expressionism, which influenced his own painting, but whose stronger accents he moderated. Unlike many of his colleagues he was neither touched by the social realism of the 1930s nor did he turn to abstract painting, but sought his motifs in country life which he interpreted in a lyrical and introvert way. After 1960, however, he tended towards abstract painting, but using strong, figurative methods.

36 Horses on a Green Hill, 1960
(Hestar í grænni brekku)
Oil, 80 × 95
Listasafn ASÍ
COLOUR PLATE IX

37 Black Mountains, 1963
(Svört fjöll)
Oil, 70 × 65
Listasafn Íslands Lí 1252
PLATE 21

38 Red Boat, 1972
(Rauður bátur)
Oil, 90 × 96
Listasafn Íslands Lí 1594

38a In the Farmyard, 1956
(Í hlaðvarpanum)
Oil, 90 × 115
Listasafn ASÍ

Svavar Guðnason
1909 - 1988

Svavar Guðnason was born in south-east Iceland. In 1935 he went to Copenhagen where he attended courses at the Royal Academy of Fine Arts in 1935-37. Inspired by the radical movements in Danish art, Guðnason left the Academy in Copenhagen in 1938 and went to Paris where he attended the school of Fernand Léger. He returned to Copenhagen and stayed there until 1951, when he settled in Iceland. Guðnason exhibited for the first time at the Artists' Autumn Exhibition in Copenhagen in 1935. Soon he became acquainted with radical movements in Danish art of the 1930s. He was a contributor to the radical review *Hell Horse* and exhibited at the Autumn Exhibitions in 1943-49. He was one of the artists who founded the international group COBRA, in which he was active until he returned to Iceland.

By the late 1930s Guðnason had already left objective reality behind, to express his personal experiences through colour alone. At first working with biomorphic and geometric forms he later seemed to be more interested in improvisation and his painting developed towards a kind of abstract expressionism. His first private exhibition in Reykjavík in 1945, where he showed abstract expressionist paintings, has been considered a turning point in modern Icelandic abstract art. With his vigorous and colourist

work he prepared the ground for abstract painting in Iceland. Influenced by 'art concret', his paintings became more geometric in the 1950s but his straight lines soon gave way to expressive brush-strokes.

Guðnason always kept in contact with Denmark where he exhibited several times, among them as a member of the artists group 'Groenningen' from 1960. He was represented in numerous international COBRA exhibitions and at the Biennial of Venice in 1972.

39 Mount Hágöngur, 1947
(Hágöngur)
Oil, 130 × 97
Listasafn ASÍ
COLOUR PLATE X

40 The Dictator, 1949
(Einræðisherrann)
Oil, 160 × 136
Listasafn ASÍ
PLATE 23

Nína Tryggvadóttir
1913-1968

Nína Tryggvadóttir was born in Seyðisfjörður on the east coast of Iceland. From 1933-35, while living in Reykjavík, she attended drawing classes given by the painters Jóhann Briem and Finnur Jónsson. She went to Copenhagen where she studied at the Royal Academy of Fine Arts in 1935-39. In 1937 she exhibited for the first time at the Charlottenborg Exhibition in Copenhagen. After becoming impressed by the radical movements in Danish art in the 1930s she made a visit to Paris in 1939. She stayed in Iceland in 1939-43, where her first exhibition attracted much attention.

Tryggvadóttir went to New York in 1943 to continue her art studies with Hans Hofmann and Fernand Léger until 1946. In 1945 she held her first private exhibition in New York and in 1947-52 she participated in the September Exhibitions in Reykjavík. She lived in Paris in the 1950s, exhibiting at such places as the Salon des Réalités Nouvelles, and in 1960 settled in New York.

At first she chose her motifs from everyday surroundings, which she treated in a semi-Cubist way. Soon her painting became more abstract, characterised by her intuitive understanding of structure and colouristic sense, and around 1950 her art balanced

between lyric and geometric abstraction. Her paintings were deeply inspired by Icelandic nature, especially in her expressive use of colour.

41 Abstract, 1956
(Abstrakt)
Oil, 137 × 124.5
Listasafn Íslands LÍ 3554
COLOUR PLATE XI

42 Composition, 1960
(Komposition)
Oil, 127 × 112
Listasafn Íslands LÍ 1244

Ragnheiður Jónsdóttir Ream
1917-1977

Ragnheiður Jónsdóttir Ream was born in Reykjavík. She moved to the USA in 1945 and lived there until 1969. She started her art career late after studying the piano. In 1954 she began art studies at the American University in Washington DC, where she studied for the next four years. She held some private exhibitions in the USA and participated in several group shows. In 1967 she held her first private exhibition in Reykjavík and became established in Icelandic art as a lyrical and very independent landscapist. Her landscape paintings have a clearer relation to abstract art than to the Icelandic landscape tradition.

43 Landscape, 1977
(Landslag)
Oil, 95 × 80
Listasafn Íslands LÍ 3916

Kristján Davíðsson
b.1917

Kristján Davíðsson was born in Reykjavík. He attended classes in drawing and painting at the private school of the painters Finnur Jónsson and Jóhann Briem in 1932-33 and 1935-36. In 1945 he moved to the USA where he studied at the art school of the Barnes Foundation in Merion in 1945-47, and in 1946-47 at the University of Pennsylvania, where he had his first private exhibition in 1946. In 1949 he took part in the Autumn Exhibition in

Copenhagen, where his abstract paintings attracted attention. He exhibited for the first time in Iceland in 1950. The same year he stayed in London and Paris, where his acquaintance with informal art was to be decisive for his own painting. His source of inspiration is often the dynamic nature of the Icelandic countryside.

He has been represented at numerous Scandinavian and international art exhibitions and at the Biennial of Venice in 1984.

44 Snow, Water and Land 1, 1989
(Snjór, vatn og land)
Oil, 120 × 100
The Artist

45 Snow, Water and Land 2, 1989
(Snjór, vatn og land)
Oil, 120 × 100
The Artist

45a Land and Water in the Spring, 1989
(Land og vatn á vordægri)
Oil, 155 × 180
Verzlunarskóli Íslands
PLATE 25

Louisa Matthíasdóttir
b.1917

Louisa Matthíasdóttir was born in Reykjavík. In 1934 she went to Copenhagen to study at the School of Handicrafts until 1937. In 1938 she continued her studies at the private school of Marcel Gromaire in Paris. Like her friend Nína Tryggvadóttir, Matthíasdóttir went to the USA in 1942 for further studies with Hans Hofmann. She has been living in the USA since then, exhibiting annually, either solo or with groups, but continues to derive many of her motifs from Iceland. These works show scenes from the countryside with sheep and horses, or urban scenes with tiny houses, all in bright colours and far away from the noisy life of modern society, but painted with an objective intensity.

46 The Harbour of Reykjavík, 1987
(Reykjavíkurhöfn)
Oil, 60.5 × 78
The Artist
COLOUR PLATE XII

47 Girl with a Horse, 1987
(Stúlka og hestur)
Oil, 56 × 99
The Artist
PLATE 24

Ásgerður Búadóttir
b.1920

Ásgerður Búadóttir was born in Borgarnes, a town in western Ice-Iceland. From 1942-46 she studied at the Icelandic College of Art and Crafts in Reykjavík. Shortly afterwards, she went to Copenhagen and studied at the Royal Academy of Fine Arts under the Danish painter Vilhelm Lundstrøm from 1946-49. In 1949 she travelled through France and there for the first time she saw weaving used as a free and modern art medium. On her return to Iceland she attended a short course in tapestry weaving which proved to be her ideal medium. Like her elder colleague Júlíana Sveinsdóttir, Búadóttir approached the textile art through painting and her textiles render a sensibility of the pictorial possibilities in combination with the technique. For a while her works showed a strong Constructivist influence based on the fundamental horizontal and vertical elements of warp and weft. Later a need for richer textual quality and optical tactility began to assert itself. Although Búadóttir's works always are abstract they are imbued with a strong sense of real experience, especially of Icelandic nature.

Búadóttir is one of the most important Icelandic textile artists and has been represented at numerous Scandinavian and international exhibitions.

48 Shielded Moon, 1976
(Skarðatungl)
Icelandic wool and horsehair, 158 × 115
Listasafn Íslands LÍ 3841
PLATE 36

49 Ice and Fire, 1975-78
(Ís og eldur)
Icelandic wool and horsehair, 141 × 136
The Artist
COLOUR PLATE XIII

50 Sea of Fire I, 1981
(Eldland I)
Icelandic wool and horsehair, 132 × 114
Private Collection

Eiríkur Smith
b.1925

Eiríkur Smith was born in Hafnarfjörður, a town near Reykjavík. In 1946-48 he studied at the Icelandic College of Art and Crafts in Reykjavík. In 1948 he went to Copenhagen to study at the private school of the Danish painter Rostrup Bøyesen for the next two years. Like many young Icelandic artists of that time he went to Paris where he stayed from 1950-51. Smith became one of the pioneers of geometric abstraction in Iceland, but later inclined towards a lyrical and abstract expressionism. After intensive studies of Pop Art in the late 1960s he began merging the human figure and its surroundings into his paintings and for a while he treated his subject in a super-realist way. In his recent works the interpretation of nature is more lyrical, often suggesting the presence of dreamlike human or fantastic figures, and with clear reference to Icelandic folklore.

51 Two Figures and Grey Mountains, 1987
(Tvær verur og grá fjöll)
Oil, 170 × 200
The Artist
PLATE 28

52 Mountain in Winter, 1989
(Vetrarfjall)
Watercolour, 74 × 103
The Artist
PLATE 29

Hringur Jóhannesson
b.1932

Hringur Jóhannesson was born on a farm in northern Iceland. He studied at the Icelandic College of Art and Crafts in 1949-52. He has exhibited regularly, both in Reykjavík and around Iceland since his first private show in 1962.

Jóhannesson represents the generation of artists that started their careers after the dominance of abstract art of the 1960s, but without following that movement artistically. At the beginning he concentrated on chalk and pastel drawing of land- and townscapes. In the mid-1960s he started working in oil. At first his painting showed influence from Pop Art but later became almost super-realistic, with large close-ups of his surroundings. In his landscape

painting, usually from his native Aðaldalur in northern Iceland, the presence of man is suggested with everyday objects incorporated into the picture.

53 View into a Barn, 1988
(Horft inn í hlöðu)
Oil, 100 × 120
The Artist
PLATE 31

54 Serpentine and Sky, 1988
(Slönguform og himinn)
Oil, 100 × 120
The Artist

Hildur Hákonardóttir
b.1938

Hildur Hákonardóttir was born in Reykjavík. In 1964-68 she studied at the Icelandic College of Art and Crafts in Reykjavík and in 1968-69 at the Edinburgh College of Art. As a weaver Hákonardóttir brought a new element into Icelandic art with her figurative textiles and three-dimensional works, often inspired by the women's rights movement. She was active in the SÚM group with which she exhibited several times after her first private exhibition in the SÚM Gallery in 1971. From 1975-81 she was head of the Icelandic College of Art and Crafts, where she established a faculty of experimental art.

Besides exhibitions in Iceland she has taken part in several Nordic exhibitions of textile art.

55 Heaven and Earth, 1983
(Himinn og jörð)
Tapestry, 249.5 × 115
Listasafn Íslands LÍ 4346

Sigurður Guðmundsson
b.1942

Sigurður Guðmundsson was born in Reykjavík. He studied at the Icelandic College of Art and Crafts in Reykjavík in 1960-63, and in Holland at Academi 63 in Haarlem in 1963-64 and 1970-78.

Guðmundsson represents the generation of artists who were influenced by Pop Art and the Fluxus movement in the 1960s. He

soon became one of the most active members of the súm group
in Reykjavík, where he held his first private exhibition in the súm
Gallery in 1969.

In the 1970s Guðmundsson developed a very personal con-
ceptual style, based on lyrical premises. He then began to photo-
graph his performances, which proved to be the ideal medium for
his conceptual poetry. Since then he has been working with sculp-
ture which has the same suggestive power as his photographed
performances.

Although living abroad since the mid-1960s, he has maintained
strong contact with Iceland, and was one of the founders of the
Living Art Museum in Reykjavík in 1978. As a conceptualist
Guðmundsson has earned an international reputation and has
taken part in numerous international exhibitions, among others at
the opening of Centre Georges Pompidou in 1977. His works
were shown at the Biennial of Venice in 1976 and in 1978 (*I Paesi
Nordici*).

56 **Mountaintops**, 1967
(Fjallatoppar)
Mixed media, 30 × 45
The Artist

Magnús Tómasson
b.1943

Magnús Tómasson was born in Reykjavík. In 1963-69 he studied
at the Royal Academy of Fine Arts in Copenhagen. Tómasson
began his career as a painter, holding his first private exhibition
as early as 1962. In Copenhagen he began working with sculpture
and creating three-dimensional works. He became an active mem-
ber of the súm group and in 1968 he participated at an outdoor
exhibition, where he showed his metal sculptures for the first time.
Often based on mythological ideas, his works are full of both
irony and poetry. In 1969 he began to work with what he called
'visual poetry' and used boxes as containers for visual metaphors
of his ideas. In the 1970s he began his series *History of Aviation*,
where he transformed his thorough studies of that subject into
visual poetry.

Tómasson has been represented at several art exhibitions within
Scandinavia.

57 **For a Tired Bird**, 1982
(Handa threyttum fugli)
Mixed media, 71.5 × 61.5
The Artist

58 **For a Fully-Fledged Bird**, 1980-82
(Handa velfleygum fugli)
Mixed media, 71.5 × 62
The Artist

59 **Bird Flown Away, Cloud Blown Away**, 1981
(Burtfloginn fugl, burtfokið ský)
Mixed media, 71.5 × 62
The Artist

60 **The History of Aviation**, 1977
(Úr sögu flugsins)
Mixed media, 62.5 × 86.5
The Artist
PLATE 33

61 **The History of Aviation**, 1977
(Úr sögu flugsins)
Mixed media, 62 × 87
The Artist
PLATE 34

62 **The History of Aviation**, 1975-81
(Úr sögu flugsins)
Mixed media, 72 × 101.5
The Artist
PLATE 35

Einar Hákonarson
b.1945

Einar Hákonarson was born in Reykjavík. He studied first at the
Icelandic College of Art and Crafts in Reykjavík in 1960-64, and
then at the Valand Art School in Gothenburg, Sweden, in 1964-67.
During his studies Hákonarson became acquainted with Pop Art,
which proved to be decisive for his art. He also started working
in graphics and was awarded prizes for his graphic works at inter-
national exhibitions. On his return to Iceland in 1967 he reintro-
duced figuration into Icelandic painting, which had been dominated
by abstract art for over fifteen years, and also established graphics
as a discipline in Icelandic art.

In his earlier works Hákonarson referred to mass-produced
machinery, to comment on the human condition in modern
society, which has been his main subject ever since.

63 In the Mountain Hall, 1986
(Í fjallasal)
Oil, 150 × 200
Listasafn Íslands Lí 4775
COLOUR PLATE XV

64 Fear, 1986
(Ótti)
Oil, 170 × 155
The Artist
PLATE 30

Ása Ólafsdóttir
*b.*1945

Ása Ólafsdóttir was born in Keflavík, a town in the south-west
of Iceland. In 1969-73 she studied at the Icelandic College of Art
and Crafts in Reykjavík, and in 1976-78 at the Craft School at
Gothenburg University, Sweden, where she studied textiles. Liv-
ing in Sweden for many years, she exhibited both there and in
Iceland. A number of her works are owned by Swedish institutions
and in Iceland she also has works in public buildings.

Although living abroad for some time Ólafsdóttir seems to
have found her sources in Icelandic nature and culture. Some of
her textiles she has based on patterns typical in Icelandic tradi-
tional turf houses. In others a deep experience of nature is inherent
and the Icelandic landscape can be recognised as stylised geo-
metric and organic forms.

65 Light and Shadows, 1987-88
(Ljós og skuggar)
Tapestry, 175 × 130
Menntaskólinn á Laugarvatni
COLOUR PLATE XIV

66 Caged Birds, 1987
(Fuglar í búrum)
Tapestry, 120 × 86
The Artist

67 Looking Out, 1988
(Horfa út)
Tapestry, 112 × 80
The Artist

Gunnar Örn Gunnarsson
*b.*1946

Gunnar Örn Gunnarsson was born in Reykjavík. Gunnarsson is
a self-taught painter. In 1963 he went to Denmark to study the
cello and a year later he began to paint. He returned to Iceland
in 1965, but worked as a fisherman for the next five years. He
held his first private exhibition in Reykjavík in 1970 and a year
later he took part in the Artists' Federation Autumn Show, where
his Expressionist figurative paintings attracted much attention. He
lived in Denmark in 1973-75, where he devoted himself to art.
In the 1970s his paintings were dominated by the female body
and characterised by a psychological tension. Around 1980 his
style changed and his paintings became more fantastic, full of
fabulous creatures, and were characterised by raw colours and an
intensity which brought him close to Neo-Expressionism. In his
recent paintings the Icelandic landscape has played an important
role.

Gunnarsson has been represented at several international art
exhibitions and at the Biennial of Venice in 1988.

68 Folktale, 1986-88
(Thjóðsaga)
Oil, 180 × 206
Listasafn Íslands Lí 4783
COLOUR PLATE XVI

Sigurður Örlygsson
*b.*1946

Sigurður Örlygsson was born in Reykjavík. In 1967-71 he studied
at the Icelandic College of Art and Crafts in Reykjavík and in
1971-72 at the Royal Academy of Fine Arts in Copenhagen with
the painter Richard Mortensen. In 1974-75 he stayed at the Art
Students' League in New York. Örlygsson held his first private
exhibition in Reykjavík in 1971, where he displayed 'hard-edge'
paintings. His visit to New York seems to have had a decisive
influence on the future development of his art and in the mid-
1970s he began to break out of strong geometry by enlivening
his compositions with repeated forms, reminiscent of clouds,
wheels, letters or trivia, and by working in collage. His latest
works have been large-scale paintings incorporating objects into
the Icelandic landscape.

69 Situation Vacant
(Laus staða)
Oil, 180 × 240
Listasafn Reykjavíkur, Kjarvalsstaðir LR-536
PLATE 32

Georg Guðni Hauksson
b.1961

Georg Guðni Hauksson was born in Reykjavík. In 1980-85 he studied at the Icelandic College of Art and Crafts, and in 1985-87 at the Jan van Eyck Akademie in Maastricht in Holland like so many Icelandic art students of his generation. Since his first private exhibition in Reykjavík in 1985, Hauksson has attracted much attention for his interpretation of the Icelandic landscape. His paintings of mountains have been characterised by tonal values and a compact simplicity which in his recent paintings has resulted in a kind of nature-inspired abstract geometry. In his works Hauksson paints 'the mountains from his mind' as he has said himself and his silent mountain paintings are like a symbol of Iceland. Being the youngest among the Icelandic artists represented in the exhibition he acts as a link between the Icelandic landscape painting of the pioneers and contemporary art.

70 Ingólfshöfði, 1986
Oil, 23.5 × 121
Private Collection
COLOUR PLATE XVII

71 Etchings portfolio, 1987
Four etchings, each 35 × 37.5
The Artist

Bibliography

BOOKS

Ásgeirsson, Bragi, and Johannessen, Matthías: *Erró. An Icelandic artist*, 79 pp, col. ill, Reykjavík 1978 (English translation)

Auðuns, Jón: *Einar Jónsson myndhöggvari* (The Sculptor Einar Jónsson), with biography (English translation), 262 pp, ill, Reykjavík 1982

Björnsson, Björn Th: *Guðmundur Thorsteinsson* (Muggur), (2nd ed), 141 pp, col. ill, Reykjavík 1984

Björnsson, Björn Th: 'Island', in *Nordisk malerkunst – Norræn málaralist*, Oslo 1951, pp41–56 (in Danish)

Björnsson, Björn Th: *Íslensk myndlist á 19. og 20. öld, I–II* (Icelandic Art of the 19th and 20th centuries), 590 pp, ill, Reykjavík 1964-73

Björnsson, Björn Th: *Myndhöggvarinn Ásmundur Sveinsson* (The Sculptor Ásmundur Sveinsson), 66 pp, ill, Reykjavík 1956

Björnsson, Björn Th: *Thorvaldur Skúlason: brautryðjandi íslenzkrar samtímalistar* (Th S: A Pioneer of Icelandic Contemporary Art), with a summary in English, 208 pp, col. ill, Reykjavík 1983

Björnsson, Sigurjón, and Ingólfsson, Aðalsteinn: *Jóhannes Geir*, 88 pp, col. ill, Reykjavík 1985

Fox Weber, Nicholas, Pearl, Jed, and Rosenthal, Deborah: *Louisa Matthíasdóttir*, 60 pp, col. ill, New York 1986. Icelandic translation, Reykjavík 1987

Gretor, Georg: *Islands Kultur und seine junge Malerei*, 50 pp, ill, Jena 1928

Guðmundsson, Tómas: *Ásgrímur Jónsson* (A memoir of the artist), 66 pp, ill, Reykjavík 1956; 2nd ed: *Myndir og minningar*, 139 pp, with new ill, Reykjavík 1962

Guðmundsson, Tómas, and Stefánsson, Eggert: *Gunnlaugur Blöndal* (a brief text with English translation), 107 pp, ill, Reykjavík 1963

Ingólfsson, Aðalsteinn: *Eiríkur Smith*, 100 pp, col. ill, Reykjavík 1982

Ingólfsson, Aðalsteinn (Foreword): *Erró, myndverk 1974-1986* (paintings 1974-1986), 240 pp, col. ill, Reykjavík 1986

Ingólfsson, Aðalsteinn: 'Iceland' in *Northern Poles: Breakaways and Breakthroughs in Nordic Painting and Sculpture of the 1970s and 1980s*, pp.47-120, ill, Copenhagen 1986

Ingólfsson, Aðalsteinn: *Kristín Jónsdóttir*, 197 pp, col. ill, Reykjavík 1987

Ingólfsson, Aðalsteinn, and Johannessen, Matthías: *Kjarval – málari lands og vætta* (Kjarval – A Painter of Iceland), 96 pp, col. ill, Reykjavík 1981

Íslensk list (Iceland Art, Essays on Sixteen Icelandic Artists), 176 pp, ill, Reykjavík 1981

Íslenzk myndlist (Art in Iceland), Kristján Friðriksson (ed), 160 pp, ill, Reykjavík 1943

Johannessen, Matthías: *Bókin um Ásmund* (on Ásmundur Sveinsson), 56 pp, ill, Reykjavík 1971

Johannessen, Matthías: *Gunnlaugur Scheving*, 262 pp, Reykjavík 1974

Johannessen, Matthías: *Kjarvalskver*, 97 pp, ill, Reykjavík 1968

Johannessen, Matthías: *Sculptor Ásmundur Sveinsson – An Edda in Shapes and Forms*, 72 pp, ill, Reykjavík 1972

Johannessen, Matthías: *Sverrir Haraldsson* (in Icelandic and English), 160 pp, col. ill, Reykjavík

Kvaran, Ólafur: *Einar Jónssons skulptur – formutveckling och betydelsevärld*, 286 pp, ill, doctoral thesis from the University of Lund, 1987 (with English summary)

Kvaran, Ólafur, and Óskarsson, Baldur: *Jón Engilberts*, 112 pp, col. ill, Reykjavík 1988

Laxness, Halldór (Foreword): *Ásmundur Sveinsson* (English translation), 228 pp, ill, Reykjavík 1961

Laxness, Halldór (Foreword): *Jóhannes Sveinsson Kjarval*, 100 pp, black/white and col. ill, Reykjavík 1950

Laxness, Halldór: *Svavar Guðnason*, ill, Copenhagen 1968

Listasafn Íslands 1884-1984, Íslensk listaverk í eigu safnsins (National Gallery of Iceland 1884-1984), 237 pp, ill, Reykjavík 1985

Margeirsson, Ingólfur (ed): *Ragnar í Smára* (fifteen essays on an Icelandic maecenas in the 20th century), 203 pp, col. ill, Reykjavík 1982

Pálmadóttir, Elín: *Gerður* (a biography of the Icelandic sculptress Gerður Helgadóttir, 1928-1975), 234 pp, ill, Reykjavík 1985

Pétursson, Valtýr, and Thórarinsdóttir, Guðrún: *Thórarinn B Thorláksson*, 64 pp, col. ill (with English summary), Reykjavík 1982

Ponzi, Frank: *Finnur Jónsson: Íslenskur brautryðjandi* (Artist Before his Time), 103 pp, col. ill, Reykjavík 1983 (in Icelandic and English)

Ponzi, Frank: *Ísland á átjándu öld* (18th-century Iceland), ill, Reykjavík 1980 (in Icelandic and English)

Ponzi, Frank: *Ísland á nítjándu öld* (19th-century Iceland), 159 pp, ill, Reykjavík 1986 (in Icelandic and English)

Runólfsson, Halldór B: *Jóhann Briem*, 80 pp, col. ill, Reykjavík 1983

Runólfsson, Halldór B, and Vilhjálmsson, Thor: *Tryggvi Ólafsson*, 95 pp, col. ill, Reykjavík 1987

Schram, Hrafnhildur: *N. Tryggvadóttir – Serenity and Power*; Icelandic ed: *Nína í krafti og birtu*, 92 pp, col. ill, Reykjavík 1982

Schram, Hrafnhildur, and Sigurðsson, Hjörleifur: *Ásgrímur Jónsson*, 82 pp, col. ill, Reykjavík 1986

Steinar og sterkir litir (essays on sixteen Icelandic artists with a Foreword by Björn Th Björnsson), 262 pp, ill, Reykjavík 1965

Uttenreitter, Poul, *Jón Stefánsson*, 90 pp, ill, Reykjavík 1950

Vilhjálmsson, Thor: *Kjarval*, 143 pp, col. ill, Reykjavík 1964

Thorsteinsson, Indriði G: *Jóhannes Sveinsson Kjarval I–II* (a biography), 616 pp, Reykjavík 1985

CATALOGUES

Aldarspegill, Listasafn Íslands (National Gallery of Iceland), Reykjavík 1988.
With the essay: 'Reflections on Icelandic Art' by Halldór B Runólfsson, an art historian, pp.171-224 (English translation)

La Biennale di Venezia, 1978: Sigurður Guðmundsson, pp.187-89; 1980: Magnús Pálsson, pp.160-61; 1982: Jón Gunnar Árnason and Kristján Guðmundsson, pp.158-59; 1984: Kristján Davíðsson pp.172-73; 1986: Erró, pp.288-89; 1988: Gunnar Örn Gunnarsson, pp.192-93

50 ans de peinture en Islande (1936-1986), Saint-Malo, Rochefort-sur-Mer and Paris 1986.
With short biographies and illustrations of works by twenty-two Icelandic artists

Dreams of a Summer Night: Scandinavian Painting at the Turn of the Century, Hayward Gallery, London 1986.
One Icelandic artist: Thórarinn B Thorláksson, pp.280-87

Fjórir frumherjar, Listasafn Íslands (National Gallery of Iceland), Reykjavík 1985.
With essays on four pioneers of modern painting in Iceland, Th B Thorláksson, Á Jónsson, J Stefánsson and J S Kjarval (English translation)

Gunnar Örn, Achim Moeller Fine Art, New York 1989.
With an essay on the artist by Edward F Fry

Helgi Thorgils Friðjónsson, Kjarvalsstaðir, Reykjavík 1989, 67 pp, ill

Íslandsk kunst – gammel og ny, Louisiana, Humlebæk, Denmark 1962.
With essays on Icelandic art by Halldór Laxness and Dr Selma Jónsdóttir (in Danish)

Íslensk abstraktlist (Icelandic abstract art), Kjarvalsstaðir, Reykjavík 1987.
With four essays on Icelandic abstract art, written by Icelandic art historians

Íslenzk list 1900-1965 (Icelandic Art), Colby College Art Museum, Waterville, Maine, USA 1965.
With an essay on Icelandic art by Dr Selma Jónsdóttir

Íslenzk myndlist í 1100 ár (1100 years of Icelandic Art), Kjarvalsstaðir, Reykjavík 1974

Jóhannes Jóhannesson, Listasafn Íslands (National Gallery of Iceland), Reykjavík 1985.
With an essay on the artist by Bera Nordal, an art historian, 99 pp, ill

Jóhannes S Kjarval, Listasafn Íslands (National Gallery of Iceland), Reykjavík 1985.
A catalogue of all works by J S Kjarval in the National Gallery of Iceland, with complete bibliographic reference, 182 pp, ill

Jóhannes S Kjarval 1885-1972, Nordic Arts Centre, Sveaborg, Helsinki 1986.
With introduction by Gunnar B Kvaran, an art historian

Júlíana Sveinsdóttir, Listasafn Íslands (National Gallery of Iceland), Reykjavík 1989.
With an essay on the artist by Hrafnhildur Schram, an art historian, 80 pp, ill (English translation)

Karl Kvaran, Listasafn Íslands (National Gallery of Iceland), Reykjavík 1986.
With an essay on the artist by Bera Nordal, 36 pp, ill

Kirkjulist (Ecclesiastical and religious art in Iceland), Kjarvalsstaðir, Reykjavík 1983.
With essays on ecclesiastical art and architecture in Iceland, 77 pp, ill

Kjarval, Aldarminning (Kjarval, Centenary Exhibition), Kjarvalsstaðir, Reykjavík 1985.
With essays on J S Kjarval's paintings, drawings and writings, 84 pp, ill (in English)

Konkret i Norden/Nordic Concrete Art 1907-1960, Nordic Art Centre, Sveaborg, Helsinki 1988.
With *ia* the essay: 'Concrete Art in Iceland' by Halldór B Runólfsson, pp.160-63, and interviews with the artists Valtýr Pétursson and Hörður Ágústsson by Bera Nordal, pp.173-82

Kristín Jónsdóttir, Listasafn Íslands (National Gallery of Iceland), Reykjavík 1988.
With an essay on the artist by Aðalsteinn Ingólfsson, an art historian, 83 pp, ill (English translation)

Kristján Guðmundsson – Teikningar/Drawings 1972-1988, Kjarvalsstaðir, Reykjavík 1989

Maðurinn í forgrunni, Kjarvalsstaðir, Reykjavík 1988.
Icelandic Figurative Art 1965-1985, 112 pp, ill

Norðanad, Peintures, Sculptures contemporaines, Musée des Arts Décoratifs, Paris 1986.
A Scandinavian art exhibition with the participation of three Icelandic artists: Hreinn Friðfinnsson, Helgi Thorgils Friðjónsson and Sigurður Guðmundsson, pp.86-115 (in French)

*Northern Light: Realism and Symbolism in Scandinavian Painting 1880-1910.
Scandinavia Today*, Brooklyn Museum 1982.
With the essay: 'Art in Iceland at the Turn of the Century' by Dr Selma Jónsdóttir, Director of the National Gallery of Iceland, pp.57-59.

Icelandic artists: Ásgrímur Jónsson, pp.158-59, and Thórarinn B Thorláksson, pp.224-27

Northern Light, Nordic Art at the Turn of the Century, Yale University Press, New Haven and London 1988.
Icelandic artists: Ásgrímur Jónsson, pp.124-27, and Thórarinn B Thorláksson, pp.244-49

Nýlistasafnið 10 ára, Listasafn Íslands/Nýlistasafnið (National Gallery of Iceland/The Living Art Museum), Reykjavík 1988.
With the essay: From súm to the Living Art Museum by Guðbergur Bergsson, an author related to the súm group (English translation)

Scandinavian Art, The Seibu Museum of Art, Tokyo 1987-88.
Icelandic artists: J S Kjarval, pp.56-59, Gunnar Örn Gunnarsson, pp.96-101, H Th Friðjónsson, pp.128-33

Sigurjón Ólafsson, The Sigurjón Ólafsson Foundation, Reykjavík 1985.
An illustrated catalogue of all the works by the sculptor Sigurjón Ólafsson in the sculptor's museum, with biography and bibliographic reference

Sleeping Beauty – Art Now, Scandinavia Today, The Solomon R Guggenheim Museum, New York 1982.
Icelandic artists: Hreinn Friðfinnsson, pp.52-62, and Sigurður Guðmundsson, pp.62-71

Svavar Guðnason, Norræna húsið (Nordic House), Reykjavík 1986.
With two essays on the artist by Robert Dahlmann Olsen and Per Hovdenakk

SÚM 1965-1972, Kjarvalsstaðir, Reykjavík 1989.
With interviews with seven members of the súm group and two essays on súm

Textílfélagið 10 ára (The tenth anniversary of the Textile Guild), Reykjavík 1985.
With biographies of its exhibitors (English translation)

Toimen maisema/Ett annat landskap/Another landscape, Nordic Arts Centre, Sveaborg, Helsinki 1986.
Two Icelandic artists: Kristján Davíðsson and Nína Tryggvadóttir

Valtýr Pétursson, Listasafn Íslands (National Gallery of Iceland), Reykjavík 1986.
With an essay on the artist by Halldór B Runólfsson, 48 pp, ill (English translation)

JOURNALS

Árbók Listasafns Íslands (The annual journal of the National Gallery of Iceland), Reykjavík 1989– .
With the essay: 'Fair is thy hand …' by Júlíana Gottskálksdóttir and Hrafnhildur Schram (on Ásgrímur Jónsson's interpretation of an Icelandic folk-tale)

Árbók Listasafns Sigurjóns Ólafssonar (The annual journal of the Sigurjón Ólafsson Museum), Reykjavík 1986– .
With texts about the sculptor Sigurjón Ólafsson 1908-1982

The Arts in Iceland, Reykjavík 1988– .
A cultural magazine with articles on Icelandic art and crafts (in English)

Iceland Review, Reykjavík 1961– .
A magazine about Iceland today with regular articles on Icelandic art and crafts (in English)

Skírnir (The annual journal of the Icelandic Literary Society).
1985: Gunnar B Kvaran: 'Rými/tími í verkum Errós' (Space/time in the works of Erró), pp.182-217; 1988: Aðalsteinn Ingólfsson: 'Bók um bók frá bók …' (an essay on Dieter Roth's book art), pp.51-82

Storð, 1983-1985.
A cultural magazine with articles on Icelandic art

Teningur, 1985– .
A magazine of contemporary art and literature, with interviews with Icelandic artists

Lenders

Ásmundarsafn, The Ásmundur Sveinsson Museum
Kjarvalsstaðir, The Reykjavík Municipal Art Museum
Listasafn ASÍ, The Icelandic Labour Unions' Museum
Listasafn Íslands, The National Gallery of Iceland
Menntaskólinn á Laugarvatni, Laugarvatn College
The Parliament of Iceland
Verzlunarskóli Íslands, The Icelandic College of Commerce

Ásgerður Búadóttir
Kristján Davíðsson
Sigurður Guðmundsson
Thorvaldur Guðmundsson (HÁHOLT)
Einar Hákonarson
Georg Guðni Hauksson
Hringur Jóhannesson
Louisa Matthíasdóttir
Ása Ólafsdóttir
Eiríkur Smith
Leifur Sveinsson
Magnús Tómasson

and other private owners

Sponsors

The financial assistance of the following
towards the production of
Landscapes from a High Latitude
is most gratefully acknowledged:

EIMSKIP
Icelandair
Manufacturers Hanover Ltd
Tryggingamiðstöðin
Iceland Seafood Ltd, Hull
Fylkir Ltd, Grimsby
Ísberg Ltd, Hull
Anglo-Icelandic, Kent
Icelandic Freezing Plants Ltd, Grimsby
John W Gott Ltd, Grimsby
MGH Ltd, Immingham
Samband of Iceland
The Scandinavian Bank Group plc

The Visiting Arts Unit of Great Britain
South East Arts